NEW

How to Draw
CHARTS &
DIAGRAMS

How to Draw
CHARTS &
DIAGRAMS

BRUCE ROBERTSON

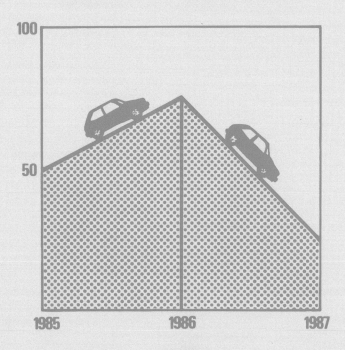

NORTH LIGHT BOOKS

Cincinnati, Ohio

First published in North America 1988
by North Light Books
an imprint of F & W Publications, Inc.
1507 Dana Avenue
Cincinnati, Ohio 45207

ISBN 0-89134-242-7

Consultant	Arthur Lockwood ARCA
	The Diagram Group
Editors	Annabel Else
	Moira Johnston
	Denis Kennedy
	Nicol Russel
Indexer	David Harding
Art director	Philip Patenall
Art staff	Joe Bonello, Alastair Burnside, Richard Czapnik, Brian Hewson, Richard Hummerstone, Lee Lawrence, Paul McCauley, Jane Robertson, Graham Rosewarne, Guy Ryman, Mik Williams, Martin Woodward.
Acknowledgements	'Peanuts' cartoon on page 149 copyright © by United Features Syndicates, Inc. Reprinted by permission.
	Grateful thanks are due to Nigel Taffs of Computair.
	Every effort has been made to acknowledge sources but we apologize for any omissions that may inadvertently have occurred.

Filmset by Bournetype, Bournemouth, England
Printed and bound by Toppan Printing, Singapore

Foreword

Charts and diagrams are the visual presentation of information. Since text and tables of information require close study to obtain the more general impressions of the subject, charts can be used to present readily understandable, easily digestible and, above all, memorable solutions. Every day we are faced with facts, figures and the interrelationship of information. In business and market research reports, school, university and government publications, and sports analyses, there is a need to convey information economically. For most of us, paragraphs of facts or columns of figures are usually a daunting and ineffective way of conveying information.

Charts are not difficult to construct – you do not need special drawing or mathematical skills or even a high level of design aptitude to produce clear solutions. Most charts convey their main message by the size, shape and position of the parts. Graph lines ascend or descend, area charts offer larger or smaller elements, flow charts reveal relationships of position, maps show the location of places, and transparent drawings of objects or the human form display the inner relationships of the parts. By converting the raw data into a visual form the patterns of the subject matter become clearer. Detailed company accounts do not immediately show where the major revenues are obtained or spent, but a pie diagram instantly reveals the largest components of a company's trading.

The purpose of this book is to explain the design solutions available to the reader, to suggest the most appropriate style, and to provide information sufficient to enable the chosen solutions to be accurately constructed. Throughout the book, scales and formulas are provided to enable you to calculate easily the proportions of your chosen solution. Protractors with 100 divisions for percentage pie charts, value-reading scales for squares, triangles, circles, cubes and spheres are provided, with additional mathematical equations to cross-check or construct area charts. Procedures for evaluating and avoiding errors of interpretation help you to unravel source data. The final section of the book contains basic grids which can be photocopied or traced and then used as a structure onto which you can plot your proposed charts.

Surprisingly, although there have been millions of charts and diagrams produced for many different branches of science, industry, commerce, education and culture, there have been very few masters of this art. There are, however, two notable exceptions. In the 18th century William Playfair invented and developed unique methods of presenting historic and economic data visually and, in the early part of the 20th century, Otto Neurath developed a widely copied method of producing unit pictorial diagrams under the title of 'isotypes'. Modern designers have exploited the graphic opportunities afforded by full-color printing and computers and, although some of these design solutions have been mostly concerned with impressing the reader with elaboration, this book concentrates on the much more valuable and simpler task of presenting the facts in an understandable and memorable way.

Contents

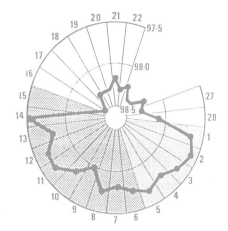

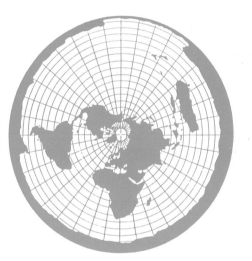

Part One

PENCE

400

300

200

176.5p

205.6p

270.0p

324.7p

OCT 85
349.0p

APR
86
441.9p

OCT 81 OCT 82 OCT 83 OCT 84 OCT 85

Integræ Naturæ *speculum, Artisque imago*

8

UNDERSTANDING CHARTS

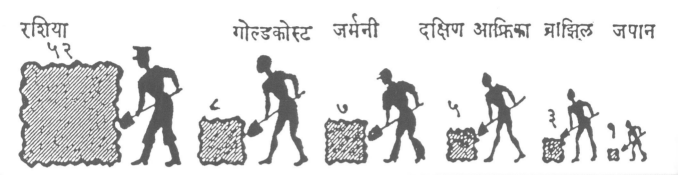

Why charts?

Before you choose a style for your chart, and certainly before you put pencil to paper, there are three important topics to consider. If you want to present the information in chart form, then you must think about the following: What are your abilities? What is the chart for? What do your readers need? Understanding the consequences of your answers to these questions will help you to avoid producing inappropriate solutions.

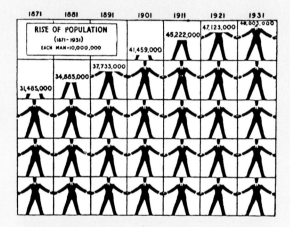

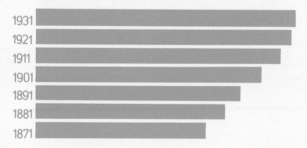

Simple is always best
The chart (*top*) is attractive but misleading. By drawing the figures holding hands the importance of the **height** of the column is lost because we do not know in which direction to read the information. The lower, simpler solution is much clearer. Never try to be clever . . . be clear.

Questions to ask about your abilities
- Can you understand the source data?
- Can you trust the sources?
- Can you edit or modify the sources?
- Can you do the calculations involved in converting the data to a chart?
- Can you use the correct equipment to produce the chart (calculators, drawing instruments etc.)?
- Can you draw the chart with skill?
- Can you understand the uses to which the chart will be put? (Is it for slides, display or publication?)
- Can you annotate the chart properly?

Questions to ask about your chart
- Is it made to impress?
- Is it made to entertain?
- Is it made to reveal information?
- Is it made to store information?
- Is it made to support the text?
- Is it made to accompany explanations?
- Is it made to be alone, unexplained?

Questions to ask about your readers
- What will they do with your chart?
- What do they know about the subject?
- What do they expect of data?
- Do they speak a specialized graphic language?
- Do they get all the information elsewhere in another form?
- Are they prepared to work to understand your chart and to reveal its information?

Complex made simple

The chart (*right*), from a popular Japanese newspaper, is excellent, clearly and simply presenting complex information. The reader can easily deduce the following:

1 It is a Japanese population chart.

2 Women are shown on the right, men on the left.

3 The vertical scale is for age, oldest at the top, youngest at the bottom.

4 The central horizontal scale, reading outwards, is for population figures.

5 The pattern is similar for both sexes.

6 When those aged 35–39 were born, there were serious population changes (due to World War II).

7 The majority of the population is below 50. This chart has encapsulated over 180 figures. It shows clearly the general features and attention is drawn to areas of significance.

Simple made complex

The chart (*right*) comes from the publicity literature of a pharmaceutical company. It is presented without any scale; and the device of a three-dimensional chart is used to disguise its lack of basic data. It is useless.

1 It appears to say that categories (**A**) and (**B**) begin lower than (**C**).

2 It appears to say that all categories progress upwards.

3 It appears to say that category (**C**) is advancing more steeply than the others. Without scales, what it appears to say cannot be verified.

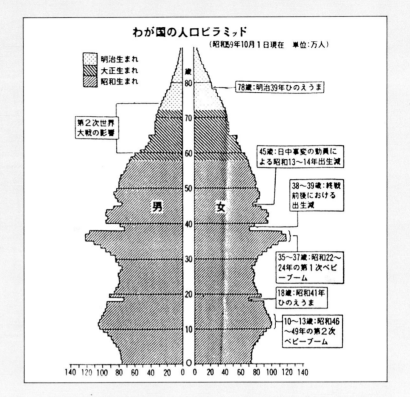

The language of charts

Before beginning to plan your chart, ask yourself the question: "Who am I talking to?" A chart is a bridge between you and your readers. It reveals your skills at comprehending the source information, at mastering presentation methods and at producing the design. Its success depends a great deal on your readers' understanding of what you are saying, and how you are saying it. Consider how they will use your chart. Will they want to find out from it more information about the subject? Will they just want a quick impression of the data? Or will they use it as a source for their own analysis? Charts rely upon a visual language which both you and your readers must understand.

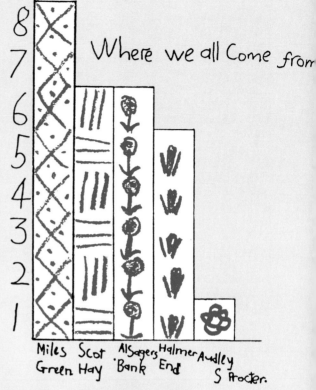

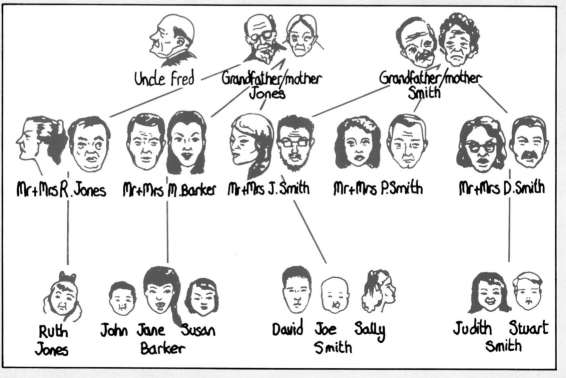

Talking to yourself

The two charts (*opposite*) were devised from research done by their creators. The first, by a young pupil, charts the origins of classmates by the neighborhood they come from. The second is a genealogical tree produced from information about relatives and from photographs in the family albums. The artist constructed three levels: brothers, sisters and cousins on the base line, parents, aunts and uncles on the center and grandparents on the top.

Talking to professionals

The chart (*right*) ranks the countries of Africa by their Gross National Product per capita, a specialized classification made on a naive assumption. The gross market value of all goods and services claimed by each country in the year the survey was done was divided by the population of that country at that time. This simply results in a figure which indicates how rich each person would have been if everyone had shared equally in the total wealth, a situation never likely to happen.

Talking in codes

Charts may use specialized visual language – symbols and signs devised for a particular group of readers. The chart (*right*) is a detail from the wiring instructions for instaling a central heating system. Only those who know the subject can understand the abbreviations and symbols.

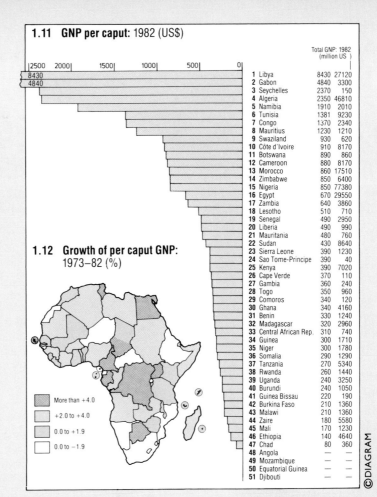

1.11 GNP per caput: 1982 (US$)

		GNP per caput	Total GNP: 1982 (million US)
1	Libya	8430	27120
2	Gabon	4840	3300
3	Seychelles	2370	150
4	Algeria	2350	46810
5	Namibia	1910	2010
6	Tunisia	1381	9230
7	Congo	1370	2340
8	Mauritius	1230	1210
9	Swaziland	930	620
10	Côte d'Ivoire	910	8170
11	Botswana	890	860
12	Cameroon	880	8170
13	Morocco	860	17510
14	Zimbabwe	850	6400
15	Nigeria	850	77380
16	Egypt	670	29550
17	Zambia	640	3860
18	Lesotho	510	710
19	Senegal	490	2950
20	Liberia	490	990
21	Mauritania	480	760
22	Sudan	430	8640
23	Sierra Leone	390	1230
24	Sao Tome-Principe	390	40
25	Kenya	390	7020
26	Cape Verde	370	110
27	Gambia	360	240
28	Togo	350	960
29	Comoros	340	120
30	Ghana	340	4160
31	Benin	330	1240
32	Madagascar	320	2960
33	Central African Rep.	310	740
34	Guinea	300	1710
35	Niger	300	1780
36	Somalia	290	1290
37	Tanzania	270	5340
38	Rwanda	260	1440
39	Uganda	240	3250
40	Burundi	240	1050
41	Guinea Bissau	220	190
42	Burkina Faso	210	1360
43	Malawi	210	1360
44	Zaire	180	5580
45	Mali	170	1230
46	Ethiopia	140	4640
47	Chad	80	360
48	Angola	—	—
49	Mozambique	—	—
50	Equatorial Guinea	—	—
51	Djibouti	—	—

1.12 Growth of per caput GNP: 1973–82 (%)

More than +4.0
+2.0 to +4.0
0.0 to +1.9
0.0 to −1.9

©DIAGRAM

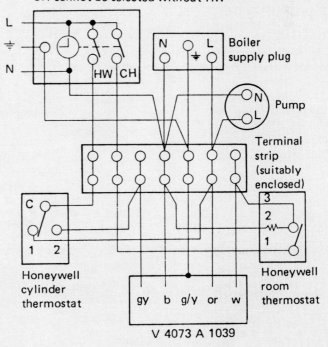

Programmer
CH cannot be selected without HW

L
N
HW CH

N L Boiler supply plug

N L Pump

Terminal strip (suitably enclosed)

C
1 2
Honeywell cylinder thermostat

3
2
1
Honeywell room thermostat

gy b g/y or w

V 4073 A 1039

13

Converting your information

Before you start on the preparation of any chart, work must be done on the raw data. The various quantities must be sorted out and listed and they must, of course, all be expressed in compatible units. Most statistics contain elements which can confuse or produce contradictory impressions when converted into visual statements. The process by which information on quantities is compiled as numerical tables often hides the main story. The task of converting the data to a visual presentation also involves sorting out what the information really reveals.

Transforming data

There are a number of essential procedures in the process of converting the source data into a chart. Most of them are devised to ensure that at each stage you return to the original information to check that you are not including errors.

- Collect the data
- Check the data for trustworthiness
- Edit the data

Then a variety of activities may be necessary:
- Convert to common units
- Convert to understandable units
- Round up and down smaller values
- Simplify by combining elements
- Regroup the elements
- Re-order the ranking of elements
- Simplify the data
- Check your results with original source
- Select the chart style
- Plot the data
- Check your scheme with original source
- Draw your chart
- Annotate your chart
- Check your solution with original source

Rounding the data

Source material often includes exact amounts with values less than one which are difficult to include on your chart. There are two methods of leveling up or down all the values. Both produce figures which are an approximation only to the correct amount.

Method one

The commonest system makes use of the rule that a fraction or decimal place of less than half of one is removed and a fraction or decimal place of half or more is made up to the next whole number.

1.1 becomes 1	1.5 becomes 2
1.2 becomes 1	1.6 becomes 2
1.3 becomes 1	1.7 becomes 2
1.4 becomes 1	1.8 becomes 2
	1.9 becomes 2

Thus, any number with a decimal place of less than half will round down four times out of nine and any number with a decimal place of half or more will round up five times out of nine. This produces an in-built statistical bias.

Method two

This bias can be avoided by following the rule that fractions or decimal places of half of one are alternately rounded up and down. If preceded by an even number they are rounded down, and by an odd number rounded up. 0.1 to 0.4 are rounded down and 0.6 to 0.9 are rounded up as usual.

1.5 becomes 2	6.5 becomes 6
2.5 becomes 2	7.5 becomes 8
3.5 becomes 4	8.5 becomes 8
4.5 becomes 4	9.5 becomes 10
5.5 becomes 6	

Statistical pitfalls

When you start your preparations, remember to check your source data (example *below*) for inconsistencies and errors, before you begin work on the visualization. The list (*right*) indicates some common dangers that can frustrate your attempts to visualize the information.

Possible dangers

1 Irregular intervals; missing years in the time scale.
2 Incomplete data; this can create problems.
3 Extremes; values ranging from 0.7 to 2527 can be difficult to include on the same scale.
4 Differing units; values in different units cannot be compared without converting them to a common factor or segregating them on the chart.
5 Incorrect totals; tables are not trustworthy since they are the result of simple mathematical activities that can go wrong. Always check totals.
6 Footnotes; often these expose deficiences or irreconcilable features.

68. Tin concentrates (Sn content) — Concentrés d'étain (Sn contenu)

Production

Country	1948	1957	1958	1959	1960	1961	1962	1963	1964	*1965	Pays
WORLD [1]	148 700	165 700	117 700	121 100	138 700	138 700	143 900	143 600	149 600	154 600	MONDE [1]
Argentina	284	185	208	229	242	523	580	506	801	*1 030	Argentine
Australia	1 917	1 983	2 273	2 389	2 211	2 789	2 759	2 906	3 605	3 914	Australie
Bolivia [3]	37 935	28 242	18 013	24 193	20 543	20 996	22 150	22 603	24 587	23 407	Bolivie [2]
Brazil	187	298	416	468	1 581	590	743	1 172	*1 220	*1 220	Brésil
Burma	1 165	705	910	813	965	966	1 058	929	577	*610	Birmanie
Cameroon	103	72	76	63	59	69	23	27	42	41	Cameroun
Canada	314	[2]322	361	339	282	508	296	421	162	*370	Canada
China (mainland) [4]	(4 900)	(16 300)	(18 300)	(21 300)	(24 400)	(24 400)	(24 400)	(24 400)	(24 400)	(...)	Chine (continentale) [4]
Congo (Brazzaville)	—	—	23	30	33	44	42	41	34	*50	Congo (Brazzaville)
Congo, Dem. Rep. of	11 684	12 678	9 844	9 337	9 350	6 675	7 312	7 166	6 596	6 311	Congo, Rép. dém. du
France	86	467	—	---	53	156	295	278	477	473	France
Germany, Eastern [4]	(160)	(680)	(730)	(730)	(730)	(730)	(730)	(730)	(730)	(...)	Allemagne orientale [4]
Indonesia	31 104	28 168	23 572	21 960	22 959	18 872	17 588	13 155	16 607	14 935	Indonésie
Japan	120	960	1 123	1 005	857	868	873	874	795	805	Japon
Laos	32	278	306	299	389	340	373	*410	*510	*490	Laos
Malaysia	45 534	60 244	39 075	38 127	52 813	56 927	59 543	60 909	60 967	64 692	Malaisie
Mexico	185	481	553	383	371	539	585	1 072	1 225	511	Mexique
Morocco	—	7	6	11	10	13	11	9	14	*12	Maroc
Niger	3	51	62	58	54	48	42	56	53	*60	Niger
Nigeria	9 384	9 766	6 330	5 612	7 798	7 904	8 342	8 869	8 861	9 700	Nigéria
Peru	65	12	30	25	25	17	*15	*15	*15	*12	Pérou
Portugal	717	1 145	1 269	1 147	654	741	690	730	687	592	Portugal
Rhodesia, Southern	115	288	541	615	652	681	688	506	520	*520	Rhodésie du Sud
Rwanda	1 380	1 832	1 514	1 142	1 297	1 498	1 346	1 291	1 382	1 443	Rwanda
South Africa	462	1 486	1 440	1 293	1 305	1 454	1 445	1 554	1 610	1 694	Afrique du Sud
South West Africa	105	646	167	4	265	307	375	450	482	421	Sud-Ouest africain
Spain	339	506	474	297	196	234	235	160	88	115	Espagne
Swaziland	20	25	15	5	6	5	5	4	*5	*12	Swaziland
Tanzania, Un. Rep. of	97	14	19	70	146	184	221	238	292	259	Tanzanie, Rép.-Un. de
Thailand	4 308	13 745	7 842	9 839	12 275	13 484	14 915	15 835	15 847	19 353	Thaïlande
Uganda	176	43	42	37	34	34	70	168	216	199	Ouganda
United Kingdom [4]	876	1 044	1 104	1 272	1 218	1 229	1 200	1 246	1 246	1 334	Royaume-Uni [4]
United States	5	—	—	51	10	*10	*10	*10	*10	*12	Etats-Unis
Zambia	—	—	—	1		1	5	1	10	16	Zambie

Source: International Tin Council (London).
Note. The figures relate to the tin content of tin concentrates produced or, where so indicated, exported.
[1] Excluding China (mainland), Czechoslovakia, Eastern Germany, North Viet-Nam and the USSR.
[2] Tin content of exported tin concentrates and in tin-lead alloy.
[3] Prior to 1960, content of ore plus metal exported.

Source: Conseil International de l'étain (Londres).
Remarque. Les données se rapportent au contenu en étain des concentrés d'étain produits ou, lorsque indiqué ainsi, exportés.
[1] Non compris la Chine (continentale), la Tchécoslovaquie, l'Allemagne orientale, le Viet-Nam du Nord et l'URSS.
[2] Contenu de l'étain des concentrés d'étain exportés et de l'alliage étain-plomb.
[3] Avant 1960, contenu du minerai plus métal exporté.

Terms for charts

"Nomographs or alignment charts consist of scales, either straight or curved, which are arranged in various configurations to enable you to draw either straight or curved lines across intersections resulting from the individual values of a group of related equations." This quotation comes from a specialist textbook on charts and diagrams; but for normal use we would refer to this sort of chart simply as a graph.

Because the ordinary usage of charts developed independently in a variety of professions, the terms referring to them vary extensively. Geographers, for example, use "histogram" for the chart statisticians call a "column" or "bar" chart. To make things more confusing, some types of chart closely resemble other types. Stepped graphs, for instance, look much like grouped bars.

CHARTS OF RELATIONSHIP

 Line charts are usually a single line with intervals plotted along the line at irregular points. They include *thermometer charts*, *linear charts*, and *time lines*.

 Flow charts are either intervals plotted on one or more lines or a series of parallel lines of varying length. They include *chronologies*, *progress*, *schedule*, *process*, and *procedure charts*, and *time lines*.

 Tree charts are lines beginning in a single source and branching into a group of arms. They include *fan charts*, *family tree charts*, *pedigree charts*, and *genealogy charts*.

 Organizational charts have links between points, indicating the relationships of the items in the chart.

 Matrix charts are usually rectangular grids into which data is placed against their vertical and horizontal values. They include *classification charts*, *tabulation charts*, *distance charts*, *table charts*, and *placement charts*.

 Scatter charts are a form of matrix chart. They include *placement charts*, *triangular charts*, *trilinear charts*, *correlation charts*, *position charts*, *bivariate charts*, *shotgun charts*, and *scatter plot charts*.

CHARTS OF LENGTH, AREA AND VOLUME

 Charts of length
The terms bar and column are interchangeable. Column usually refers to a vertical arrangement, but bar can mean either. *Histograms* are column charts, usually without vertical divisions, and resemble stepped graphs. They include *ranked charts*, *rating column charts*, and *frequency distribution bars*.
Ranged bars are charts in which the positions of the bars are the result of a particular axis or direction.

 Population pyramids, *bilateral* and *two-way histograms* are paired bars ranged from a center line.

 Deviation bars and *two-directional bars* are bars set against a single-value line (often zero).

 Radial bars, *polar coordinated bars*, and *star charts* are all bars that begin at a common center and radiate outward.

 Range bars, *slide bars*, and *floating bars* are bars set against a background scale and located according to the range of their extremes.

 Divided bars, *composite bars*, *segmented bars*, *banded bars*, *multiple bars*, *component bars*, *area bars*, *subdivided bars*, *relative part bars*, and *strata surface bars* are all bars containing subdivisions within the bar.

Charts of area
Pie charts are circular area charts containing segments representing parts of the whole. They include *sector charts*, *cake charts*, *circle charts*, and *divided circle charts*. *Block charts* and *unit charts* are charts that use regular areas to express values.

 Charts of volume
These are expressed as cubes, spheres, or columns.

Textbooks on chart design often follow the rule favored by some members of the legal profession, one of whom once asked, "Why put forward a simple case simply, if clients will pay more for a complex presentation of simple facts?" No doubt professional chart makers will argue strongly about the misappropriation of terms, but such disputes have little to do with the task of selecting the most suitable solution, whatever it's called, for your chart design.

To avoid wasting valuable space, we have therefore put the specialist terms into groups and present them below, following the various divisions of the book itself. To locate a chart style by name, consult the groups that most closely resemble the chart design you're after.

GRAPHS

Graphs are usually rectangular grids with the vertical axis representing values and the horizontal time. They include *rectilinear, coordinate, arithmetic line, frequency, fever,* and *alignment charts,* as well as *time series plot graphs* and *nomographs.*

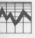
Graphs plotted on logarithmic scales include *semi-log charts,* where one axis is a logarithmic scale, and *log-log,* if both are. *Ratio charts* and *rate-of-change charts* have similar scales.

Graphs on a circular grid include *radial, circular, polar,* and *polar coordinate charts.*

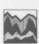
Graphs with shaded areas between the curve and a single value line (usually zero) include *deviation area graphs* and *silhouette charts.*

Graphs with two curves in which the areas between each curve are shaded include *net difference surface graphs* and *high-low charts.*

Charts in which the areas between the curves are shaded include *area, surface, multiple strata, subdivided, accumulated area, divided area, banded* and *combined surface graphs* as well as *stratum charts.* Values may be measured from the base line up the vertical axis or between each curve independently.

Graphs with adjusted individual valuations include *progressive average, moving average,* and *moving total curves.*

Graphs with both axis scales of 100, so the valuations are percentages of the totals, are known as *Lorenz charts.*

Graphs in which the curve moves forward both vertically and horizontally between points include *stepped graphs* and *stair charts.*

MAPS

Isoline maps
These consist of lines joining up all points of similar value. The area between one isoline and the next contains the range of values. Isoline maps are the most common way of depicting change on a map surface, and they include *isopleth, contour,* and *line relief maps.*

Area-shaded maps
These contain various tones representing different values within each area. They include *choropleth* and *crosshatched maps.*

Distribution maps
These show the distribution at particular points. They include *dot maps* and *plot maps.*

Flow maps
These contain particular or general lines of flow.

Grid maps
These are maps that have superimposed grids into which data is placed.

Choosing a style

The most important factor in drawing a diagram of your information is selecting a method of presentation. Each style has its advantages and disadvantages, and each can change the reader's understanding of the information. Differences can be suppressed or exaggerated. Changes in trends highlighted or modified. Although the actual mathematical values cannot, without dishonesty, be altered, their appearance can easily be disguised depending on the method of presentation. The drawings on these two pages all use the same information, but it's immediately obvious that a bar diagram tells the reader of differing changes over the time, and a divided area diagram shows the values as differing sizes.

Visual methods
The eight methods illustrated on these pages show some of the solutions possible. Each is based on the same information and the value for 1970 is shaded in on all solutions.

Basic statistics (1)
The lines of numbers do not immediately show a reader some of their relationships. Only a trained observer would notice that the 1970 value is exactly double the 1940, or that the difference between 1940 and 1950 is exactly the same as that between 1970 and 1980.

1940	1,275,340
1950	2,351,910
1960	3,109,250
1970	2,550,680
1980	3,627,250

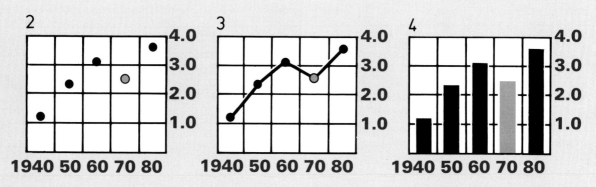

2 — 1940 50 60 70 80

3 — 1940 50 60 70 80

4 — 1940 50 60 70 80

Scatter graph (2)
Each time interval is marked along the horizontal base, and values of regular amounts suitable to the largest and smallest values marked on a vertical scale. The exact items are then plotted in the resulting grid.

Continuous graph (3)
Plotted by the same method as a scatter graph but the points are joined to reveal relationships between the values. This method is excellent at exposing trends but weak at describing differences in the individual values.

Bar graphs (4)
The most effective way of showing differences in value. Plotted as a scatter graph, but each value is given a column, the height representing their value. These relative lengths easily reveal differences and also show trends. A method simple to create and effective in presentation.

5

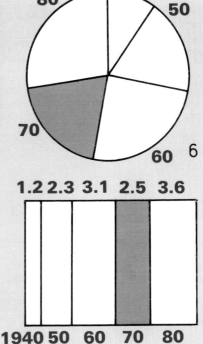

80 1940 50

70 60 6

1.2 2.3 3.1 2.5 3.6

1940 50 60 70 80

Area diagrams (5)
A very difficult method requiring you to convert the numerical values into units representing areas. For circles divide each number by πr^2 and for squares find the square root of each number. Both circles and squares minimize the changes between values.

Divided area (6)
The sum of all the items is used to represent the total area, either a circle or rectangle. Each value is then expressed as part of the total. The main disadvantages are that the method requires mathematical skill to convert the values to percentages and the resulting designs show only comparisons of size.

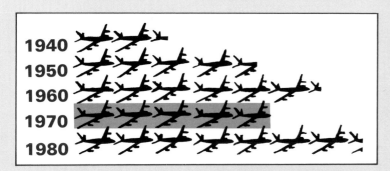

1940
1950
1960
1970
1980

Pictorial (7)
These diagrams have the added advantage of giving the reader some immediate indication of the subject matter portrayed. Usually the symbols are calculated to represent a regular division of the values. For example, each airplane equals half a million passengers.

Edited diagrams (8)
It is very unwise to present your figures with an incomplete depiction as this can so easily misrepresent the situation. The columns could extend beyond the bottom of the page by any length. If it were one centimeter then the changes are substantial, but if it were 100 centimeters the changes would be insignificant.

8

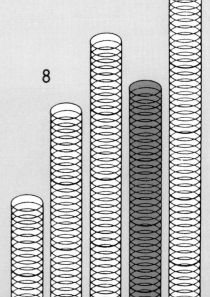

Honesty is the best policy

Charts offer opportunities to distort information, to misinform. An old adage can be extended to read: "There are lies, damned lies, statistics and charts." Our visual impressions are often more memorable than our understanding of the facts they describe. On the opposite page are examples of four possible dangers. Never let your design enthusiasms overrule your judgement of the truth.

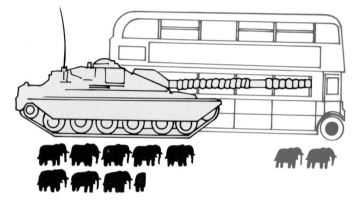

Like to like
Comparing objects is only successful if the units in which they are measured are comparable. The weight of two vehicles is easier to evaluate if both are measured in the same units. The chart (*above*) shows that a tank is as heavy as 8½ elephants, while a bus weighs only two.

Forests, not trees
Very often cartographers cover maps with all the available information, sometimes in a form we cannot evaluate. The chart (*below*) is a detail from a map showing urban population distribution expressed as meaningless balls.

Simplicity can confuse
The chart (*right*) uses linking lines for ten items to weave a net of confusion between the data and the locations. Always keep the message dominant and the necessary structures subservient.

Scales made to lie
The five bars on the chart (*right*) represent very different values. The logarithmic scale confuses their values badly. The actual ranges are:

A	5.7 units
B	9.8 units
C	24.6 units
D	44.7 units
E	87 units

E is over 15 times larger than **A**.

It depends how you do it
Easy comparison between the same two factors in the charts (*right*) depends on familiarity with their form. Bars clearly show differences which can be evaluated without effort. Cubes and recessional bars are harder to judge.

Bending the truth
Two charts (*right*) detail a section of the New York subway map in mid-Manhattan. The nearer design shows the stations in their correct relationships. The far design repositions them to suit the designer's need for decoration.

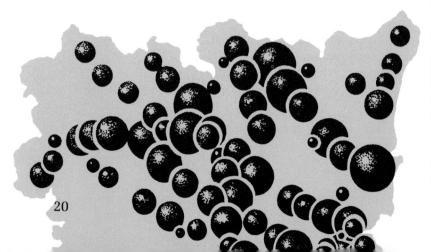

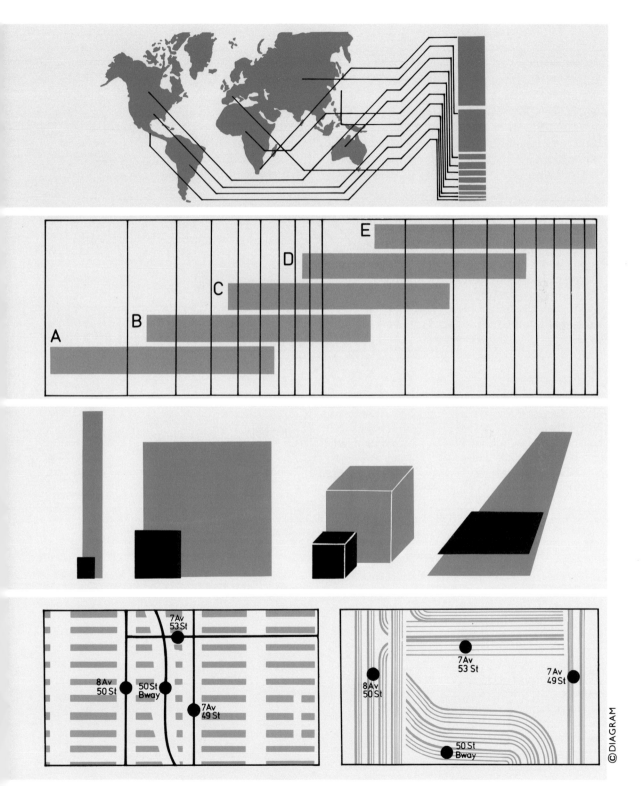

21

The uses of charts

Wherever information has to be presented, charts offer an alternative to text and tables of figures. They are concise, memorable often intelligible without language, and can make significant additions to the story. Their form and method of manufacture can be as varied as any other type of visual communication, whether schoolbook graph or computer-generated visual display unit (VDU). Once you've chosen the style of your chart, discuss with experienced practitioners the most efficient means of creating and reproducing it. Charts made for a slide projection, for instance, should appear different to those done for a school report. Try to keep your style and method of construction within the limitations imposed by the medium for which it is ultimately intended.

Schoolwork
Hand-drawn charts need not be poorly produced. The chart (*right*), by a girl of eight, is helped by its having been done on graph paper. She was able to draw the lines without using rulers and squares just by following the lines of the grid. The lengths were calculated by counting the small squares on the grid.

Exhibitions
Charts are often most effective on display panels when used to achieve some simple, striking impression. The world map (*right*) depicts headquarters and subsidiaries of a large international company.

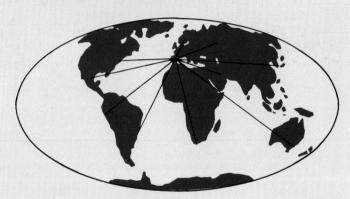

Publications
The use of charts in books, magazines, and pamphlets is infinite. The diagram (*right*) shows how to place a person on a stretcher, using six bearers. This illustration, though complex to look at, is able to explain a series of movements clearly. Many words would be needed to describe the same activity.

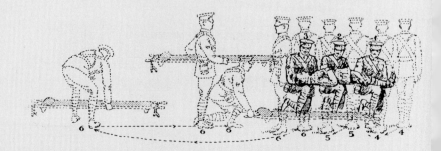

Ephemera

Charts can be used as keys to unlock information. This simplified map (*right*) appeared on the boarding card of an international airport. Its language must be simple, and people must be able to identify the corridors. Booking clerks ring the departure gate to show where you go to board your aircraft.

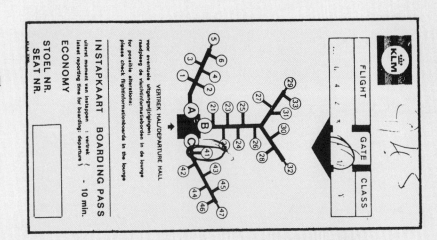

Lecture aids

Including charts in talks can clarify points you wish to get over to an audience. Try to keep your charts to single ideas, simply depicted. The chart (*right*) shows the rise in world fishing catches from 1960 to 1975.

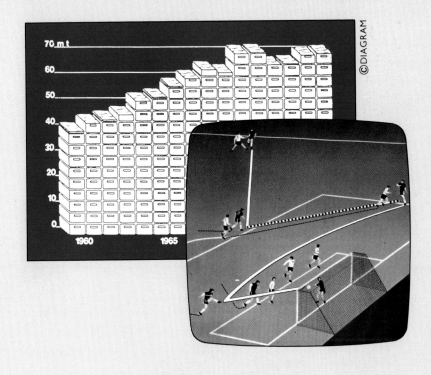

TV and movies

Charts are being employed increasingly to explain events that may not have been possible to photograph at the time. Chart (*right*) explains how a complex goal was scored in an international football match. Normal camera records of the event would not be as clear.

Computers

The wizardry of electronics enables charts to move, to show other aspects, and to be built up from very complex information. The chart (*right*) shows contractions of the left ventricle of the heart. Real-life depictions of this activity would be confused by the presence of surrounding organs.

23

Displaying your charts

Charts on display have one very serious drawback. They must stand alone without benefit of text or lecturer's voice to draw attention to the important factors. For this reason, then, you must take special care to present your ideas clearly. Whether the chart is temporary or permanent, or whether elements of the chart can be replaced or added to must influence your choice of design.

COMPANY PROFITS

Personal record
The illustration (*right*) shows how easily a chart can reveal changes in a situation. Make your personal charts clear and clean, with the minimum of irrelevant detail.

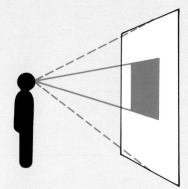
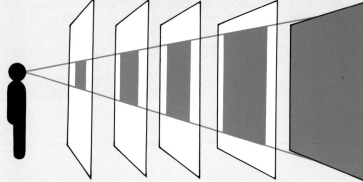

Three rules to remember when designing a display chart.
1 Ensure it is visible.
2 Ensure it is legible.
3 Ensure it is intelligible.
Visibility
Applies chiefly to the position of text, titles, and keys (*above*). Don't make viewers raise their heads to read copy in a high position or bend down to read below their field of vision.
Legibility
The ability to read text depends on its size and your distance from the chart. Do not use elaborate typefaces or small text on dark or textured backgrounds. Before starting your chart, test a sample-size label at the distance you estimate your chart will be displayed. Normally the farther away the display (*above*), the larger the area of chart that is visible.
Intelligibility
Display charts present information without your explanation or without captions and text. Don't overload. Stick to single ideas, simply presented.

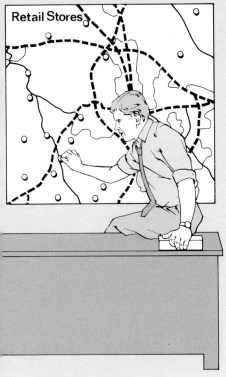

Progress charts
Keeping watch on developments by adding information to a chart enables you to have a permanent record of an activity if this is combined with regular updates.

Permanent display
Charts on show as permanent elements of a display need strong surface protection to prevent wear and tear. It is often preferable to put them inside a glass frame, which allows you to make your charts by normal drawing techniques. The total display must be firmly fixed to the wall, because large panels can be deceptively heavy and require strong attachments. Be very careful to place the keys and legends to your chart in a prominent part of the design. Keep all labels and annotations simple, without too much detail.

Factors to consider
Before you begin the design and construction of a display chart, it's a good idea to make yourself a checklist of answers to the questions (right).

Factors to consider
- Who will see the exhibition chart?
- How long will they get to view it?
- Do they already understand the subject?
- Are there other elements present such as photographs, models, or publications in the form of catalogs and guides?
- How will you make the chart?
- How will you transport it to the site?
- What is the layout of the display to be like?
- What is the lighting and position of viewers?
- How long will the chart be needed?
- Do you require surface protection?
- Are there any further uses for the chart?

©DIAGRAM

Talking with charts

Pictures are often more impressive than statistics. Using diagrams in a talk can help people remember vividly what they have heard, and they tend to retain impressions of the image long after they have forgotten most of the detail. The technique is a favorite in schools, seminars, colleges, and conferences.

There are four basic methods of presenting the charts.

1 Drawing each in turn, during the lecture, on a blackboard or, using colored pens, on large sheets of paper.

2 Revealing separate sheets that have been prepared in advance.

3 Projecting your drawings by a mirrored light onto a screen.

4 Projecting prepared transparencies onto a screen.

Key points to consider

- Because each chart gets shown for only a short length of time, your audience has little opportunity to do more than try to memorize its overall features. Consider therefore making cheaply produced black-and-white copies of your lecture charts available on request.

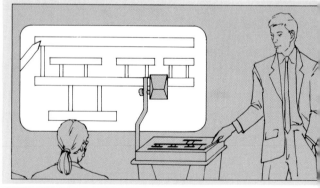

- Your listeners cannot re-examine a chart once you've moved on to the next, and probably have no information except what you tell them. So make each chart simple, with large, legible annotations, and anchor it to one idea.
- Use bold colors.
- Use short copy.
- Don't overload with detail.
- Make sure people sitting at the back of the room can easily read the chart.
- Monitor your audience's response to each chart, and be prepared to revise design and detail if necessary.

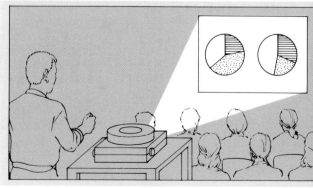

1 Direct-drawing method

The traditional method is to draw each chart with chalks or pens, either erasing them and replacing them with new ones or drawing a series on a row of surfaces.

Advantages
- Production is inexpensive.
- Only the basic drawing tool is required.

- The chart is drawn during the talk, so pieces can be added or – if using chalks – deleted.

Disadvantages
- You must be able to draw the chart while standing.
- You must be able to talk and draw simultaneously, because your audience's attention will wander if you have to break off.

- You must be able to remember the information and details about each chart.
- Most serious of all – you must be able to draw each chart without using any measuring tools. So coping with circles, bars, and so on can be difficult. And all the charts must be redrawn for every subsequent talk.

2 Pre-produced charts

These are normally large sheets of strong paper onto which the charts have been drawn and painted.
They should be only the size of a large artist's portfolio, so you can store and carry then conveniently. The charts are individually hung on pegs or all clipped together at the top edge.

Advantages
- They are prepared using all available tools and techniques.
- You can use flat colored areas, dry transfer lettering, or type-set labels.
- They can have clear-film overlays, which when lifted reveal – under masked areas – additional information.
- The order can be rearranged, new charts added, old ones updated.
- When lecturing, only a strong display structure is needed.
- The complete set can be reused.

Disadvantages
- Hard to handle – the weight is redistributed as the lecture progresses.
- Charts wear badly with use.

3 Overhead projectors

These are light-projecting machines that allow you to place clear originals on a horizontal surface and throw the image (from a light source below the drawing) onto a screen.

Advantages
- Charts can be prepared using available tools and techniques.

- They can have flat colored areas, dry transfer lettering, colored lines.
- They can have clear-film overlays, which when lifted reveal – under masked area – extra data.
- The order can be rearranged, new charts added, old ones updated.
- Charts can be easily stored and transported.

- Charts can be reused.
- If you point to an item on the chart, this will show on the projection.
- You can use felt-tipped pens while lecturing.

Disadvantages
- You work on clear film, which requires skill.
- You need a special projector and screen.
- You need electric power.

4 Slide projections

This is the most sophisticated method available and enables you to combine charts with other visual materials, such as photographs of the subject.

Advantages
- Professional appearance of slides greatly enhances your charts.
- All the charts can be prepared in advance.

- Slides can use any form of artwork that is suitable for being photographed.
- They can be rearranged in any order, replaced, or updated.
- They can be easily stored.
- They can be reused.
- They can be included with other visual material, such as transparencies and other photographed items.

Disadvantages
- Slides are expensive to produce.
- They require electric power.
- They require a projection camera.
- They require experience in reappraising artwork for conversion to transparencies.

© DIAGRAM

Printed charts

To understand the qualities of printed charts, you must see real examples. Charts in this book are produced by lithography, and were drawn the sizes they appear here. The designer used a technical pen, working on a smooth plastic film. Tonal variations were achieved by the printer photographing solid black masks of certain areas, which were reduced in differing values by a photographic screen technique. Before beginning your artwork, discuss with the printer the opportunities available. Many well-conceived charts are handicapped by inappropriate printing. Remember, printed charts offer the reader two major advantages. First, you can provide extra typographical information, captions, and supporting text. Second, readers can examine the charts at their own speed and if need be inspect them again.

A Office copy machines
There are three ways of making charts on office copiers. All produce line images, so tones come from built-up textures of lines and dots.

Stencil duplicators
The public transport system of Kyoto, Japan (detail *right*), shows the poor quality of this technique.

Dyeline machines
Print same-size line originals. Much used by architects and engineers.

Photocopying machines
Normally used for copying typescript or printed pages. Also used for printing charts but costly if you need a lot of originals.

B Electrically printed charts
Computer generated, using a dot matrix system or laser printer. Both systems are slow for large editions. Statistical chart (detail *right*) was produced with a dot matrix printer.

C Lithography
Traditional form of printing cartography. The charts were drawn with pen (detail *right*) or with a fine metal point on plastic film. Results were photographed and printed by lithography.

Silkscreen
This method is a stencil process, normally useful only for large images as detail is difficult on small charts. Leningrad subway map (detail *right*) was printed by silkscreen.

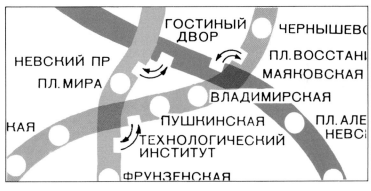

Letterpress
This is the method used by newspapers and traditional book printers. Choropleth map (detail *right*) was created by printer laying mechanical tints over individual areas. Letterpress charts consist of lines and dots. No flat tones are possible.

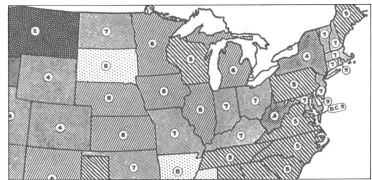

Gravure
The technique for printing books and magazines with large editions. The four-color map of Frankfurt's public transport system (detail *right*) showed in the original a wide range of colors and tones.

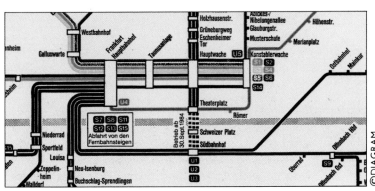

29

Computer-generated charts

Sales literature and promotional advertising are available in plenty for making computer-generated charts. For a modest sum you can get programs that will create pie charts, bar and graph charts, and do many mathematical tasks. But advanced programs producing colored maps, charts, and multi-viewed projections are expensive and require professional skills to generate images from data.

Before buying computer-chart programs, think first of how to use the end product – the printout. Computers are ideal for creating accurate plottings of the data from which you can then redraw the chart. Whatever system you settle on, the principles of simplicity, clarity, and service to the reader still apply. Modern technology is no substitute for intelligence.

Stock items
One of the major advantages of using computer graphics is the capacity of the machine to store stock images, maps, and grids (*left*). Structures that would normally have to be redrawn for every chart can be recalled and new data superimposed.

Mathematical versatility
The major advantage of the computer is the speed with which it can recalculate, rearrange, convert, and visualize mathematical statements as simple charts. A small desktop printout calculator with graphic programs included can save hours of mental arithmetic and dangerously inaccurate plotting. The nine examples (*below*) show what a simple machine can offer, its chief asset being that it provides a quick, accurate snapshot of the actual shape of statistics.

1 Tabular figures
2 Line graph
3 Bar graph
4 Data ranked and converted to percentage
5 Pie chart
6 Divided bar
7 Ranked line graph
8 Ranked bar graph
9 Ranked divided bar

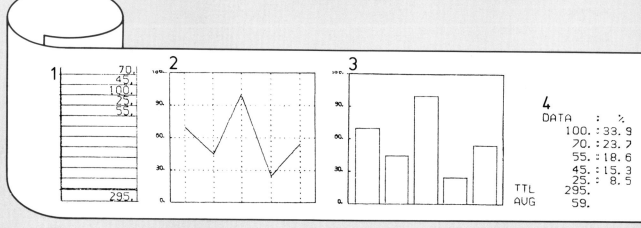

Slide production (*right*)

Computers that produce color slides are very costly but have several advantages.

1 They produce multicolored solutions to a variety of chart styles.

2 They can cheaply prepare, review, revise, and reproduce.

3 They can generate many copies of similar quality.

4 The mechanical methods of producing color and line mean that the overall qualities exceed those of most inexperienced draftsmen.

Information revisions

Computers enable you to make charts that can be changed without expensive redrawing. The map (*right*) records the distribution of research data in 10-square-kilometer boxes. New information can be replotted on another version and the changing strengths of tone reveal differences between the two charts.

Defects

The main defect of generating charts by computer is the inability of most printing attachments to draw the resulting chart. The example (*right*) shows how badly the machine draws smooth curves and applies clean tonal areas.

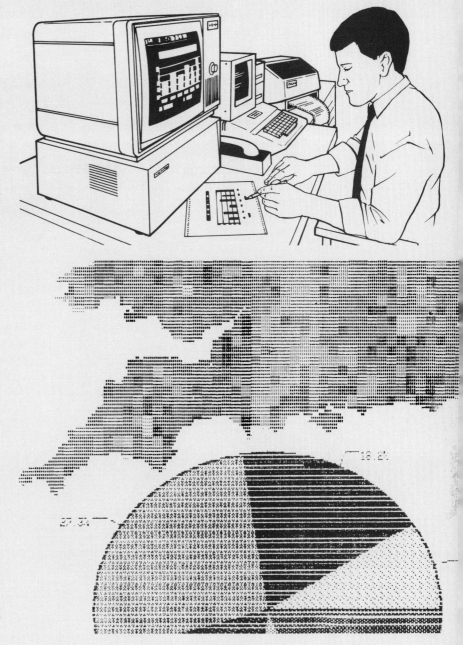

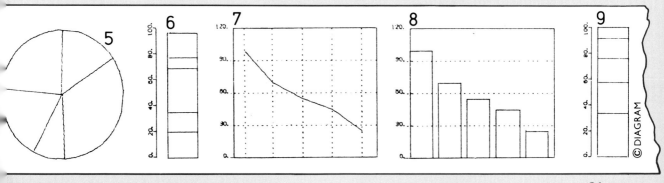

Part Two

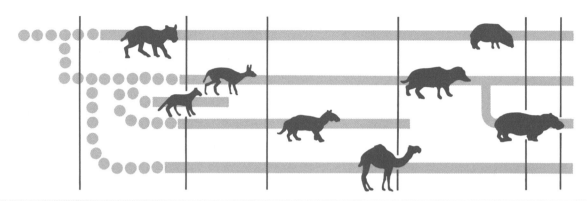

Lincolnshire.	Lincolne	Grantham	Beckingham	Gaynsburgh	Burton	Barton	Market Rasen	Horne Castle	Bullingbrooke	Spilsby	Wayne-fleete	Boston	Quaploade	Spalding	Crowland	Market Deeping	Bourne	Folkingham	Stamforde	Alforde	Dunnington	Lowthe	Salt-fleete	Thongcaster	Grymsby	Great Limbergh	Kirton in Lindesy
Sleeforde.	14	9	10	26	38	42	24	15	17	19	23	15	17	14	18	17	13	5	18	25	8	24	29	30	34	29	30
Kirton in lindes.	15	33	25	7	14	13	10	20	25	27	32	31	40	38	44	43	38	31	51	27	32	19	23	9	16	10	
Great Limbergh	20	36	28	17	13	8	9	19	22	23	28	31	42	40	47	47	42	35	47	21	33	13	15	4	6		
Grymsbye.	22	38	32	23	18	13	12	18	20	20	25	29	40	40	46	47	43	36	49	18	34	10	10	8			
Thongcaster.	16	32	25	15	14	11	6	16	20	20	26	27	37	36	43	43	38	31	44	20	30	11	14				
Salte-fleete.	24	38	33	29	28	22	44	14	14	13	16	23	34	35	42	43	39	33	45	9	29	6					
Lowthe.	20	32	27	28	25	21	10	9	11	11	15	19	30	31	37	38	34	28	41	9	25						
Dunnington.	22	15	18	31	41	41	24	16	16	17	19	8	9	7	13	14	11	7	17	23							
Alforde.	23	33	31	31	34	29	17	11	8	6	7	15	26	28	35	37	33	28	39								
Stamforde.	36	14	22	40	52	54	38	32	32	34	35	25	18	14	10	5	7	13									
Folkingham.	18	8	13	28	40	42	25	19	17	22	25	15	14	10	14	12	8										
Bourne.	26	12	19	35	48	49	32	25	25	27	29	19	13	8	8	5											
Market deeping.	31	16	23	40	52	53	37	29	30	30	32	21	13	10	5												
Crowland.	33	20	27	42	53	54	37	29	28	29	29	19	9	7													
Spalding.	26	17	23	37	48	48	31	22	21	22	22	13	4														
Quaploade.	38	21	26	39	49	48	32	22	20	20	20	11															
Boston.	21	22	23	32	40	38	22	12	9	10	11																
Waynfleete.	26	32	31	35	40	36	22	12	7	5																	
Spilsbye.	20	28	26	29	35	31	17	7	3																		
Bullingbrooke.	18	26	24	28	33	30	16	5																			
Horne Castle.	14	24	20	23	29	27	11																				
Market Rasen.	10	27	20	14	18	17																					
Barton.	18	42	34	19	8																						
Burton.	24	39	30	14																							
Gaynsburgh.	12	26	17																								
Beckingham.	10	9																									
Grantham.	18																										

The vse of this Table.

THe Townes or places betweene which you desire to know, the distance you may finde in the names of the Townes in the vpper part and in the side, and bring them in a square as the lines will guide you: and in the square you shall finde the figures which declare the distance of the miles.

And if you finde any place in the side which will not extend to make a square with that aboue, then seeking that aboue which will not extend to make a square, and see that in the vpper, and in the side, and it will showe you the distances. It is familiar and easie.

Beare with defectes, the vse is necessarie.

Inuented by IOHN NORDEN.

CHARTS OF RELATIONSHIPS

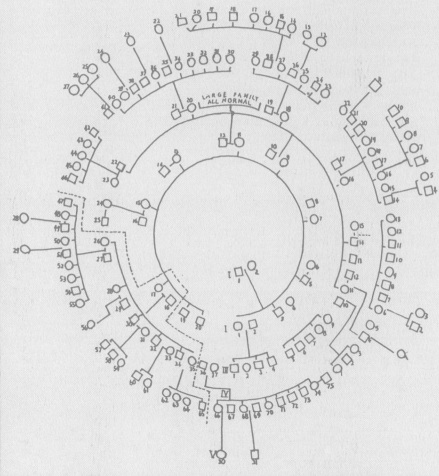

Line charts

Charts showing relationships illustrate connections between a collection of items of information. They can be a storehouse for retrievable information. The next 20 pages show you how items can be assembled in linear, branched, interlinked, rectangular or spacial networks. Before selecting a chart format from the possible design alternatives later in this book, consider the features of the information you want to present by examining them in a simple chart of relationships. The process of re-writing your source material in a linear or matrix structure will help you to discover the key points in the data. The simplest and easiest charts to construct are line charts, in which the information is plotted against a continuous strand. This may be a scale or simply a line joining regularly spaced points.

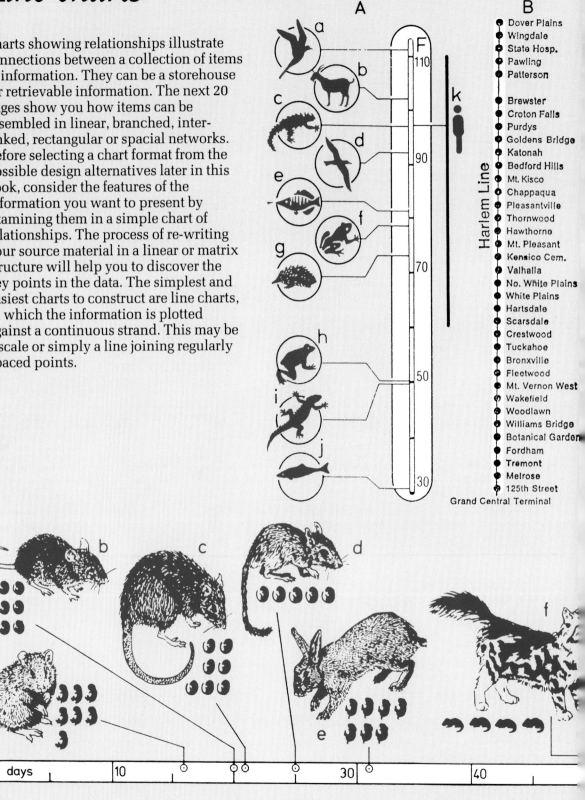

A

F
110
90
70
50
30

k

B
Dover Plains
Wingdale
State Hosp.
Pawling
Patterson

Brewster
Croton Falls
Purdys
Goldens Bridge
Katonah
Bedford Hills
Mt. Kisco
Chappaqua
Pleasantville
Thornwood
Hawthorne
Mt. Pleasant
Kensico Cem.
Valhalla
No. White Plains
White Plains
Hartsdale
Scarsdale
Crestwood
Tuckahoe
Bronxville
Fleetwood
Mt. Vernon West
Wakefield
Woodlawn
Williams Bridge
Botanical Garden
Fordham
Tremont
Melrose
125th Street
Grand Central Terminal

Harlem Line

F

0 days 10 30 40

34

C D

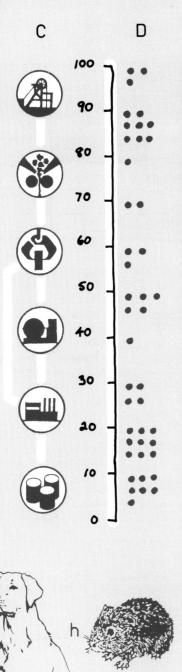

100
90
80
70
60
50
40
30
20
10
0

Stops on a line
The charts on these two pages show data plotted on to a scale. All the methods are easy to construct but need identifying labels; most simply letters, which are repeated in the captions.

A Scale line charts
Each item is plotted against its value on a scale whose range is larger than the highest and lowest values.

B Regular interval line charts
On this rail plan, stops are evenly spaced and named in sequence. Neither size nor distance between stops are indicated.

C Process line charts
Symbols for activities are put in sequence. No account is taken of importance, size, duration or any other factors involved.

D Tally line charts
Quantitative values of stops on a line are recorded either regularly, as here, or at specific points on the scale.

E Quantitative line charts
Items are plotted in accordance with value. A logarithmic scale is used because the items here cover a vast range (the value of the top one is 10,000 times bigger than that of the bottom).

F Combined-features line charts
Items are placed according to one factor, and more data is noted alongside. This chart plots gestation periods (in days) and average numbers of births of various pets.

g h

60

E

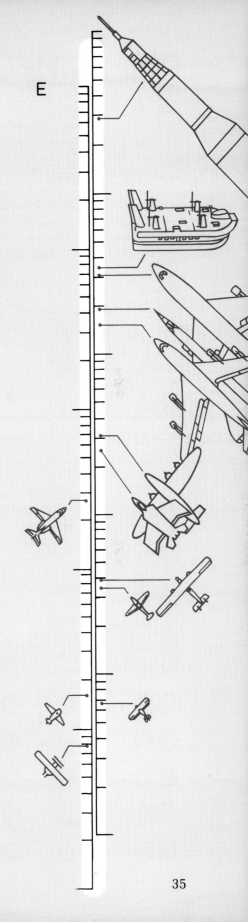

35

Flow charts

Flow charts are devised to reveal the relationships in time of a number of parallel activities. They appear as bands which can be decorated with information to bring out aspects of their character. Normally the horizontal scale is time, marked in regular intervals, and the vertical axis is used to stack items (not necessarily in any related order).

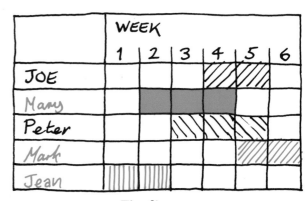

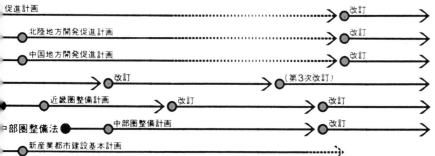

Timelines
The very simple and easily constructed chart (*above*) records staff holidays. Each column represents one week and each row one employee.
Duration (*left*)
The start, activities during progression, and the end of events can be marked by differing lines or dots. Horizontal charts enable you to include information on the lines.

Ranking order
Lines representing parallel activities can move around in the vertical plane to indicate changes in their order within a group. The chart (*left*) shows line (**1**) at (**A**) moving down in rank to (**4**) at (**B**) and then to (**5**) at (**C**), where it remains for the duration of the chart. This information can also be expressed more simply in groups of digits (*lower left*).

A1	C1	B1	B1	B1
B2	B2	C2	E2	E2
C3	E3	E3	D3	C3
D4	A4	D4	C4	D4
E5	D5	A5	A5	A5

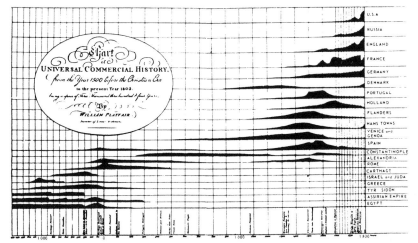

Value added

Parallel bands can incorporate information which affects their shape. The chart (*left*) is by a founding father of chart design, William Playfair, and was devised over 200 years ago. Each band represents one nation's power and influence in the world.

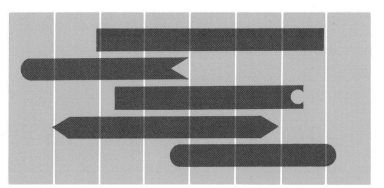

Terminal distinctions

The shapes of the ends of bars can be varied to indicate characteristics of the changes (*left*). Flat ends normally suggest immediate changes; pointed, rounded and otherwise modified ends can signal less absolute changes.

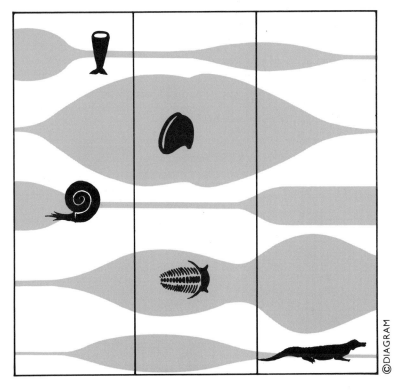

Growth and decline

Horizontal bands can swell and diminish to indicate increasing and decreasing activity. The chart (*left*) shows evidence of fossil finds which suggests greater incidence during certain periods in early history than at others.

©DIAGRAM

Tree charts

Tree charts have a simple structure but an infinite variety of shapes. They represent the developing links between a group of elements. They are seldom quantitative and normally show a source from which all items spring. They can usefully sort out relationships which may not otherwise be clear. Once you have found a method of labeling, the opportunities for drawing an interesting chart are endless.

Trees
Most organizations can be considered to originate from one source and divide into ever smaller elements. Each will have its own divisional profile. The chart (*below*) shows a company organization, with stockholders as the roots, management as the trunk, and departments as the branches.

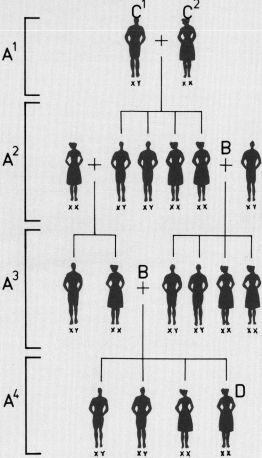

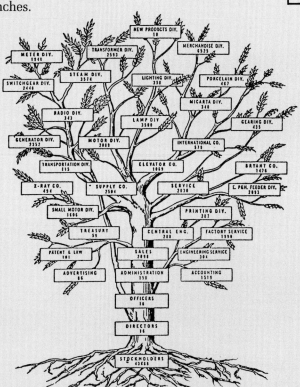

Elements (*above*)
Tree diagrams have four features:

A Levels. Information can be assembled in rows vertically, to read up or down; or horizontally, to read from left to right.

B Links. Elements and units can be connected by lines, symbols or tones.

C Items. The individual elements of the information.

D Variants. The differences between elements which may help to classify the groups.

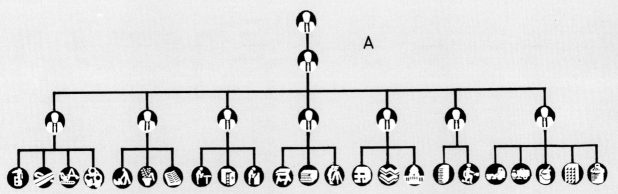

A

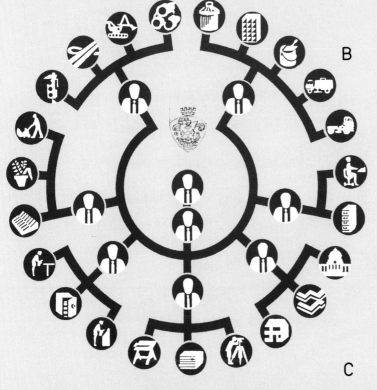

B

Formatting

Arranging the elements and the links between them can result in a variety of structures. Always sketch out your tree diagram, solving all the problems – arrangement, labeling, links etc. – before beginning the accurate scheme. Consider the effects of the design – what the chart is saying – before selecting a solution. The three charts on this page are based on the same information organized into different structures.
A Vertical: the information reads from top to bottom.
B Circular: the information reads out from the center.
C Horizontal: the information reads from left to right.

C

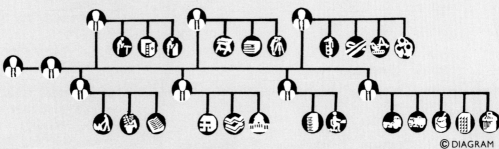

© DIAGRAM

Organizational charts

Producing sketches of your data in the form of organizational charts can very often remove confusion about the subject and also reveal major features. In your artwork each element should be uniquely symbolized and the relationships indicated by linking lines. Such a chart is very useful for presenting complex relationships simply and in a small space. Good organizational charts show the main patterns very clearly.

Arranging the data (right)
Relationships between the same ten factors are shown in three charts, the links being arrows. In the first (top) all the elements have equal value. The second (middle) illustrates the subject but would require a key to identify the elements. The elements in the third (bottom) are arranged in an order similar to how they would appear in reality: source, recipient and environment.

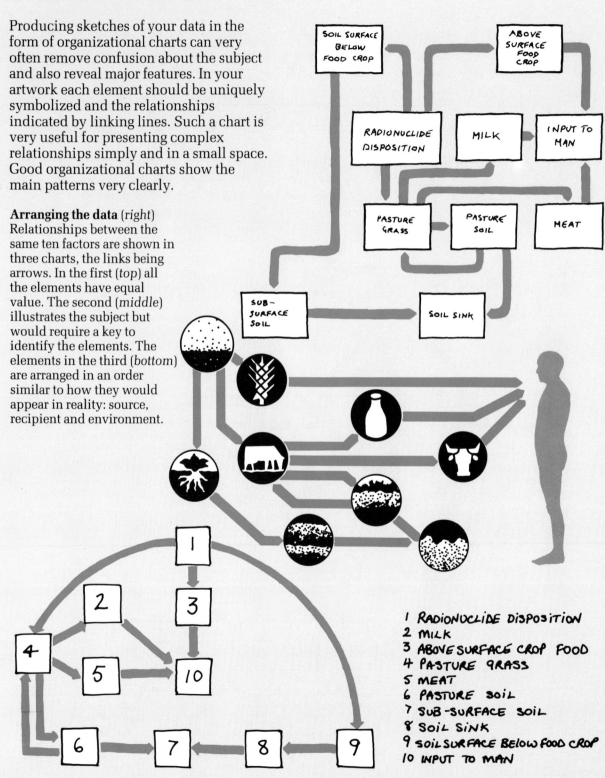

1 RADIONUCLIDE DISPOSITION
2 MILK
3 ABOVE SURFACE CROP FOOD
4 PASTURE GRASS
5 MEAT
6 PASTURE SOIL
7 SUB-SURFACE SOIL
8 SOIL SINK
9 SOIL SURFACE BELOW FOOD CROP
10 INPUT TO MAN

Type of activity

These two charts also illustrate different methods of identifying groups of activity. The chart showing the judiciary (*top*) uses a variety of lines, symbols and tones to link the elements. The chart on painting uses textures and sizes to differentiate the styles and groups of painters.

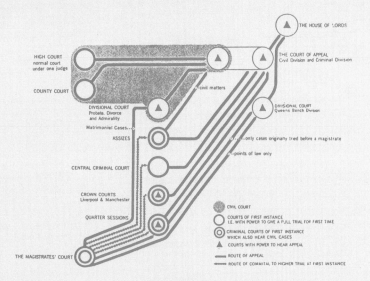

Direction of information

The relationships in organizational charts can work in every direction and be read in whichever way you prefer. The two charts (*right*) read in opposite directions. The first (*top*) illustrates the system of law courts in England, so moves up from the lower to the higher courts; it is devised to be read upward.

The second (*bottom*) chart shows the development of European painting, beginning with earlier times at the top and descending to the present; it is devised to be read downward.

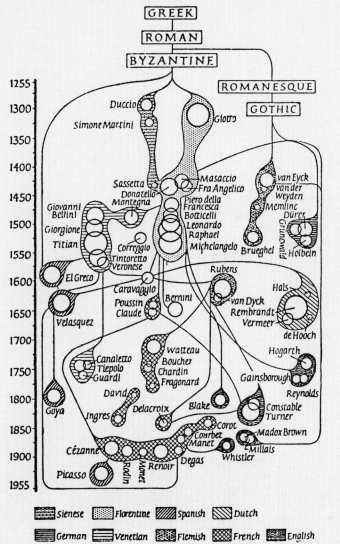

41

Matrix charts

Matrix charts are rectangular grids with two axes which can be used to reveal features in the data against two categories. Each panel can record four features: the relationships between the categories, the types of data in these relationships, the quantities of the data and combinations of all three. The four charts (*right*) illustrate the principal features of the matrix and give examples of its application.

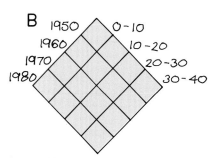

Labeling
Matrix charts are normally horizontal, if they are rectangular, or square, on the page (*above* **A**), but to avoid labeling vertically, charts can be drawn as diamonds (*above* **B**) so that all lettering can be set horizontally on the page.

Storage
Units in a matrix can store a great deal of information. The periodic table (detail *below*) places each element in relation to the horizontal and vertical columns, and within each unit five features of its element can be included.

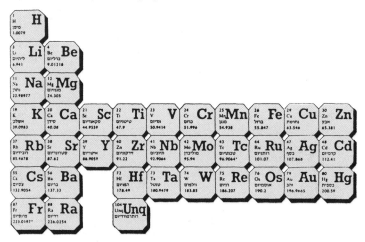

Placement
The simplest form of matrix chart plots the relationship of the data against the two axes. It can be very useful in pointing up general patterns of information.

Type
The grid of the matrix allows you to plot the relationships and also to show the types of category within each unit.

Quantity
Matrix grids can be used to plot quantities in the data in relation to their categories either by clusters of dots or by shading in the whole units, or parts of them.

Combined features
All three aspects of the data can be plotted: location, type and quantity.

Pictorial matrix charts

Adding pictures to a matrix increases its interest and helps to identify and illustrate the subject of the chart. The pictures can either be outside the grid area, as decoration, or at the heads of categories as identification, or appear as indications of the type of item within categories.

Spatial matrix
Plotting items on to a receding matrix (*right*) can be effective but difficult because you must reproduce a symbol in regularly decreasing sizes and draw each as if it were on the surface of the grid.

Category heads
Symbols can represent category types. The chart (*right*) plots where in a village types of pets live. Each vertical category is a type of pet and each horizontal one a type of pet owner's home. It shows that most owners live in houses and that cats and dogs are the most popular pets.

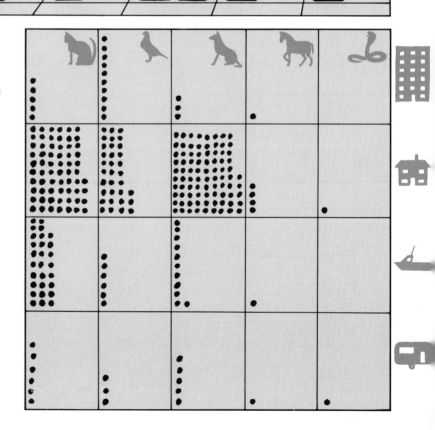

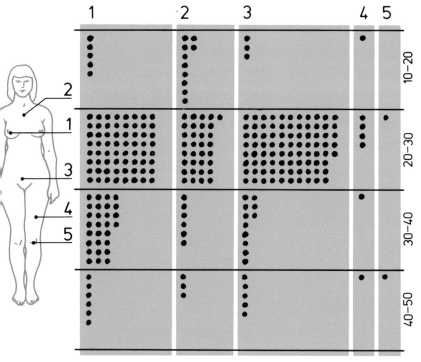

Adding and adapting
To your matrix can be added an image tying the subject and aspects of the data to the categories. The chart (*left*) shows the incidence of cancer in women by location on the body and by age, using the figure as a link. The space given to the categories varies according to the data.

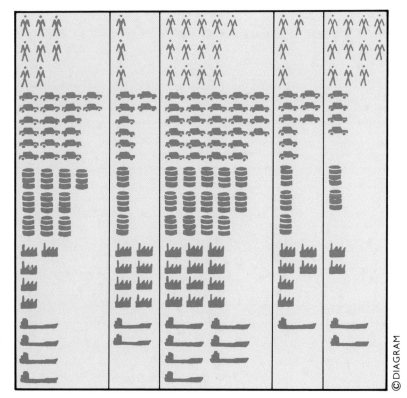

Symbols (*left*)
Your plotting of incidence and type within categories can be made more interesting and attractive if you depict each class of the group by a symbol. This technique means that you must be able to draw small symbols in a regular and repetitive manner, perhaps by using photoprinting or stencils.

Numerical matrix charts

Classification tables are very often the source for data from which charts are devised. They should be examined very carefully to check that the information within them is accurate and that nothing is missing. They normally act as a data retrieval source, a kind of cupboard containing facts and, as such, can be interpreted in a variety of ways.

1.16		Population and productivity: a statist▸

		1970 population ('000)			
REGION	Country	Rural	Urban	Total	Rural
MEDITERRANEAN AND ARID NORTH AFRICA		**40691**	**28402**	**69093**	**46376**
	Algeria	7482	6264	13746	7307
	Egypt	19027	13897	32924	22811
	Libyan Arab Jamahiriya	1274	712	1986	–
	Morocco	10010	5300	15310	11920
	Tunisia	2898	2229	5127	3048
SUDANO – SAHELIAN AFRICA		**35011**	**6334**	**41345**	**42605**
	Burkina Faso	4785	292	5077	5742
	Cape Verde	237	16	253	283
	Chad	3237	415	3652	3680
	Djibouti	–	–	–	82
	Gambia, The	398	70	468	475
	Mali	4872	814	5686	5726
	Mauritania	1073	174	1247	–
	Niger, The	3793	353	4146	4610
	Senegal	2823	1185	4008	3541
	Somalia	2144	645	2789	3221
	Sudan, The	11588	2271	13859	14053

Tidiness
The chart (*above right*) is a section from a vast table on African resources. Items that are not known are indicated by a dash, not a gap (which could be taken to mean an omission). Subdividing the areas helps to retain the main structure of the design and groups data by different classes.

```
FOOD CONSUMPTION
Per capita consumption of major food commodities, 1980
(kilogrammes)

                  Beef    Fish    Fruit   Cheese

United States     46.9    5.8     40.2    8.0     100.9

Italy             25.2    11.0    119.1   14.2    169.5

Netherlands       20.1    12.2    69.0    13.5    114.8

Sweden            17.0    16.7    54.8    13.5    102.0

                  109.2   45.7    283.1   49.2    487.2
```

Divisions
Typographical charts are set out in seven major divisions:
A The heading, which contains title, subtitle, unit values and (perhaps) the source of the data.
B The categories, ranked by value, alphabetically or in some other relevant order.
C The items, whose position can be transposed with that of the categories.
D The individual values of the categories and items.
E The subtotals of the categories.
F The subtotals of the items.
G The gross total.

```
 _____
|                                         |
|  A                                      |
|_____    |
|     |            |              |       |
|  B  |  C         |              |       |
|     |_____|_____|   E   |
|     |                           |       |
|     |  D                        |       |
|     |                           |       |
|     |_____|_____|
|     |                           |       |
|     |  F                        |  G    |
|     |                           |       |
|_____|_____|_____|
```

Factors to consider

- Put the numbers that can be compared in columns rather than rows.
- Adjust all numbers to common values (round up or convert to common scales).
- Arrange the items in an appropriate sequence.
- Where possible, put larger groups at the top (or in bold), and put less important figures at the bottom or in a smaller size.
- Calculate the totals of the figures in the columns and check that they are correct.
- Use the layout to help structure the design areas.
- Write a caption which brings out the main points of the chart.
- Give sources.

	Crude steel production (million metric tons)	Population (thousands)	Wheat production (thousand metric tons)
Germany	35.9	60,651	8,632
France	18.4	54,335	24,324
Spain	13.4	37,346	4,368
	67.7	152,332	38,342

	Germany	France	Spain	
1 Steel production	35.9	18.4	13.4	67.7
2 Population	60,651	54,335	37,346	152,332
3 Wheat production	8,632	25,342	4,368	38,342

1(million metric tons) 2(thousands) 3 (thousand metric tons)

Order
The relationships of items can create ambiguity. Always avoid putting columns of figures in rows where the implication might be that they can be totaled but where categories are completely different. The two tables (*left*) contain the same data but the top one shows the correct presentation.

	Berlin	Bombay	Cape Town	Darwin	London	Los Angeles	Mexico City	Moscow	New York	Peking	Quebec	Rio de Janeiro	Rome	Tokyo	Wellington
Berlin	—														
Bombay	3,910														
Cape Town	5,977	5,134													
Darwin	8,036	4,503	6,947												
London	574	4,462	6,005	8,598											
Los Angeles	5,782	8,701	9,969	7,835	5,439										
Mexico City	6,037	9,722	8,511	9,081	5,541	1,542									
Moscow	996	3,131	6,294	7,046	1,549	6,068	6,688								
New York	3,961	7,794	7,081	9,959	3,459	2,451	2,085	4,662							
Peking	4,567	2,964	8,045	3,728	5,054	6,250	7,733	3,597	6,823						
Quebec	3,583	7,371	7,857	9,724	3,101	2,579	2,454	4,242	439	6,423					
Rio de Janeiro	6,114	8,257	3,769	9,960	5,772	6,296	4,770	7,179	4,820	10,768	5,125				
Rome	734	3,843	5,249	8,190	887	6,326	6,353	1,474	4,273	5,047	3,943	5,684			
Tokyo	5,538	4,188	9,071	3,367	5,938	5,470	7,035	4,650	6,735	1,307	6,417	11,535	6,124		
Wellington	11,265	7,677	7,019	3,310	11,682	6,714	6,899	10,279	8,946	6,698	9,228	7,349	11,524	5,760	—

Numerical matrix charts
Putting the same factors along both axes enables you to fill the interacting boxes with values relating to both. Distance charts are a good example; every item is related with every other item. The chart (*left*) reads horizontally and vertically to give distances between cities.

47

Scatter charts

Scatter charts show the relationships between information, plotted as points on a grid. These groupings can portray general features of the source data, and are useful for showing where correlationships occur frequently. Some scatter charts connect points of equal value to produce areas within the grid which consist of similar features.

Features
Scatter charts have two main elements: the axes and the categories. The chart (*right*) has two axes – years (horizontal) and dosage of X-rays (vertical). The three categories show a cluster pattern, with one outside the group.

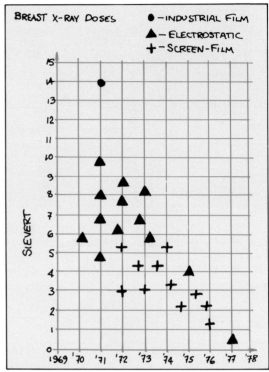

Rectangular coordinate grids
These six charts (*right*) show:
1 A grid with two axes, each normally with a percentage scale, and each beginning at zero and moving away from the lower left corner.
2 Points located along a diagonal line from the lower left corner have equal amounts of both values. Points located nearer to the sides or axes show varying proportions of the two side values, as those in the examples indicate:
3 Large amounts of (**A**) and (**B**).
4 Large amounts of (**A**) and low amounts of (**B**).
5 Low amounts of (**A**) and (**B**).
6 Low amounts of (**A**) and large amounts of (**B**).

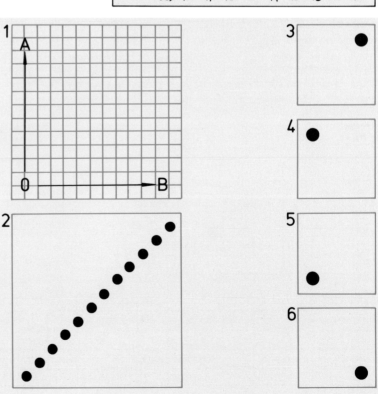

Identifying points

Scatter charts can be difficult to label because of the background grid. The chart (*right*) shows the ages and present population size of various cities.

1 Unidentified points show only the distribution of the data.

2 Text labeling the points can cause difficulties against a background grid.

3 Marking each point with a symbol requires a key outside the chart.

4 Numbering each point means the accompanying caption can identify them within the text.

Triangular coordinate grids

The five charts (*right*) show:

1 A grid with three axes, each normally with a percentage scale, and each beginning at zero along one side and ending at 100 at the opposite point. Any dot plotted within the triangle will have a combined category total of 100.

2 The point in the center has equal proportions of all three categories. Points nearer to the corners have higher or lower proportions of the three categories, as those in the examples show:

3 Large amounts of (**B**) and low amounts of (**A**) and (**C**).

4 Large amounts of (**C**) and low amounts of (**A**) and (**B**).

5 Large amounts of (**A**) and low amounts of (**B**) and (**C**).

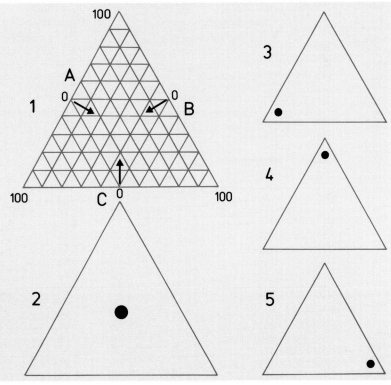

Three-dimensional placement charts

Data can be plotted on a structure with three axes – a spatial grid. This normally uses the two horizontal axes, or bases, for the categories and the vertical axis for the values. Before attempting to draw the grid framework in an unfamiliar structure, quickly sketch out the information on a regular geometric projection.

In the three charts (right) the same data point has been plotted on different frameworks.

Geometric grids (top right)
The axes are set at right angles to each other and plotted on structures with regular geometric relationships. The values start at a common corner and move outward toward the edges.

Circular grids (center right)
These are harder to visualize and construct and not so easy to understand. To draw them you will need circle and oval templates. The values are measured vertically, up the center axis; radially, outward from the center; and circumferentially, around the edge, normally in a clockwise direction.

Perspective grids (lower right)
The axes in these grids are similar to those in a geometric grid but are drawn as a recessional box seen from a single viewpoint.

Influence of grids
The two charts (*above*) plot the same data on to different geometric grids (see sections *right*). Each projection reveals different aspects of the information. Note the apparent relationship between the two columns of equal height, (**A**) and (**B**).

Choice of grid
The three views (*right*) of a three-dimensional matrix are devised from geometric grids. Test out your ideas on the grids on pages 114 and 183.

Part Three

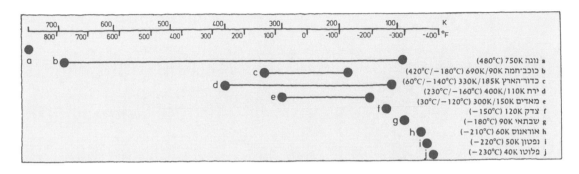

נוגה 750K (480°C)		a
כוכב-חמה 690K/90K (420°C/−180°C)		b
כדור-הארץ 330K/185K (60°C/−140°C)		c
ירח 400K/110K (230°C/−160°C)		d
מאדים 300K/150K (30°C/−120°C)		e
צדק 120K (−150°C)		f
שבתאי 90K (−180°C)		g
אוראנוס 60K (−210°C)		h
נפטון 50K (−220°C)		i
פלוטו 40K (−230°C)		j

CHARTS OF LENGTH, AREA AND VOLUME

Japanese Merchant Shipping
Losses 1942-1945

Tonnage destroyed

Tonnage afloat

1941 — 6,350,000

1942 — 1,150,000 — 5,940,000

1943 — 2,070,000 — 4,940,000

1944 — 4,120,000 — 2,650,000

1945 — 1,560,000 — 1,530,000

Tonnage newly acquired

Types of chart

Numerical values can be illustrated vividly as areas and a group of values or categories can easily be expressed as different sized areas. These can be square, rectangular, triangular, circular or irregular in shape. The most usual method of illustration is to create rectangular areas (or bar charts) in which the lengths are divided into values and the widths remain constant.

Bar charts are the easiest to construct and the simplest to evaluate. A single bar can represent a group of categories within one overall value, or several bars can illustrate a group of categories with a variety of values. A group of bars may start from a common end (based bars), or be individually plotted against a scale (ranged bars) or set in any number of patterns (arranged bars).

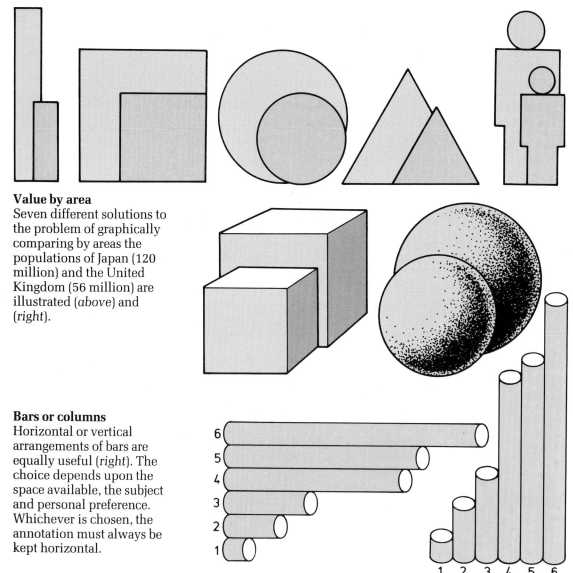

Value by area
Seven different solutions to the problem of graphically comparing by areas the populations of Japan (120 million) and the United Kingdom (56 million) are illustrated (*above*) and (*right*).

Bars or columns
Horizontal or vertical arrangements of bars are equally useful (*right*). The choice depends upon the space available, the subject and personal preference. Whichever is chosen, the annotation must always be kept horizontal.

Types of bar

A whole selection of arrangements of bars can present information very successfully. The choice of method depends on your purposes.

(**A**) Each bar in a connected group can represent an individual category of any one subject.

(**B**) Two or more bars may be grouped to express changes in the values of two or more categories, which should be distinguished by shape, color or texture.

(**C**) Bars can be divided into constituent parts for comparison.

(**D**) A group of bars with common total values (usually 100%) can be divided to show categories with different values.

(**E**) Particularly effective are bars drawn as solid blocks in space.

(**F**) A series of bars sharing a common starting value (usually zero) can show variations on either side of that common base line.

(**G**) Plotted against a scaled background, a set of bars can be positioned to show several ranges of values.

(**H**) More unusual are bars set around a circle, their values calculated on lines radiating from the center.

(**I**) Units of value with one common factor can be shown by individual bars set beside different shaped bars plotted against different units of measurement.

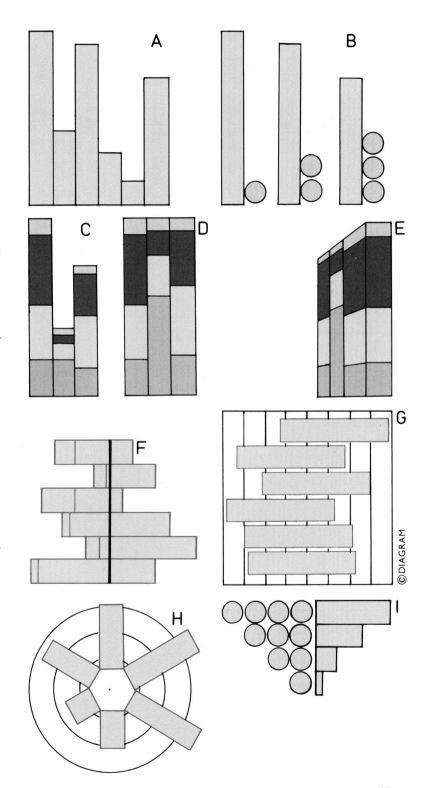

©DIAGRAM

Base-grouped bars

A series of bars constructed on a common base line provides a clear way of comparing different values by means of their irregular ends. This method is the easiest to construct, to evaluate and for the designer to embellish or manipulate. Varying techniques can accommodate bars of widely differing values or a group of bars with little variation in value. Bars can be drawn vertical or horizontal; solid or composed of small units; stacked in the same order as the source statistics or ranked in value order. There should always be a background scale and/or a number value at the end of each bar giving exact figures.

Identifying length
The two clearest methods of indicating individual bar values are (right) to include a legible scale (**A**) or to state the value of each bar in figures at its end (**B**).

Scales
The two charts (right) illustrate the same data. In (**A**) the scale brings out major differences in bar lengths. In (**B**) the scale minimizes the differences.

Extremes
When one value is very much larger than others in a group, presenting all to one scale is difficult. The solution (right) is either to break the longest bars (**A**) or to plot all on a logarithmic scale which has a much larger range of intermediate values (**B**).

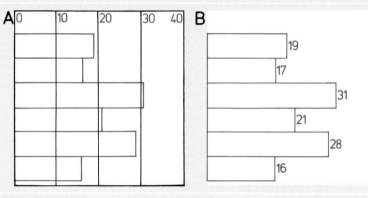

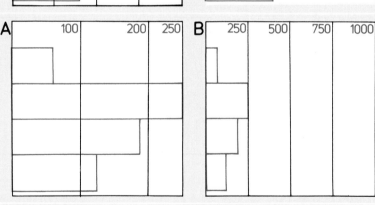

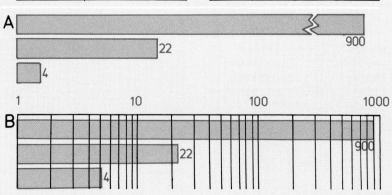

Bars with similar values
Groups of units all with large total values but small differences between them can be illustrated by the cut-off bar tops only (*right*). You must indicate clearly the values at bar ends or on your scale, and your design should show that each bar is short of its true length.

Ranked bars
Illustrating small variations is easier if the bars are ranked in order of length (*right*). This enables you to see which are longer (or shorter), even where differences are small, because of the order in which they appear.

Units
Subdividing each of a group of bars into regular units makes comparison easier. All the bars (*right*) are made up of varying multiples of repeated units or segments.

Optical length
Pictorial elements should clearly be outside the bars (*right*). In group (**A**) the engines seem to be part of the overall length, whereas in group (**B**) they do not. Note that in both diagrams row one is twice as long as row two and half as long as row three.

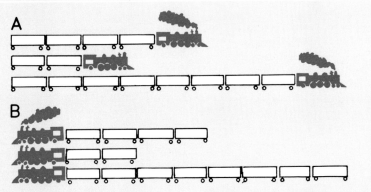

©DIAGRAM

57

Ranged bars

A series of bars positioned individually against a background is more difficult to read than those set on a base. But this type is very useful for showing a range of values, rather than specific values.

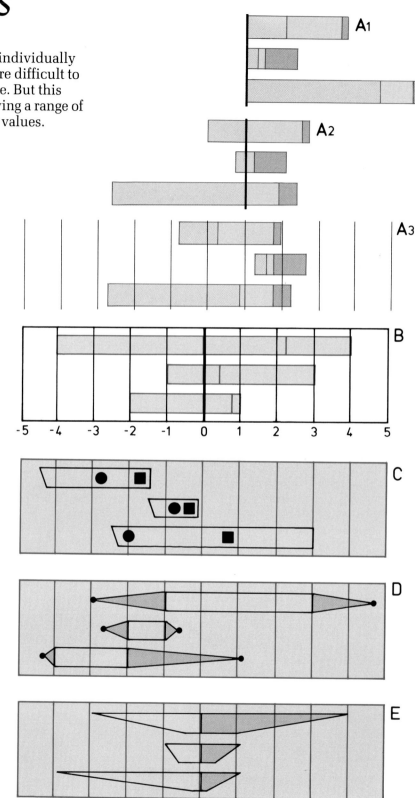

Positions (*above right*)
The relationship between the bars depends upon the method used for plotting their lengths.
A1 All based bars have a common starting line and extend in the same direction.
A2 Factor bars extend on either side of a common internal value line.
A3 Ranged bars, plotted on a background scale, are useful to illustrate ranges of value from very large to very small.
B Positives and negatives
A popular method of showing plus and minus values is to construct bars extending on either side of a median line (usually zero).
C Data carrying bars
Graphic information can be plotted at specific intervals within bars.
D Changing character bars
Changes in shape can be plotted from bar ends, indicating differences of value within parts of bars.
E Combined features
Several techniques can be combined.This example shows bars plotted from a central line, the top edges indicating a different time period from the bottom ones.

58

1,2,2,2,2,2,2,3,4,4,5,5,7,7,8,9,
3,3,4,5,5,5,5,7,7,7,7,7,7,

Bars carrying information

Range bars can convey a variety of additional factors. For example, the two groups of figures (*above right*) can be plotted in a variety of ways:

A The range:
Bars represent the range of numbers by position and length set against a common scale; points show extremes.

B The average or mean:
Points indicate the average of the values shown by the bars.

C The median:
Within the ranges of values those in the middle are indicated by points.

D The mode:
Within the ranges of values those which occur most often are shown by points.

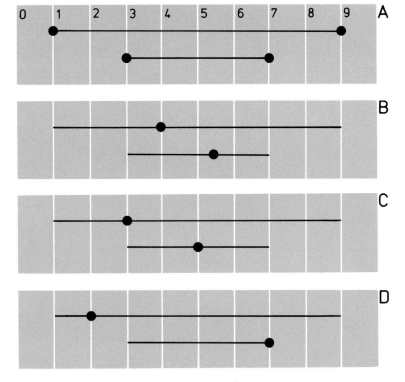

Winged bars

Stacking two rows of bars with a common set of intervals and scales permits easy comparison of similar statistics. This technique is most often used to portray male and female population figures and produces a "population pyramid."

Segregated bars

Stacking two rows of bars with a common set of time intervals but without a common scale, shows changes in both sets of data over time, revealing the relationships between them.

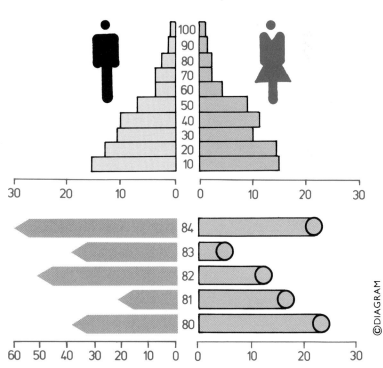

©DIAGRAM

59

Arranged bars

The arrangement on a page of a group of bars influences the ease with which values, as represented by bar lengths, can be compared. Two main factors influence the positions: the order in which the bars are plotted, and the resulting pattern.

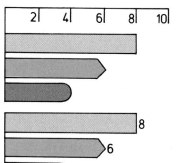

These two pages present five different bar arrangements using identical statistics. Each creates its own particular effect. In every group the longest and the shortest values have been indicated by the letters (**A**) and (**B**) to help evaluation.

Vertical grouping (*left*)
Most common and easy to understand, and to check on values, is a row of vertical bars on a grid in the same order as the source data.

Fan bars (*right*)
Bars are arranged in value order, then superimposed at one base point and displayed in a fan-like pattern to occupy the least space.

Bar ends (*left*)
The method you use to terminate your bars can influence their apparent length. The normal squared ends may not be suitable if bar values are very similar. Explore the effects of pointed or rounded ends.

Annotation
Whatever arrangement you choose, always remember to ensure that the actual values of your bars can be read either from the background scale or from clear annotation at the ends.

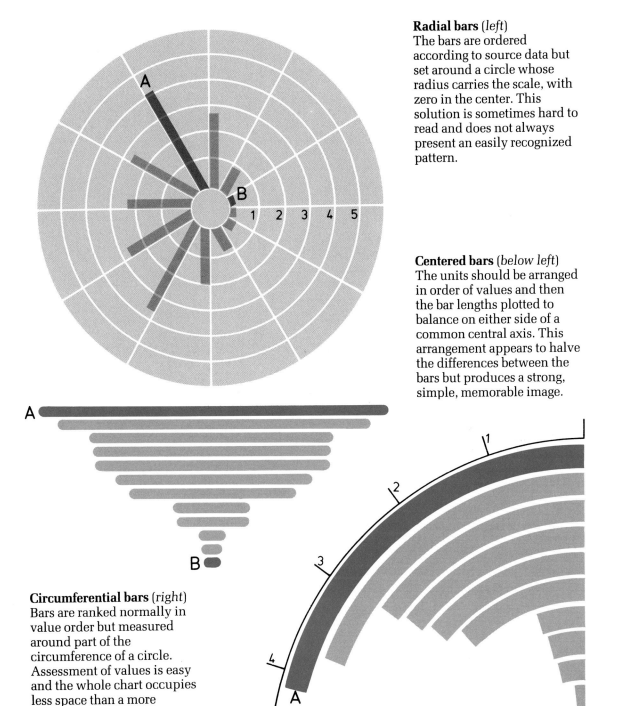

Radial bars (*left*)
The bars are ordered according to source data but set around a circle whose radius carries the scale, with zero in the center. This solution is sometimes hard to read and does not always present an easily recognized pattern.

Centered bars (*below left*)
The units should be arranged in order of values and then the bar lengths plotted to balance on either side of a common central axis. This arrangement appears to halve the differences between the bars but produces a strong, simple, memorable image.

Circumferential bars (*right*)
Bars are ranked normally in value order but measured around part of the circumference of a circle. Assessment of values is easy and the whole chart occupies less space than a more conventional bar chart.

©DIAGRAM

Grouped bars

Bar diagrams are excellent for illustrating statistical information with three constituent features: subjects; categories, parts, or factors; and values. When two subjects or categories have different units of value, it is advisable to separate them or distinguish between them by shape or color.

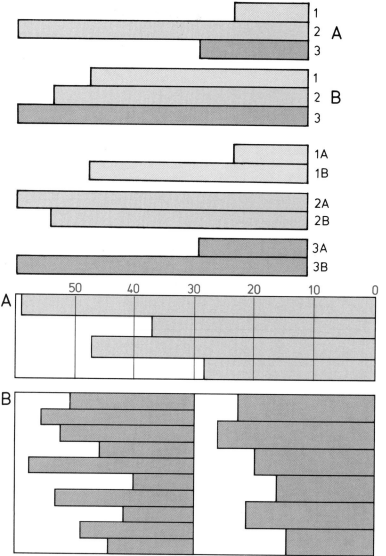

Differentiating between bars (*above*)
There are four means by which to distinguish bars:
1 By color, texture or tone
2 By shape
3 By the relative positions
4 By a combination of these methods.

Grouping bars (*left*)
Bars can be combined in several ways, for instance a chart with two categories (**A** and **B**) and with three factors (**1**, **2** and **3**) can be grouped either by category or by factor.

Allocating bar sizes
Given the maximum extent of the area, calculate bar sizes thus:
A Length: Find the largest value and draw the bar representing it to slightly less than the length of the area. Other bar lengths can then be worked out using the same ratio of bar length to represented value.
B Width: If there are to be no intervals between bars simply divide the width into equal parts i.e. 10 bars each take up one tenth of the available space, six bars, one sixth of the width. If you want spaces between the bars, keep them narrower than the bars they separate.

Advantages	Disadvantages
• Easy to construct, draw and understand	• May confuse by comparing different units
• Good for comparing similar categories	• May need two scales
• Good for comparing different features within similar categories	• May need unavailable tones, colors, textures
• Different units usable in one diagram	• May result in a very complex, confusing chart
• Allow opportunities to include pictures, symbols and patterns	
• Can be arranged in various combinations	

©DIAGRAM

Changing shapes

The four examples (*right*) show how different shapes instantly convey differences in information.

1 Two bars illustrate the same subject (trade), the same category (exports/ imports), in the same units (millions of US $). The different end devices of two similar bars distinguish the categories.

2 Two bars illustrate the same subject (population), different categories (births and deaths), in the same units (per 1000 population). The different bar images distinguish the categories.

3 Four bars illustrate the same subject (trade), different categories (money and goods), in different units (million US $ and million tonnes). The different bar shapes avoid any comparison between dissimilar units.

4 Two bars illustrate different subjects (land area and population), different categories (the years 1900 and 1980), in different units (million square miles and million people).

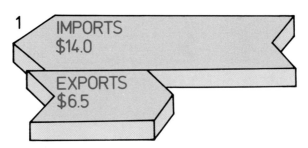

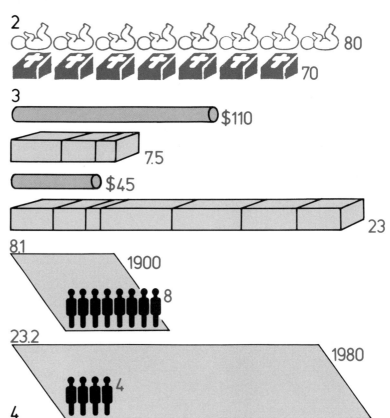

63

Divided bars

Bar diagrams can be sectioned vertically or horizontally, although it is best to divide any shape along its longest side. Use shapes with parallel sides so that the areas of the parts or categories represent the same values as the divisions along the sides. Irregularly shaped bars which are divided are misleading as the areas of categories can look different from the values they represent.

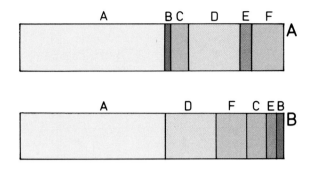

Category order
Usually the categories within a bar appear in the same order as in the statistical source (*above right* **A**). Re-arranging categories in ranking order helps to clarify their progressive differences (**B**).

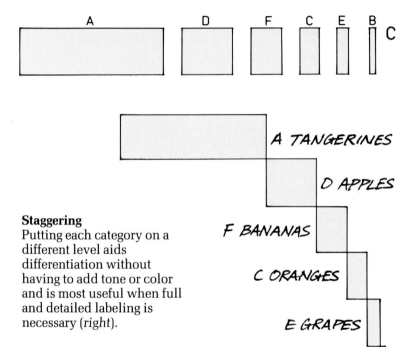

A TANGERINES

D APPLES

F BANANAS

C ORANGES

E GRAPES

B PEARS

Opening up
Bars containing categories with small values are difficult to label. Opening up the segments (*above right* **C**) helps labeling and removes the need to identify categories by different colors.

Staggering
Putting each category on a different level aids differentiation without having to add tone or color and is most useful when full and detailed labeling is necessary (*right*).

Points to check when preparing divided bars:
- That all the values of the categories are in the same units.
- That all the values add up to the total figure.
- That if percentages are used, the values add up to 100%.
- That the number of categories will not make difficulties when applying tones, colors or labeling.

- That the values of the largest and smallest categories will not make difficulties when applying tones, colors or labeling.
- That the available space will not restrict the areas of the small categories so much that they have to be tiny.
- That you have adequate surrounding space for labeling.
- That you can construct a line with proportional divisions (see page 160).

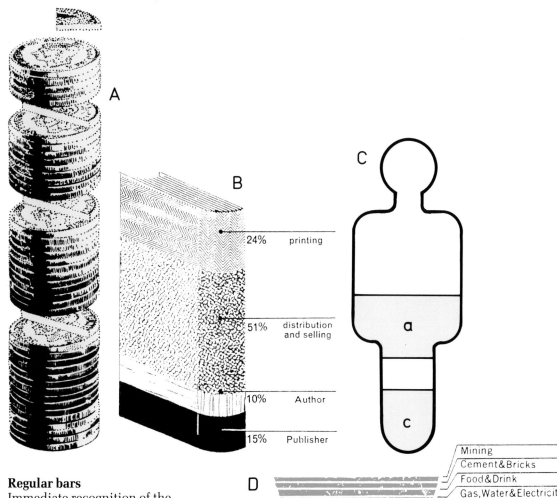

A

B

24% printing

51% distribution
 and selling

10% Author

15% Publisher

C

a

c

Regular bars
Immediate recognition of the
subject is helped by dividing
bars into identifiable regular
units, such as a stack of coins
(**A**), which are easy to draw.
Using objects similar to bars,
such as a book (**B**), avoids
misrepresenting values.

Irregular bars
Divided irregular shapes may
confuse because of incorrect
impressions given by areas or
subdivisions of the sides.
Shape (**C**) contains two equal
values (**a** and **c**) which look
different because of their
positions. Ranking values
within an irregular shape (**D**)
avoids the worst kinds of
visual distortion.

D

Mining
Cement&Bricks
Food&Drink
Gas,Water&Electricity
Clothing
Public Administration
Transport

Construction

Engineering

Steel

Divided grouped bars

Divided rectangular bars are excellent for showing the ratios of the parts to the whole and of these parts to a comparable group of parts within similar bars of the same length. Divisions show up well on adjacent bars, they can be linked, and the parts stacked or stepped. These methods offer different ways of presenting comparisons between changing values in categories within bars.

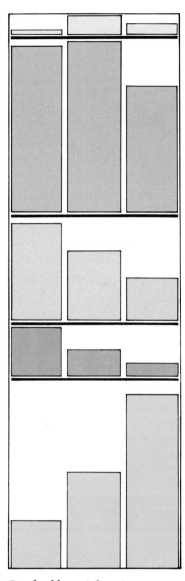

Adjacent but separate bars
Bars are best separated by spaces narrower than the bars themselves (*above*). Well-chosen colors should enable the reader to follow changes in the categories from bar to bar.

Linked bars
Divisions between the parts of the bars can be linked by fine lines in the intervening spaces so that the reader can easily trace variations in the same category (*above*). These diagrams may be difficult to label because figures put outside the bars tend to confuse the linking lines.

Stacked bars (*above*)
Each category in all the bars begins on a new base line. This method is useful for showing individual changes in categories over a group of bars. The height of the design will be the sum of the largest categories plus space for the base lines.

Percentages and absolutes

Always indicate scales for both percentage and absolute values. In the bars (*right*) bar (**A1**) shows the equivalent percentage of the value in bar (**A2**). Bar (**B1**) shows a bigger percentage than (**A1**) even though the equivalent value it represents is smaller.

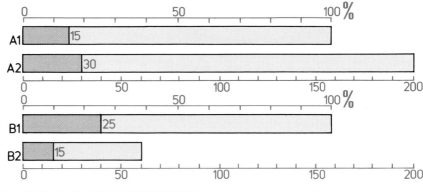

Stepped bars

The bars (*above*) are combined but are not defined by vertical lines, and the categories in each can be colored or textured. This method may be confusing when the categories are very different in value and the impression of a stepped graph is not sustained.

Dangers and difficulties

Divided bars can provide misleading or even incorrect information. Be sure you guard against:
a Adding additional categories
b Changing the order
c Omitting categories

Arrangement problems

Take care not to arrange bars in such a way that readings from bar to bar are confused. Bars with many small divisions may be difficult to annotate clearly because of lack of space.

© DIAGRAM

Divided irregular bars

Groups of divided irregular bars often present difficulties when identifying smaller sections within small bars. Before starting, make sure the largest and smallest values can be satisfactorily combined in one chart. The prime consideration is to select a solution which demonstrates the most important features of the subject.

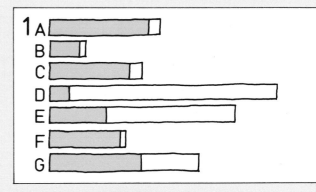

Linking lines
The main disadvantage of very irregular divided bars is the difficulty in marking the values and in tracing the relationships between some of the categories. With two or more bars, changes in the same categories can be made clearer by linking dividing lines across the intervening space (*below*).

Scales
When you require a number of bars, it is advisable to construct a clear scale with background lines that link all the bars, and to provide annotation which permits easy reading of all the values (*below*).

Ordering
A series of bars can be arranged in a variety of ways (*above*):
1 In the same order as the data
2 In order of rank according to the bar values
3 In the order of one of the categories within the bars

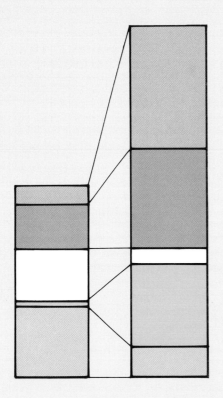

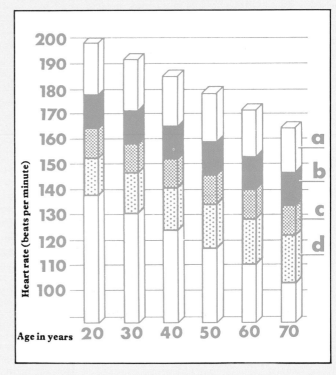

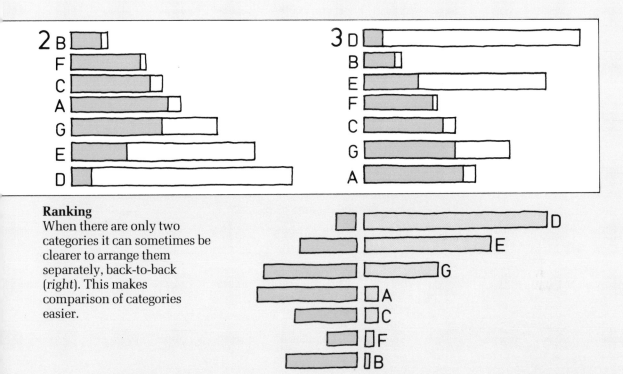

Ranking
When there are only two categories it can sometimes be clearer to arrange them separately, back-to-back (*right*). This makes comparison of categories easier.

who asked for help?
Number of official requests received, by region
● Africa ■ Latin America
◆ Asia and Pacific ✳ Europe

One symbol = 10 requests

les demandeurs
Nombre de demandes officielles reçues par région
● Afrique ■ Amérique latine
◆ Asie et Pacifique ✳ Europe

Un signe = 10 demandes

quién solicitó ayuda
Número de solicitudes oficiales recibidas por región
● Africa ■ América Latina
◆ Asia y el Pacífico ✳ Europa

Un símbolo = 10 solicitudes

	● Africa	◆ Asia and Pacific	■ Latin America	✳ Europe
1979	91	40	62	7
1980	117	71	56	6
1981	180	89	79	9
1982	208	65	105	10
1983	220	70	120	10

©DIAGRAM

Subsectioning
When it is impossible to use color to identify categories, an attractive solution is to label each part with a different symbol (*above*). These can be taken from transfer letter forms or devices.

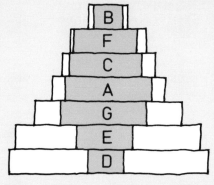

Centering
Order the bars by value and arrange them on a central axis. This seems visually to reduce the differences between bars but it is an effective and visually pleasing solution.

Divided bars in space

Bars drawn in perspective so as to recede from the reader can be viewed from two positions. The easier to construct are those sectioned along the horizontal sides facing the viewer. More dramatic but harder to draw are those with receding divisions.

Advantages
When drawn in perspective the smallest values can be put in the foreground to appear larger and more legible.

Disadvantages
Recessional bars are hard to construct accurately and unless clearly marked with category values can misrepresent relationships.

Construction
Start to build a recessional divided bar by drawing it in perspective. To find the center line (**a**, *right*), construct diagonals from the corners. Draw diagonals across the resulting two halves to find their center lines (**b** and **c**). Keep subdividing to allocate intervals close to your required scale.

Dramatic bar diagrams
Drawing a bar in sharply receding perspective and dividing it in rapidly diminishing sections produces a dramatic result (*left*).

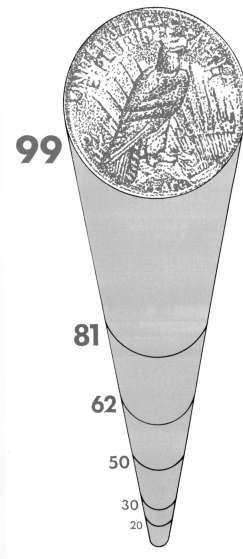

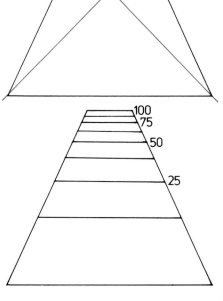

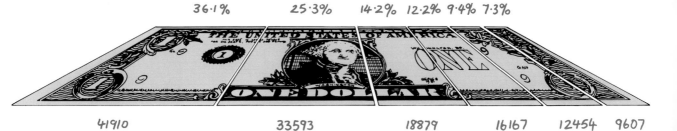

36·1% 25·3% 14·2% 12·2% 9·4% 7·3%

41910 33593 18879 16167 12454 9607

Front edged bars (*above*)
These are very easy to draw
because divisions are
calculated along the
horizontal edges facing the
viewer.

Blocked bars (*right***)**
Construct divisions from the
front edge and then complete
in perspective. Tones, colors
and textures will identify
similar categories.

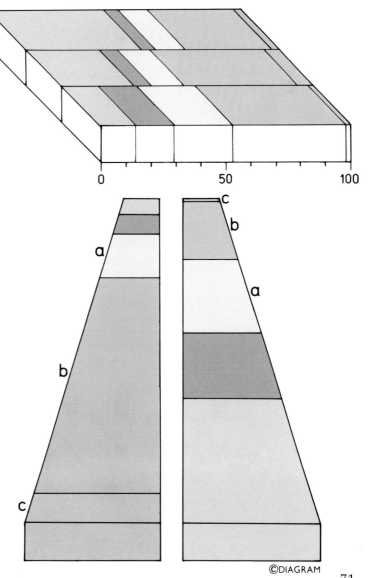

Different presentations
Two bars (*right*) present the
same data but plotted from
two different ends. Categories
with identical values appear
very unlike in area,
depending on their positions.
Categories (**a**) and (**b**) in each
bar have the same value, and
category (**c**) looks
considerably larger in the
first diagram.

©DIAGRAM

Three-dimensional bars

To enhance your design and add variety, you can use perspective to set your bars in space either as two-dimensional shapes or as apparently solid blocks only partially seen from one viewpoint. When choosing a solution, take care not to misrepresent the data and always include a scale or add exact values at bar ends.

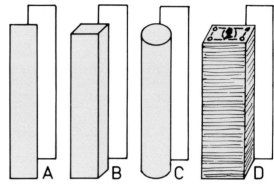

Methods (*above*)
Set your bars in space by:
A Drawing flat shapes ranged behind each other
B Constructing blocks
C Showing bars as columns
D Adding a pictorial element

Visual distortion
Take care not to distort relationships between bars, and add pictures only to simple diagrams.

Drawing units
The simple bar chart (*below* **B1**) is easy to read and the units can be counted. In the drawing of the same problem in space (*below* **B2**), the units can still be counted and the pictures give clues about the subject matter.

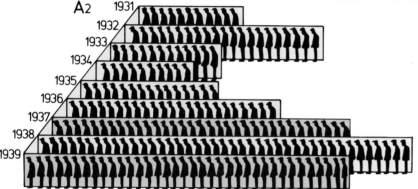

Misrepresentation
Two examples (*left* and *above*) show the effects of adding pictures: in (**A1**) the value for 1939 is larger than that for 1937. When drawn as a series set in space (**A2**), this relationship is not immediately apparent. This type of chart must always carry exact values at bar ends.

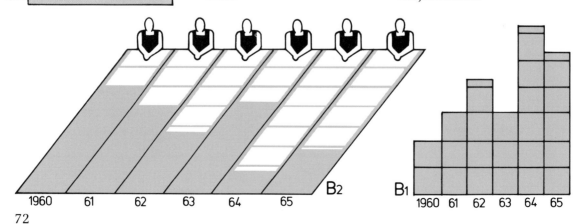

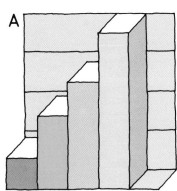

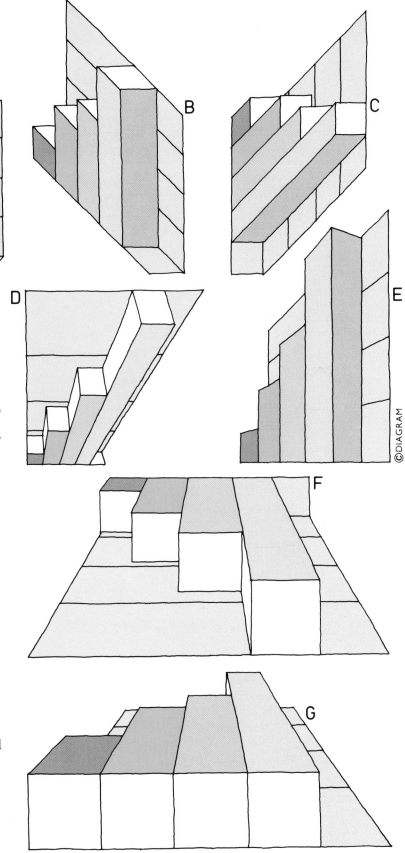

Stepping into space

On this page are seven charts in which the same information is displayed in groups of bars seen from a variety of viewpoints.

Flat side view

The easiest to construct and to assess is (**A**), which is a very simple way of enhancing your information.

Geometric projections

Constructing bars on a geometric grid or using set-squares (see page 154), provides a simple way of creating a three-dimensional effect (**B** and **C**).

Perspective views

The four views (**D**, **E**, **F** and **G**) drawn in perspective require an understanding of how to construct a recessional scale (see page 70). These bars are plotted on a background scale in which values appear to decrease as they recede into the picture. Such dramatic solutions run the risk of distortion. But if you always state the facts and figures clearly and take care to avoid misrepresentation, the results can be most effective.

©DIAGRAM

Picture bars

Incorporating pictures into your bar chart is an easy and attractive way of adding to its interest. You can either compose your bars of pictorial units or embellish your charts when already plotted. Start by sketching the whole design, then construct your bars accurately as usual, adding the pictures later. Make an effort not to produce over-elaborate designs.

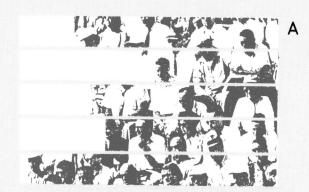
A

Picture-bar type
Overall length gives exact values in the following:
A Normally constructed bars cut out from a pictorial background
B Continuous hand-drawn units
C Overlapping and inter-mingling units
D Multiples of a common regular unit

Misrepresentation
The precise subject matter must be conveyed in all picture bars. The three examples (*right*) are from data showing the increase in fire incidents in the Bronx, New York.
E could be showing an increase in the use of water supplies in fire fighting.
F could mean an increase in the number of firemen.
G could mean an increase in the heights of buildings catching fire.

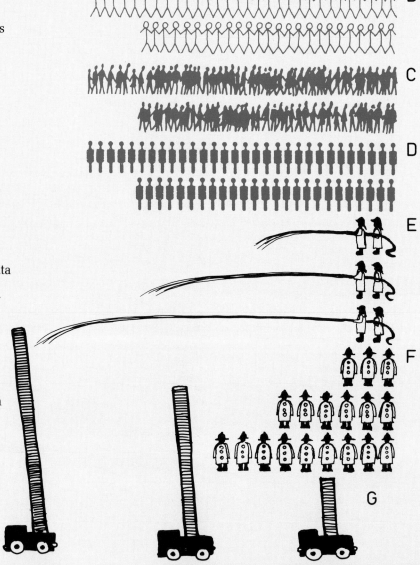

A

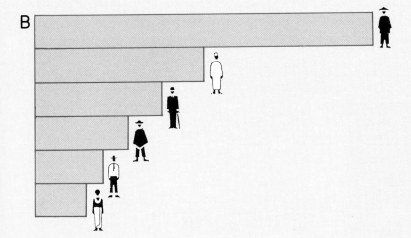

B

Pictorial identifiers (*left*)
Both divided bars (**A**) and
ranked bars (**B**) carry symbols
to identify the categories as
well as the overall subject
matter.

Relationships (*below*)
Since we estimate value by
the length of bars, the
pictorial elements must be an
integral part of the bars and
not lead to distortion or
confusion.
C The tallest figure is just over
twice the height of the
smallest, but it looks much
larger.
D Are the values indicated by
the height of the stem, or by
the overall height of the plant?
E Multiples of a single unit
provide the safest form of
pictorial bar chart.

C

D

E

1971 1972 1973 1974

©DIAGRAM

Area charts

Squares, circles, equilateral triangles and blocks are all useful visual means of expressing values to be compared. The main problems are in accurately calculating their sizes and in positioning them so as to achieve the best possible arrangement. The three groups (*below*) show the values 20, 2 and 0.2; the largest shape in each is 100 times larger than the smallest.

Formulas

Squares: The length of each side equals the square root of the value.

$$\sqrt{value}$$

Circles: The radius of each circle equals the square root of the value after dividing by 3.142.

$$\sqrt{\dfrac{value}{3.142}}$$

Equilateral triangles: The length of the sides equals the square root of the value after multiplying it by 2.309.

$$\sqrt{value \times 2.309}$$

Construction

The three formulas given (*above*) are for the construction of squares, circles and equilateral triangles. The scale (in two parts, *right*) works out the measurements for these shapes. Column (**A**) gives the value to be represented, column (**B**) the length of the sides of the equivalent projected square, (**C**) the radius of the projected circle and (**D**) the length of the sides of the projected equilateral triangle.

Positioning

The position of shapes in relation to each other is important when judging comparative sizes and therefore values. On this page the groups of squares, circles and triangles represent identical values and relationships. By separating the shapes, each can be judged on its own.

Squares

Squares with a common side or base line are less successful than those that are staggered in perspective.

Circles

Circles are normally positioned on a common base point, but this arrangement is less effective than placing them along a common center line.

Equilateral triangles

Try to avoid drawing them with a common side. Triangles are the most difficult to construct and to evaluate.

Units

Blocks of units assembled to express total values are most useful in making area comparisons. When building groups, take care to keep a constant number of units on one side. Both groups (*right*) show the relation of 22 to 11. (**A1**) and (**B1**) are twice as large as (**A2**) and (**B2**), but this is clearer in group (**A**).

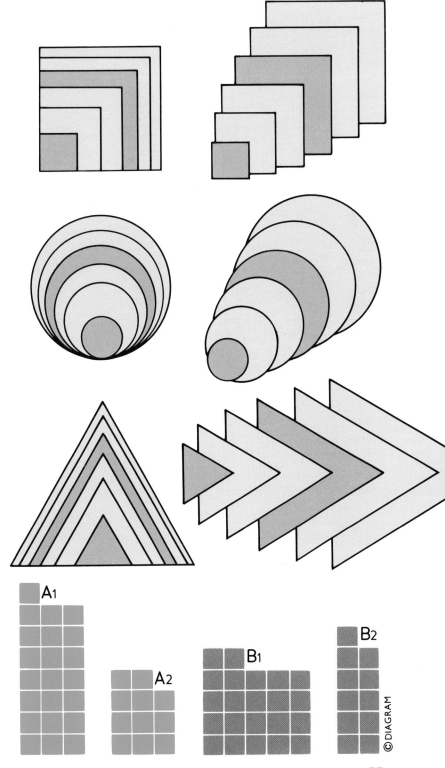

©DIAGRAM

77

Pie charts

The next eight pages illustrate the use of a divided circle – the pie diagram. This method requires you to convert your information to percentages of the total and then to plot these values on to a 360° arc. The major advantages of pie circles are when used for five or fewer elements, or for when describing, with a number of

pies, changes in two parts of a statement. The main disadvantages are when including numerous items, some of which may be very small, or similar. To facilitate easier plotting of your pie chart, we have included a segment of a circle divided into a hundred parts.

Advantages	Disadvantages
Good for revealing the division between two parts	● Difficult to calculate
Good for expressing five or fewer parts	● Difficult to label
Good for abstracting one part	● Difficult to apply tones to small areas
Good for a series of two factors where one is constant and the other changes.	● Difficult to show differences where values are similar
	● Difficult to compare two pies of differing sizes

Percentage protractor

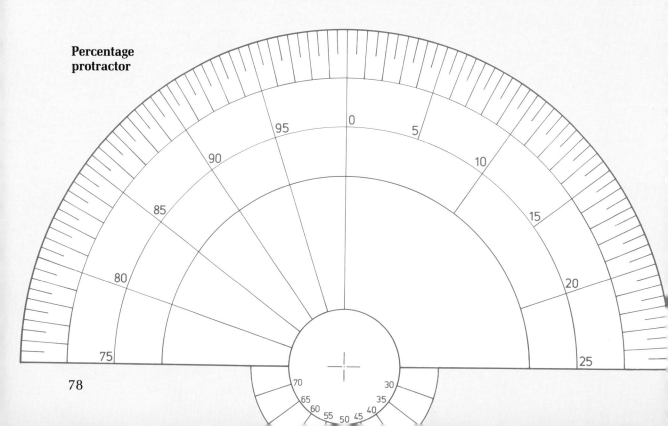

Identification

The most difficult part of presenting the pie is the problem of labeling the parts.

A Always keep text and numbers horizontal.

B Never stick labels over areas.

C When applying tones, put the darkest tone over the smallest area, and try to alternate tone densities to avoid confusion.

D Add the true value and the percentage in all cases.

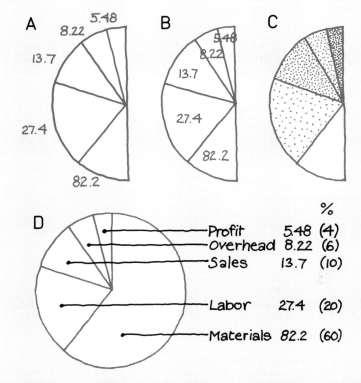

	%	
Profit	5.48	(4)
Overhead	8.22	(6)
Sales	13.7	(10)
Labor	27.4	(20)
Materials	82.2	(60)

Converting to degrees

1 Add up all the actual figures.

2 Divide the total by 100.

3 Using the result, divide each number by this factor to give as a percentage.

4 Multiply each percentage by 3.6 to convert to degrees.

As a crosscheck you must:

1 Add up all percentages to see they produce 100.

2 Add up all degrees to see they produce 360.

Compare items for proportional values. For example, here items **D** and **E** should add up to item **C**, and item **C** should be half of **B**. Most groups of figures have approximate relationships of this sort.

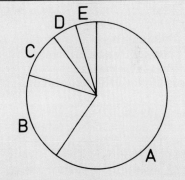

	ACTUAL	PERCENT	DEGREES
A Materials	82.2	60	216
B Labor	27.4	20	72
C Sales	13.7	10	36
D Overheads	8.22	6	21.6
E Profit	5.48	4	14.4
TOTAL	**137**	**100**	**360**

©DIAGRAM

79

Sector charts

A pie drawn as a flat oval, as if a circle were being viewed from the side, takes up less space and is as easy to construct as a full circle. You can draw your own but commercial templates are available for smaller ovals.

Construction
The method of construction of an oval pie chart is the same whatever the depth of the oval (*right*):
1 Using a percentage protractor, plot your pie sectors on to a full circle.
2 Project the intersections with the circumference of the circle up on to an oval of whatever depth you want.

Sector comparisons (*below*)
Comparisons between sectors of pie charts can be difficult so arrange the parts in the same order and distinguish in the same manner. Sector charts (**A**) and (**B**) face each other so comparing the values is not easy, unlike sectors (**C**) and (**D**), which are in the same positions.

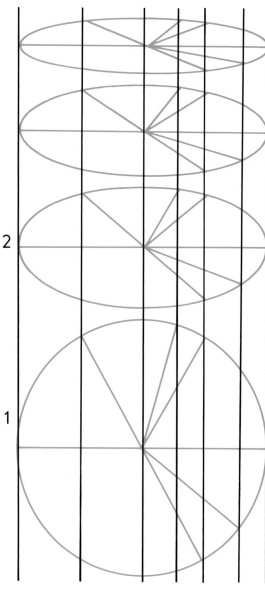

A

B

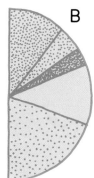

C

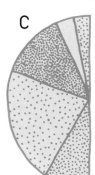

D

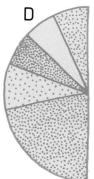

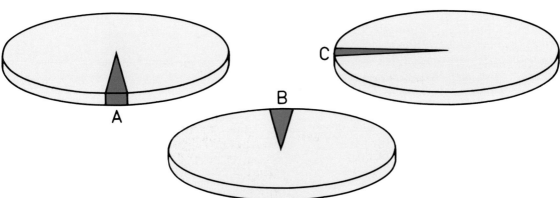

Dangers

On an oval pie chart the visual size of a sector depends on its position. Areas seen on the front (*above* **A**) or back (**B**) edges seem larger than the same value area on the side (**C**).

Multidivisional

When combining a group of pie charts (*right*), it is advisable to begin the sectors at the same point in each of the pies so that relative changes are simple to read.

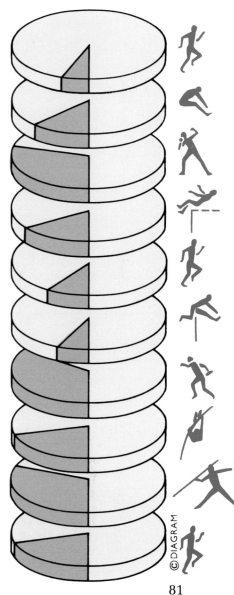

Overlap

When you need to indicate an overlap in your sectors, use color or textures. For example (*left*), of a total group membership of 100, men comprise 75% (**A**) and women 25% (**B**) and there are 15% of men and 5% of women over 60 years of age.

Circumferential

A group of values each expressed as a percentage of the same total can be presented (*left*) by drawing each as the sweep of an arc and not as a sector.

©DIAGRAM

Area circles

An illustration of the different values of a group of categories by the areas of individual circles is very difficult to construct and hard to evaluate. Nevertheless, if dramatic effect is what is required this technique can produce very striking charts.

Progressions
The population growth chart (*below*) is strong on ideas but poor at showing comparative values. (**A**) is six times larger than (**B**) and 42 times larger than (**C**).

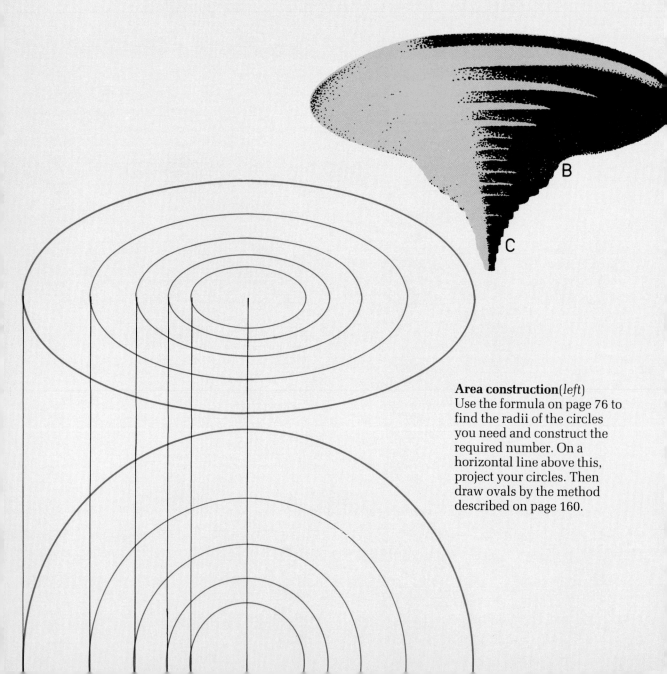

Area construction(*left*)
Use the formula on page 76 to find the radii of the circles you need and construct the required number. On a horizontal line above this, project your circles. Then draw ovals by the method described on page 160.

1 AFRICA

A	B	C
1950	30	14%
1975	105	26%
2000	370	42%

2 LATIN AMERICA

A	B	C
1950	67	42%
1975	198	61%
2000	423	77%

A Year

B Total urban population (in millions)

C % of regional population in urban areas

© DIAGRAM

Changing-area circles
Using circles to show differences in total areas, and in internal categories, allows the inclusion of many values, but the data is unclear without accompanying statistics (*above*). Avoid presenting a variety of changing relative areas in this way.

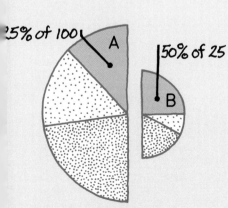

Less is more
Different overall areas make comparison of categories hard to assess (*left*). Area (**A**) is half the percentage value of (**B**) but twice the actual amount.

Sector units
Diagrams using parts or sectors to express values are easily misunderstood. The area of each sector in the circle (*above*) is irrelevant since each was calculated by using a radial scale (*above left*). If you present such charts, ensure they are accompanied by clear notes on how to read them.

Pictorial pies

Pictorial pies are fun. They convey ideas
attractively and are not hard to construct
using a percentage protractor. Removing
or pulling out a sector (or category)
focuses attention on a feature and, because
each part fits into a whole, it can be easily
evaluated.

Pie or cake
Real images are memorable.
The cake (*right*) shows how
much of the total national
wealth was possessed by the
rich – here over 85% – and
how much was owned by the
majority of the population.

Enlargement
Pulling out and enlarging one
or more sectors of a cake
(*right*) highlights divisions
and details and makes proper
labeling of small closely
grouped categories easier.

Combinations
The ends of bars can be used
in the form of pies to carry
fine details that would be lost
in one bar diagram. Each of
the three columns of varying
lengths (*right*) expresses
values below 1, the pie
section at the end of each
showing the second decimal
point value.

.32

.64

.87

Pictorial pies

Cutting and pulling out sectors from apparently solid objects (*right*) vividly portrays relationships. This technique is particularly effective using photographs for the pie chart which is constructed with the help of a percentage protractor.

Subdivided pies

A good way of expressing relationships of parts to the whole is to subdivide only a part of the pie, like the top layer (*left*).

Diminishing pies

The image (*above*) of a continually increasing pie whose slices are displayed in a staggered manner conveys the idea of increasing parts of a whole.

Regular-area charts

The ideas behind area charts with regular sides are best conveyed by devising multiples of a square. Calculating the length of the sides is simply a matter of using a pocket calculator to find out the square root of the value you want to illustrate. Finding the lengths of the sides of a rectangle involves more complicated mathematics and your diagrams will not be nearly as easy to assess.

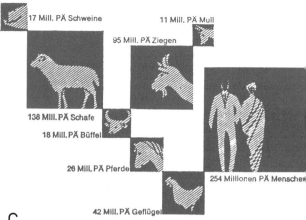

17 Mill. PÄ Schweine
11 Mill. PÄ Mull
95 Mill. PÄ Ziegen
138 Mill. PÄ Schafe
18 Mill. PÄ Büffel
26 Mill. PÄ Pferde
254 Millionen PÄ Menschen
42 Mill. PÄ Geflügel

A B C

Judging areas
The three columns of squares (*left*) reveal problems in judging values by areas. From the top row down, the squares contain areas which represent 75%, 50% and 25% of the totals. The areas of (**A**) are easily recognized as correct percentages of the wholes, whereas the areas of (**B**), located at a corner, and those of (**C**), centered on the bigger squares, are not so clear. Very few people would judge correctly the areas inside (**B**) and (**C**).

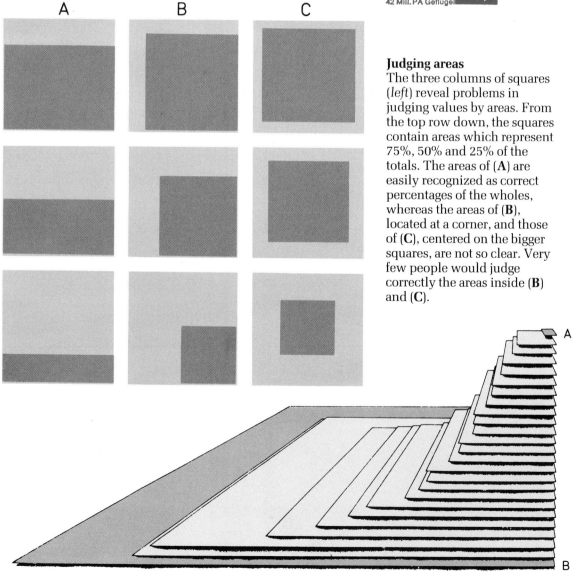

A

B

Regular units

The populations of various species in Africa (*opposite* and *below*) are here illustrated by expressing them as squares of different areas.

A

930 Millionen PÄ Rinder

43 Mill. PÄ Kamele

42 Mill. PÄ Esel

Value for money

The three bank notes (*right*) were drawn so that their areas correspond to their monetary values. The largest (**A**) is 10 times larger than (**B**) and 100 times larger than (**C**). Although they are forceful images, accurate assessment of their areas is difficult.

B

C

Editing

Because the forms of regular shapes are so familiar, parts only of those forms are easily identified. They can be edited or overlapped without distorting the relative values. The six squares (*below*) are incomplete but still indicate comparative values successfully.

Stacking

Twenty-five squares (*opposite*) have been stacked for convenience and to save space. But beware; the reader may well assess the values by the lengths of their sides, rather than by their implied areas. The side of square (**B**) is 50 times longer than that of square (**A**), but the area of (**B**) is 250 times greater.

© DIAGRAM

Unit charts

For these charts you will have to produce consistently large numbers of identical units. Where possible, one unit should represent a regular number, such as 5, 10, 100 or 1,000. The Austrian artist, Otto Neurath, produced many such charts with great success during the 1930s and '40s. He declared his guide lines: "Pictorial unit charts should be produced in a way which makes the subject matter apparent, and the values and relationships clear."

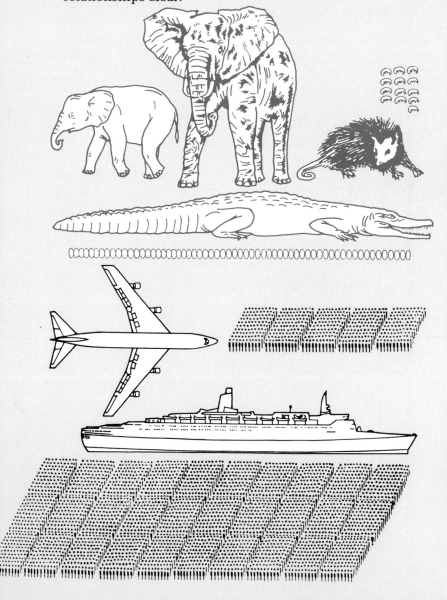

Units as parts
The total annual milk production of one prize-winning cow is illustrated (*right*) by using the milk bottle as a unit to represent one part, and the massed bottles alongside the cow give an impression of the actual output.

Units of reality
The average number of babies at birth of three animals is shown (*left*). The elephant has one, the opossum 13 and the crocodile 66. Each unit looks like the particular baby at birth.

Units as substitutes
The chart (*right*) shows the size of merchant fleets in 1914. Total tonnage is indicated by multiples of a unit, the ship, which represents 500,000 gross tons of commercial shipping of every size and type.

Grouped units
Transatlantic passenger traffic (about 550 per plane and nearly 3000 per liner) is illustrated (*left*) by heads, divided into blocks of 100, which makes drawing and comparison easier.

Units of abstraction
The chart (*right*) shows the market share of brand-name cigarettes in Germany. Each cigarette represents 2% of the annual value of the trade. Although the general impression is correct, this information would be easier to understand if presented as a pie chart.

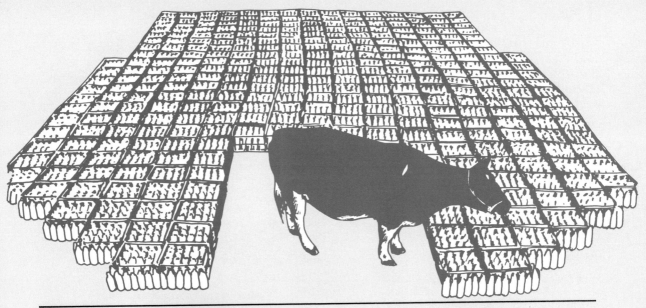

U.S.A. British Empire Other countries

Each complete symbol represents 500,000 gross tons

ISOTYPE

Irregular-area charts

Employing irregular shapes to illustrate
values can produce a striking visual image
but the result can also make accurate
assessment difficult. However, the use of
pictorial elements to emphasize a
particular aspect of your subject can be
very successful.

JULY 1923
3,465 MARKS

September 1923
1,512,000 MARKS

November 1923
201,000,000,000 MARKS

Irregular shapes
The illustration (*left*) shows
the phenomenal increase in
the price of bread in Germany
during the hyperinflation of
the 1920s. Its emotional
impact is strong but the exact
increase is almost impossible
to assess.

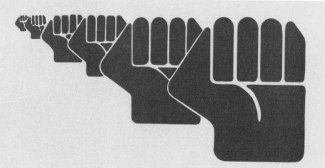

Repeated shapes
These forceful images (*left*)
demonstrate the rise of the
trade union movement in the
USA. Because the area of each
advancing symbol must
reflect an increase in value
within a replicated shape, this
type of solution is hard to
construct accurately.

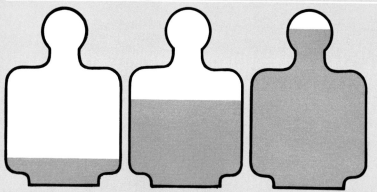

**Repeated symbol, variable
content**
The areas within the repeated
shapes (*left*) illustrate the rise
of contaminants in food. Once
a relevant basic symbol has
been designed, areas
representing the changing
factor can be calculated on a
scale based on the overall
height, and then filled in.

Multiples

India is 13½ times larger than the UK (*right*). An irregular shape is easy to repeat and if the two subjects are drawn to a common scale, basic differences will be immediately apparent and area values can be correctly interpreted.

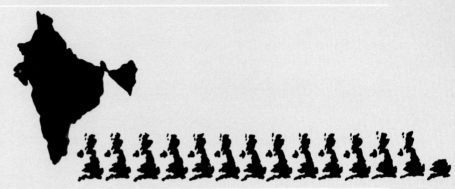

Common scale

Alaska at its widest stretch is about half as wide as the main part of the USA (*right*). Superimposing two shapes drawn to the same scale is an effective method of making comparisons.

Units

The two maps (*right*) compare the surface areas of the USA and the UK. Dividing shapes into multiples of the same unit (perhaps boxes representing 100 square miles) enables the reader to judge relative areas more easily.

Conversions to regular shapes

Neither the shapes nor the area statistics for the three countries (*right*) really convey accurately their comparative sizes. But such comparisons can be made much more easily by converting areas into regular shapes.

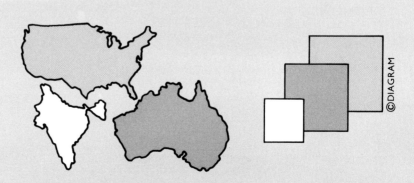

©DIAGRAM

Volume charts

Values which are shown diagramatically by volume require complex calculations and the resulting forms are difficult to assess correctly. Enlarging or reducing cubes or spheres may badly misrepresent changing values. But you can safely and vividly illustrate values by volume if you use multiples of a regular-sized block or ball or subdivide a unit of constant volume.

Formulas

Cubes: Using a pocket calculator, find the cubed root of the required value. This is the length of one side.

$$\sqrt[3]{value}$$

Spheres: Multiply the required value by 3 and divide the result by 12.56. The cube root of the answer is the radius of the sphere.

$$\sqrt[3]{\frac{value \times 3}{12.56}}$$

Scales for calculation

The scales (shown in three parts, *right*), will help you to construct your cube or sphere. The first column (**A**) shows the value to be represented, the second (**B**) the length of the side of an equivalent cube and the third (**C**) gives you the radius of a sphere of an equivalent volume.

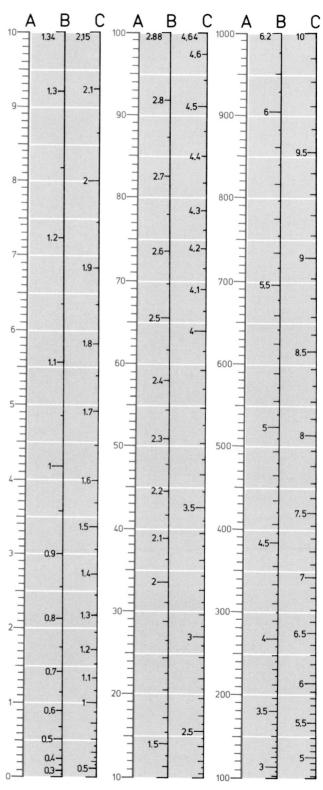

Blocks

The easiest blocks to build are those with a basic value which is represented by a single unit, the cube (*right*). The reader can understand the volume quickly because the whole block is composed of multiples of the single unit.

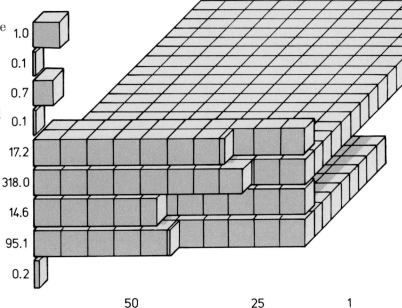

1.0
0.1
0.7
0.1
17.2
318.0
14.6
95.1
0.2

Subtraction

Select an object with a regular sectional form. Attribute the largest value to the whole object (*right*) and smaller values to 'slices'.

50 25 1

Dangers

Readers are not used to appreciating the scale of differences in volume. The diagram (*right*) illustrates different ways of depicting comparative values. (**A**) represents two values drawn to a scale based on height. The same two values are expressed by area in (**B**) and finally by volume in (**C**). Very few readers would be able to judge properly the relationship of (**C1**) to (**C2**). And (**A1**) and (**A2**) seriously misrepresent the relationship because the reader is more used to comparing areas in such diagrams, than heights.

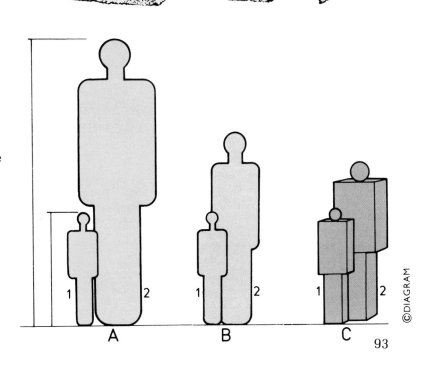

1 A 2 1 B 2 1 C 2

Part Four

GRAPHS

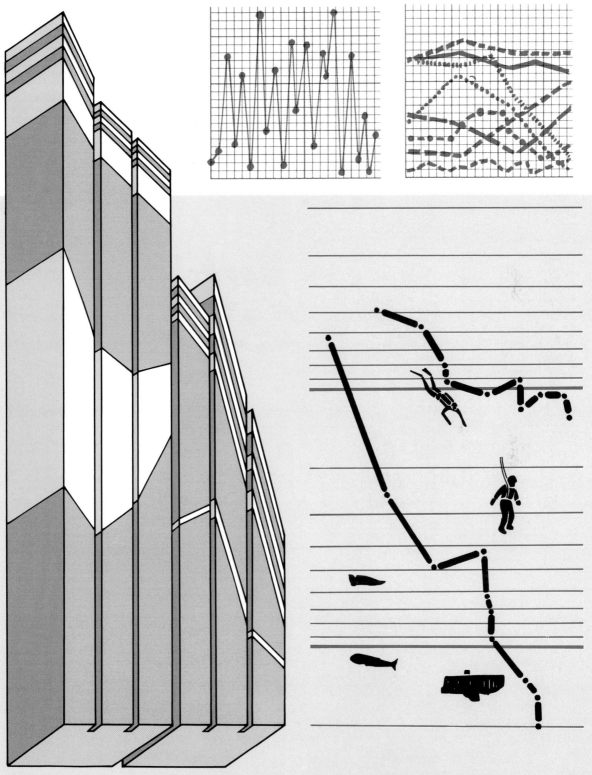

Types of graph

Graphs are a very successful form of charting alterations in a series of values marked by points, and they are easy to construct, draw and understand. They are plotted on a grid based on two axes or scales, the horizontal one usually measuring a regular time scale and the vertical one the unit values of the data. Many methods, often with specific applications, have been devised to present consecutive values on a graph.

Up and down
A graph line shows a trend and, traditionally, downward slopes indicate a decline and upward directions an improvement (*right*).

Graph styles
The 12 graphs (*opposite* and *below*) show variations: in plotting points and lines, in areas formed by the lines and in the background grid.

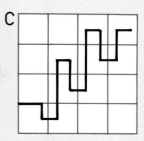

Line features
Links between plotted points vary, each type producing a different result. There are:
A direct, straight lines joining the points;
B curved lines passing through the points; and
C horizontal and vertical lines between the points, producing a bar-like profile.

Point features
D Normally a graph is produced by plotting and joining absolute and fluctuating values. The result may be an erratic line which obscures any overall trend. But a line joining points which are averages of a group of consecutive values will bring out tendencies.

Area graphs
E The areas between a series of graph lines, produced by plotting variable data, are useful for indicating the extent of variations.

Deviation graphs
F These highlight areas produced by line graphs plotted on values ranged on each side of a constant (usually zero).

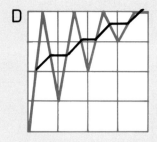

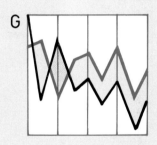 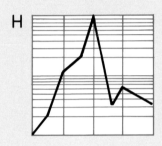 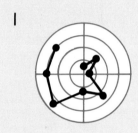

 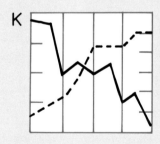

Net difference graphs
G The variable differences between two sets of related factors are shown in the area between two graphs.

Logarithmic graphs
H Plot points and lines on logarithmic scales in both directions (log-log graphs), or on a logarithmic scale on one axis, the other being normal (semi-log graph).

Radial graphs
I Graphs for which the regular scale is measured around the circumference of a circle and the scale for the data on its radius.

Multi-scaled graphs
J Graphs based on values which have been converted to a common base unit can be used to record the rate of change between points, rather than a value change.

Rate-of-change graphs
K Graph lines representing two different unit values are plotted on two super-imposed grids with one scale common to both sets of data.

Three-dimensional graphs
L A series of graphs based on three axes for which the data have two common factors and one variable.

Grids

Graphs are plotted against two scaled axes, one horizontal and one vertical, whose divisional units are projected on to a grid of intervals. Using the statistical information, readings against these two axes are plotted to give points which are connected to form continuous lines.

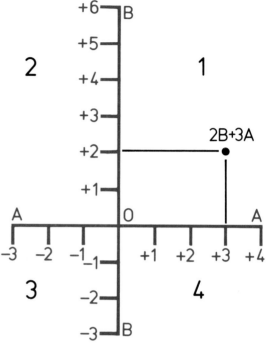

Axis and area

Axes (**A** and **B** *right*) normally cross at zero, producing four areas on which to plot the values, counting outward from the intersection. Each area contains differing ratios.
Area 1: (**A**) and (**B**) increase
Area 2: (**B**) increases and (**A**) decreases
Area 3: (**A**) and (**B**) decrease
Area 4: (**A**) increases and (**B**) decreases

Ratio of axes

The choice of a grid needs thought as differing ratios of the axes can produce different visual results. Sketch your ideas before beginning the construction. The nine charts (*right*) show the effects of ratio change.
A Vertical and horizontal equal
B Vertical normal, horizontal condensed
C Vertical normal, horizontal expanded
D Vertical condensed, horizontal normal
E Both condensed
F Vertical condensed, horizontal expanded
G Vertical expanded, horizontal normal
H Vertical expanded, horizontal condensed
I Both expanded

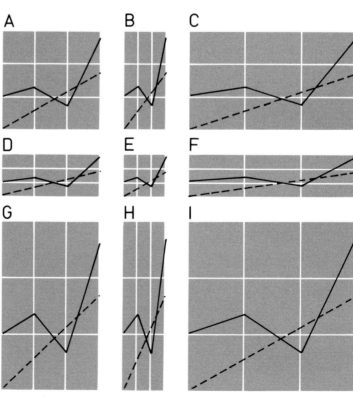

Selecting units
Care must be taken to select correct intervals and scales for the grid. The three examples (*above*) show three common defects:
A1 Regular values and irregular intervals
A2 Irregular values and regular intervals
A3 Irregular values and irregular intervals

Vertical scales
Normally graphs are plotted on regular vertical scales, but where the data have two different units a double scale can be used. The chart (**B**, *above*) uses two colors to differentiate between the scales.

Intervals
The vertical axis can be divided in three ways (*above*):
C1 by a regular scale beginning at zero;
C2 by a regular scale interrupted by a break;
C3 by a logarithmic progression in sequences.

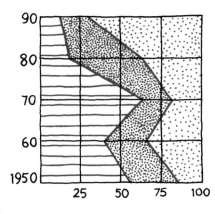

Orientation
Be careful when selecting which scale to put on the vertical and which on the horizontal; the resulting appearance is affected by your choice. Two charts (*left*) illustrate the same data with the two scales transposed.

©DIAGRAM

Curves and lines

The most important feature of a graph is the line, or lines, constructed by joining the points that have been plotted on the axes from the data. This is the message of the chart. A line graph provides two kinds of information: an impression of the changing progress of the data; and a source for retrieval of data on individual changes. Remember that the lines of any graph should always be dominant.

Joining by straight lines
Connecting the plotted points by straight lines creates a graph which shows the changes between the fixed points and nothing about the intermediate data (*left*). Such graphs are the most common form of chart.

Plotting points
Graph points are normally plotted so that the horizontal distance between each point is constant, but along the vertical scale the intervals between the fixed points varies according to the changing values of the data (*above*).

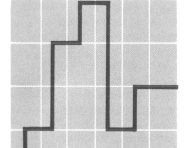

Joining by curved lines
A general impression of the progress of the statistics can be given by a graph in which a curved line connects the plotted data (*left*). The information will not be accurate enough to provide a source for precise reference.

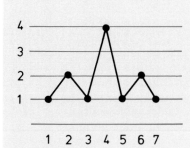

Joining by stepped lines
Linking each plotted point with a vertical and a horizontal line creates a stepped graph (*left*). The result is very similar to a bar chart (page 55). This technique avoids any possible misinterpretation of the values between the selected datum points.

Moving averages
Plotting moving averages can help to highlight trends when an irregular and erratic graph line obscures the main directions of the data. Add together groups of numbers and then divide by the number in the group. For example, the data for the graph (*above*) were replotted (*right*) using two-group, three-group and four-group average.

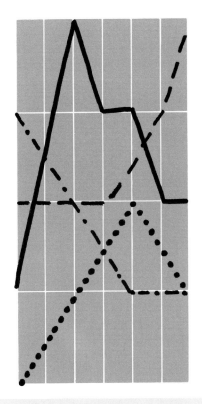

Graph lines

The essential qualities of a graph line are: cleanliness, accuracy, clarity, consistency, and in no way should they misrepresent the data.

Hand-drawn lines (*left*)

The simplest line is continuous. Great care must be taken with broken lines that the spaces and thickness are consistent, and it is important that the reader can see exactly where a line changes direction.

Mechanically produced lines (*right*)

The dry transfer method of applying preprinted lines offers the most accurate and clean result. There is a wide variety of line styles which can be applied with a roll-dispenser (see page 137).

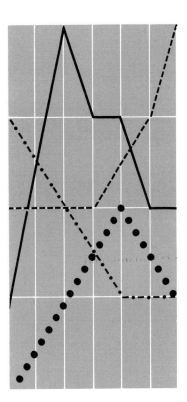

Two-group average

Three-group average

Four-group average

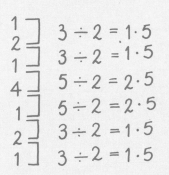

$$3 \div 2 = 1 \cdot 5$$
$$3 \div 2 = 1 \cdot 5$$
$$5 \div 2 = 2 \cdot 5$$
$$5 \div 2 = 2 \cdot 5$$
$$3 \div 2 = 1 \cdot 5$$
$$3 \div 2 = 1 \cdot 5$$

$$4 \div 3 = 1 \tfrac{1}{3}$$
$$7 \div 3 = 2 \tfrac{1}{3}$$
$$6 \div 3 = 2$$
$$7 \div 3 = 2 \tfrac{1}{3}$$
$$4 \div 3 = 1 \tfrac{1}{3}$$
$$7 \div 3 = 2 \tfrac{1}{3}$$

$$8 \div 4 = 2$$
$$8 \div 4 = 2$$
$$8 \div 4 = 2$$
$$8 \div 4 = 2$$
$$8 \div 4 = 2$$

Constructing your graph

Work out your graph in stages. Begin with the calculations, then do the general design, then plot the points and, finally, prepare the artwork. Never complete any element of a chart without having planned all the others. Work carefully and slowly to avoid accidents, and check and re-check at every step. Good graphics are clear, clean and tidy.

Stages
There are five major stages to producing finished artwork:
1 Calculating and constructing the grid
2 Plotting the data
3 Drawing the graph
4 Adding the annotation
5 Adding decorative details

Stages
1 Calculating and constructing the grid
- Horizontal scale (usually time): Check that the data has a full, sequential and regular series of numbers.
- Vertical scale (usually values): Check the range of values. If all are high numbers, consider a base value starting with the lowest. If there are sharp drops or rises in the values, consider devising a broad-based diagram.
- Do a simple sketch of the whole design to get an impression of the patterns created by the statistics.
- Select the proportions of your grid to fit within the available space.
- Estimate the area needed for annotation, adding the title, scales and source information.
- Construct the grid with sufficient intervals to let you plot the data.
- Draw the grid in pencil.
2 Plotting the data
- Plot the data as small dots or crosses. If there is more than one line, use different colored pencils.

- When complete, go through all the data **backward**, checking each dot or cross against your source.
3 Drawing the graph
- Ink in the connecting lines between the points using either hand-drawn lines or dry-transfer lines (see page 137).
4 Adding the annotation
- Draw in ink the two axes and the subdivisions on the scales.
- Add annotation to the scales (not all the divisions of which may need to be numbered).
- Keep the intervals on the final drawing simple and not congested with details.
- Add labels, titles, sources and other information by hand or other lettering techniques (see page 174).
5 Adding decorative details
- Color in important areas. If the artwork is for a printer, put in tones in accordance with his advice (see page 178).
- Add decorative elements, such as a symbol or picture, to indicate the subject.

2

3

4

%
100

80

60

40

20

0

1940 1960 1980
YEARS

5

%
100

80

60

40

20

0

1940 1960 1980
YEARS

Divided-area graphs

Charts which make use of the area between lines are useful to illustrate changes. The value of any one category is measured vertically up from the line beneath, and each area must be differentiated by tones or colors. Grids can either be drawn in very fine lines, or should be absent since a lot of linear information can be confusing. These charts are often difficult to label and may need a key.

1 Individual area graphs
All the separate graphs (*left*) have their own base lines. They are clear, there is no need to differentiate by using tones, but they give no general impressions of change.

2 Accumulated area graphs
The categories (*below*) are stacked one above the other, but the order may influence the visual impression. The same categories and values contained in both (**2A**) and (**2B**) are in example (**1**) but, because the order is different, impressions of the changes are different. Note band (**B**) in the three examples.

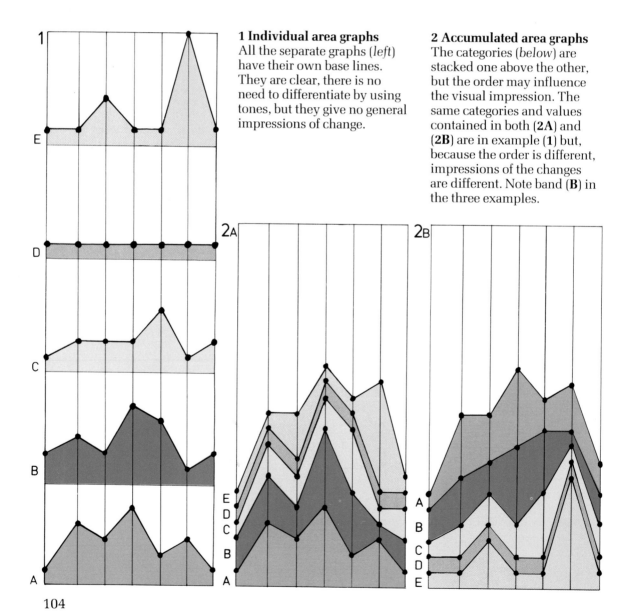

3 Divided 100% area graphs
The reading for the total depth of the graph (example **3**, *below*) is 100; each category value has been converted into a percentage. This graph is the result of converting the information in the example (**2** *opposite*). Note that in (**2B**) there is no change in the absolute values of the first two points on band (**E**), whereas in (**3**) a percentage drop is shown between the same points in the same band.

4 Deviation area graphs
Areas bounded by graph lines above and below a meridian are shaded (*below*). This method reveals variants in two directions (usually positive and negative) from a constant value.

5 Net-difference graphs
The shaded areas on the graph (*below*) emphasize the differences between two changing factors or values. With this method it is possible to use two separate colors to shade (**1**) those areas where the first factor is above the second, and (**2**) those areas where the second factor is above the first.

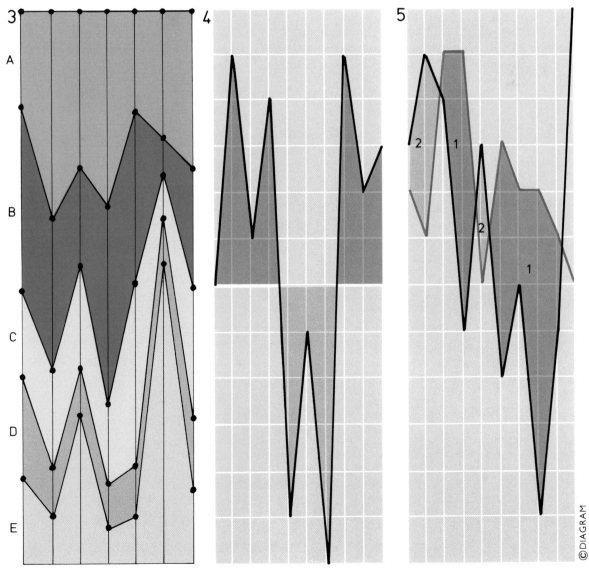

©DIAGRAM

Logarithmic graphs

Graphs are normally constructed on grids composed from scales in which the changes in values are in regular multiples. But for special purposes they can be plotted on grids whose scales show a percentage change which is expressed in logarithmic values. Care must be taken clearly to identify the units on each scale because otherwise the lines on the graph can be misinterpreted.

Grids
A grid is the projection of the interval boundaries on the two axes. The charts (*below*) show two types:
A a semi-logarithmic graph with one regular axis and one logarithmic axis; and
B a logarithmic graph with two logarithmic axes.

Logarithmic scales (*left*)
Printed log charts can be bought but you can construct your own.
1 Divide the maximum length into ten equal divisions (**A**).
2 Then divide an adjacent column (**B**) into similar intervals representing values of 0.1.
3 Use a log table to re-plot the logarithmic values on to column (**B**) and transfer these on to a new scale for your chart (**C**).

Advantages
- Good for showing rates of change
- Good for showing series with very different ranges
- Good for percentage change charts
- Good for showing relative, not absolute, changes

Disadvantages
- For use only by readers familiar with log charts
- To avoid ambiguity, scales must be clearly labeled
- Hard to construct without log chart or log tables
- No absolute zero level
- Hard to plot accurately small units in a cycle

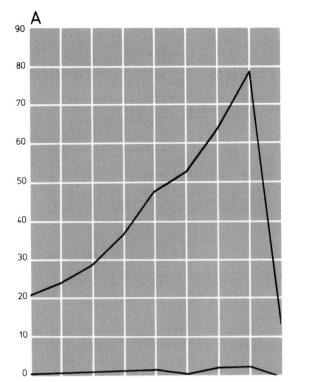

A

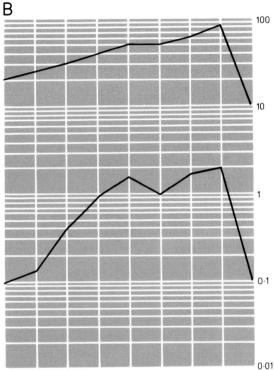

B

Comparative features

The same data appear (*above*) on a normal scale (**A**) and a log scale (**B**). Changes in lower values stand out more clearly on the log scale.

Rates of change (*right*) Normal scales (**A**) show a quantitative change; lines recording values which double (1-2, 2-4, 4-8) steepen as the values between each grow. The log scale (**B**) shows lines with the same changes at the same angle.

Unit values (*right*) Vertical distances on normal scales (**C**) are constant; the difference between 1-6 and 10-15 is the same. On log scales (**D**), these distances diminish as they advance on a cycle since the percentage difference of 10-15 is smaller than that of 1-6.

logarithmic graphs

The scale is a very important feature of a logarithmic chart since what you choose greatly influences the directions of the lines. You may either select part of a scale or produce a series of scales (cycles). Because they are the result of multiplying a value, they cannot include zero, so must start from some factor like 10 or 1. If small units are required, they can descend at intervals of 0.1, 0.001, 0.0001 etc. to infinity.

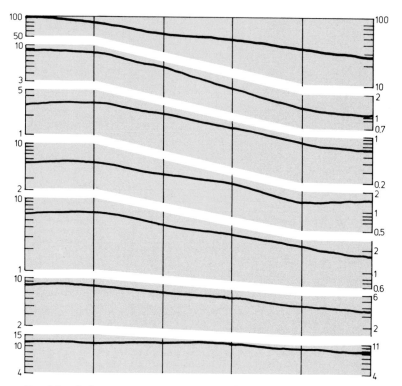

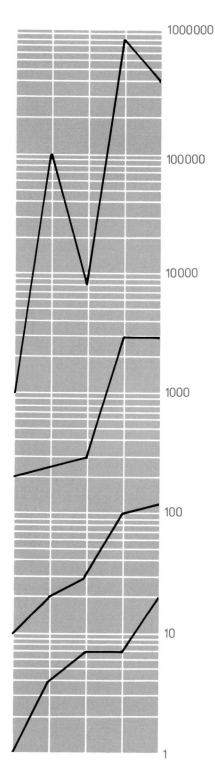

Combined charts
Because a log scale does not begin at zero, and because the lines show rates of change, it is possible to combine groups of log scales so that the reader can compare changes, but not values (*above*).

Cycles
Log scales progress upward by multiplication and downward by division, rather than by addition and subtraction. So a huge range of values can be plotted by repeating the scale in cycles. The chart (*right*) has six cycles and a range of one million units.

Making cycles
The intervals on a log scale can be produced by direct transfer from existing scales (*above* **A**) as shown in the method on page 160. Use the same means to produce cycles (**B**).

Rates of change (*right*)
The angles of the lines on a logarithmic grid show the rates of change in values:
A increasing at decreasing rates;
B increasing at uniform rates;
C increasing at increasing rates;
D neither increasing nor decreasing;
E decreasing at increasing rates;
F decreasing at uniform rates;
G decreasing at decreasing rates.

© DIAGRAM

Radial graphs

The means of constructing and plotting data on a radial and a rectangular graph are similar; but the latter's vertical intervals are scaled on the radius and its horizontal intervals on the circumference of the radial graph. Values are normally measured from the center of the circle. But the result is harder to read: in the example (*right*) it is not clear that values at 2 and 3 are nearly as large as that in sector 14.

Plotting
Using printed circular graph paper avoids time-consuming construction work. Plot the points around the circumference (*right* **A**) at regular intervals, reading in a clockwise direction. Plot the values from the center point (**B**).

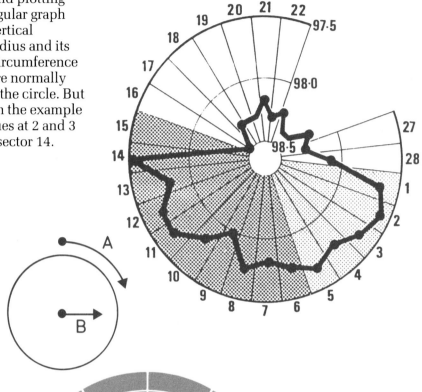

Visual distortion
Charts (**A** *left*) and (**B** *above*) were produced from the same information. The rectangular graph (**A**) shows marked increases in the values in the central group of intervals. In the circular graph (**B**), this is not so apparent.

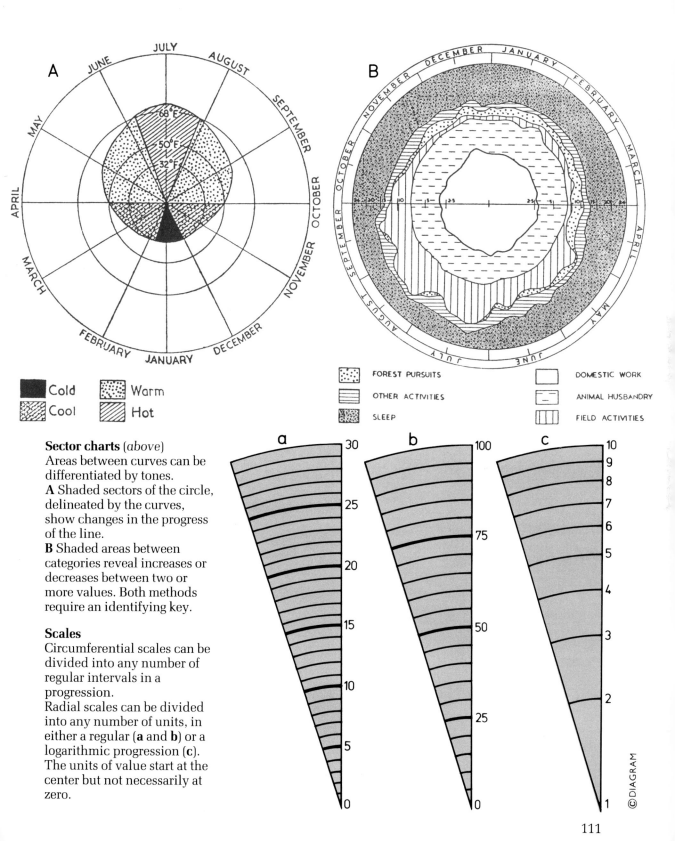

A

JULY • AUGUST • SEPTEMBER • OCTOBER • NOVEMBER • DECEMBER • JANUARY • FEBRUARY • MARCH • APRIL • MAY • JUNE

68°F
50°F
32°F

B

DECEMBER • JANUARY • FEBRUARY • MARCH • APRIL • MAY • JUNE • JULY • AUGUST • SEPTEMBER • OCTOBER • NOVEMBER

■ Cold ▨ Warm
▨ Cool ▨ Hot

⬚ FOREST PURSUITS ▭ DOMESTIC WORK
▤ OTHER ACTIVITIES ▭ ANIMAL HUSBANDRY
▨ SLEEP ▥ FIELD ACTIVITIES

Sector charts (*above*)
Areas between curves can be differentiated by tones.
A Shaded sectors of the circle, delineated by the curves, show changes in the progress of the line.
B Shaded areas between categories reveal increases or decreases between two or more values. Both methods require an identifying key.

Scales
Circumferential scales can be divided into any number of regular intervals in a progression.
Radial scales can be divided into any number of units, in either a regular (**a** and **b**) or a logarithmic progression (**c**). The units of value start at the center but not necessarily at zero.

a — 30, 25, 20, 15, 10, 5, 0

b — 100, 75, 50, 25, 0

c — 10, 9, 8, 7, 6, 5, 4, 3, 2, 1

©DIAGRAM

111

Graphs in space

When you want to present information in the form of a three-dimensional chart, you should ask yourself "Why?" Almost all solutions involve a degree of distortion, so be careful to select a view which portrays the data honestly. Three-dimensional charts are visually more exciting than flat, rectangular shapes, but they should be used only to enhance the subject, and not lead to confusion.

Stepped solutions
A group of graphs on a common projection allows each to be shown independently and the group collectively (*right*). Both scales on all the charts must be the same so that the relationships can be properly compared. Ranking the graphs avoids excessive overlapping.

Flat overlap
The simplest form of three-dimensional chart is a group of two-dimensional graphs that overlap (*left*). It can incorporate data with different unit scales (on the vertical axis) but with the same horizontal scale. Be careful the overlapping does not obscure the graphs.

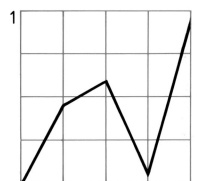

Stepping into space

A simple graph (*above*) may be displayed in a variety of three-dimensional forms. Flat graphs can be drawn on a receding plane (*above right*), or as solid objects with background supports (*right*). All the nine examples on this page use the same data but each point of view reveals a new aspect of it. Whatever view you choose, be sure to include scales to both axes so that the reader can assess the changes.

1 Normal flat plotted graph.

2 Graph receding from the first point.

3 Graph receding from the last point.

4 Extended graph viewed from the right side.

5 Extended graph viewed from the left side.

6 Graph in a horizontal receding position.

7 The same view as **6** but plotted in reverse.

8 Graph plotted on a receding surface.

9 The same view as **8** but plotted in reverse.

113

Three-dimensional graphs

The graphs on these two pages show the results of combining two series of graphs set at right angles to each other. Both series were produced from calculations plotted against three axes. The most popular form places values on the vertical axis and time and one other factor on the two horizontal axes.

Three-dimensional model
The chart (*right*) was drawn in 1879 to show the changing features of the Swedish population. The horizontal axis shows years, the receding axis ages of the population and the vertical scale numbers of people.

Plotting three-dimensional graphs
The three axes (*left*), horizontal (**A** and **C**) and vertical (**B**), were used in the construction of the charts (*above*).
1 This results from drawing a number of graphs parallel to the front horizontal axis (**C**).

2 Results from graphs drawn parallel from the side horizontal axis (**A**).
3 Results from plotting all points as in the previous graphs but joining them to each other along both horizontal axes to produce an undulating net of crossing lines.

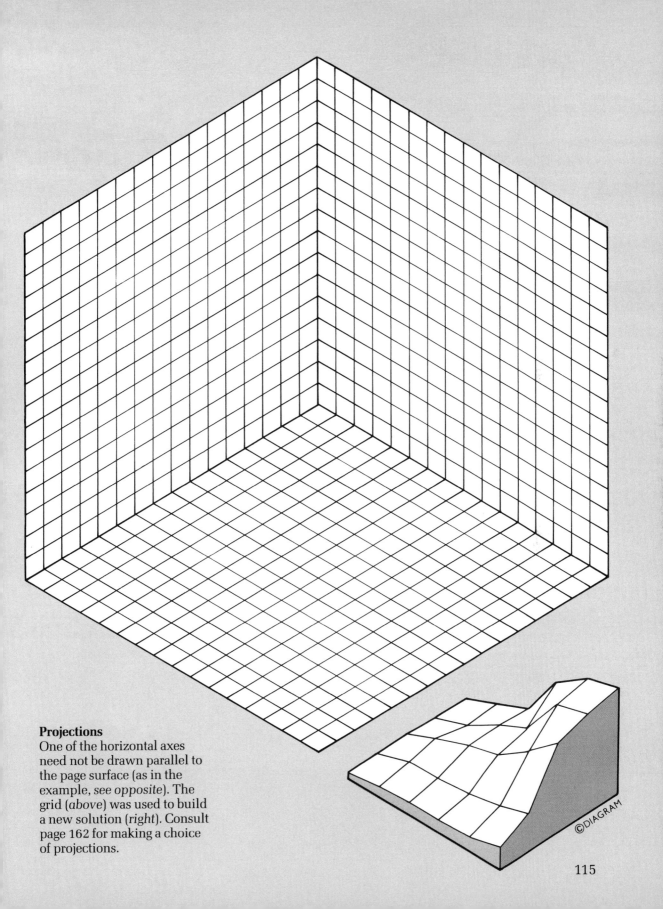

Projections
One of the horizontal axes
need not be drawn parallel to
the page surface (as in the
example, *see opposite*). The
grid (*above*) was used to build
a new solution (*right*). Consult
page 162 for making a choice
of projections.

©DIAGRAM

115

Part Five

MAPS

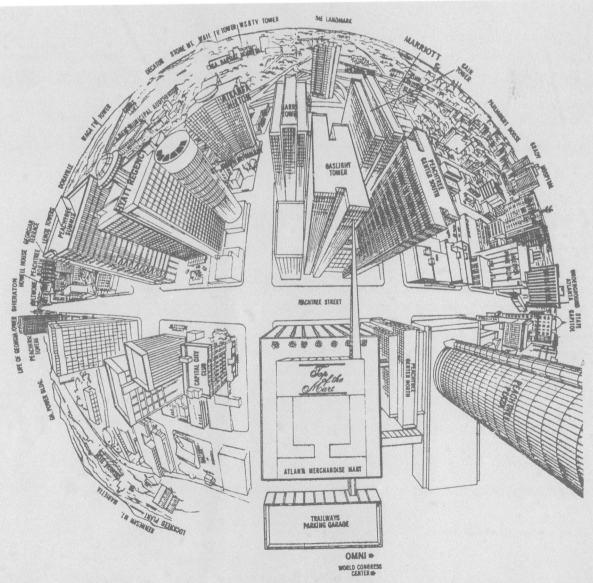

Maps as charts

The next 28 pages show you how you can adapt traditional sources of cartography (the art of making maps) for devising your own charts. Cartographic presentations of the world's surface features vary a great deal, and for normal purposes you don't need the complex information set out in an atlas. But some knowledge of the main types of map projection can be very useful. Remember that good charts always tell a story. They reveal the relevant facts about a situation much more clearly than words or statistics. So simplify your basic source material to put across your main points. Distort the map to expose the message.

Cartography
The map section (*right*) is a storehouse of useful information. It contains a mass of tiny details about many different features of the physical world, both natural and manmade.

- ● 200,000 cattle.
- ◐ 150,000 to 200,000 cattle.
- ◑ 100,000 to 150,000 cattle.
- ◔ 50,000 to 100,000 cattle.
- ○ Less than 50,000 cattle.

The heavy lines (━) show geographic divisions.

Charts not maps
The three charts (*above* and *right*) summarize a variety of statistical information about the United States. Each tells a different story and each omits all unnecessary details. Since natural and manmade features are irrelevant, no mountains, cities, roads, or railroads appear.

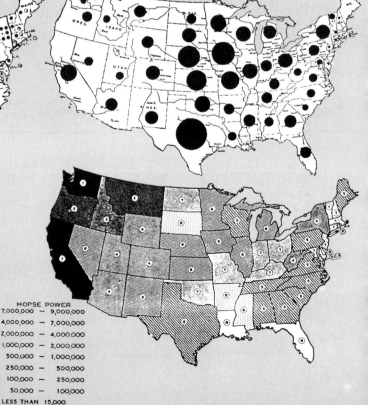

HORSE POWER

- ① 7,000,000 — 9,000,000
- ② 4,000,000 — 7,000,000
- ③ 2,000,000 — 4,000,000
- ④ 1,000,000 — 2,000,000
- ⑤ 500,000 — 1,000,000
- ⑥ 250,000 — 500,000
- ⑦ 100,000 — 250,000
- ⑧ 50,000 — 100,000
- ⑨ LESS THAN 15,000

Flat-earth theories

The world is a sphere and maps are flat. Therefore all maps of the world are distortions of reality. To overcome the problem of representing the curved surface of the earth on the flat area of a map, cartographers use a variety of different projections. For example, the chart on the right plots spatial relationships from a single viewpoint – the north pole. This topological trick creates a world in which the south pole, in reality only a point, is spread around the edge.

Block-built worlds

Designers find it useful to convert the irregular areas of the world to regular shapes. Working to a structure unifies the presentation. The chart (right) redraws a familiar cartographic projection by changing outline edges to lines drawn vertically or horizontally.

Using the familiar

The chart (right) is taken from an Indian publication of 1940 advocating independence from European imperialism. Placing the various countries against the background of the Indian subcontinent gives a clear idea of the relative sizes involved. Note that the size of Great Britain (**A**) in relation to France (**B**) is exaggerated – the true comparative sizes are shown on the far right.

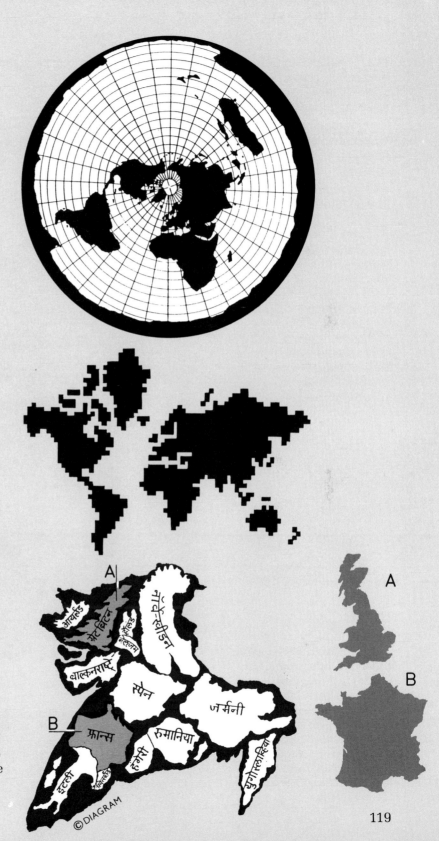

119

Storytelling

Charts can use maps for a variety of purposes. The real world can be adapted to reveal the main idea of the chart. But before you begin devising a map, consider the end result you're after. Decide what you wish to say, and use the resources of cartography to say it. Charts can tell a story, show relationships, plot general or specific data, even stand the world on its head if necessary.

Describing reality
The chart below, drawn by a Frenchman, depicts the main features of the north–south highway through Paris. Scale, sizes, details, and features are all incorrect – but the result is clear and easy to understand. Set out in this way, the realities of the situation make much more sense.

Telling stories
The two charts (*above right*) show very clearly the ability of designers to edit the information at their disposal. Your chart is what you want it to be. Whatever is important can be included but whatever is irrelevant or confusing should go. The upper chart depicts the German and (subsequent) Russian invasions of Poland in 1939 – simple broad lines thrusting across the country from west and east.

The lower map, however, was made by a Chinese copyist in the 1960s. Not wishing to explain the presence of an invading Communist nation, he omitted the right-hand arrows from his version. This is chartmaking at its simplest – not so much lying as not telling the truth.

Remember, you can always edit out what you don't wish the reader to know.

德國突襲波蘭的進軍路綫圖

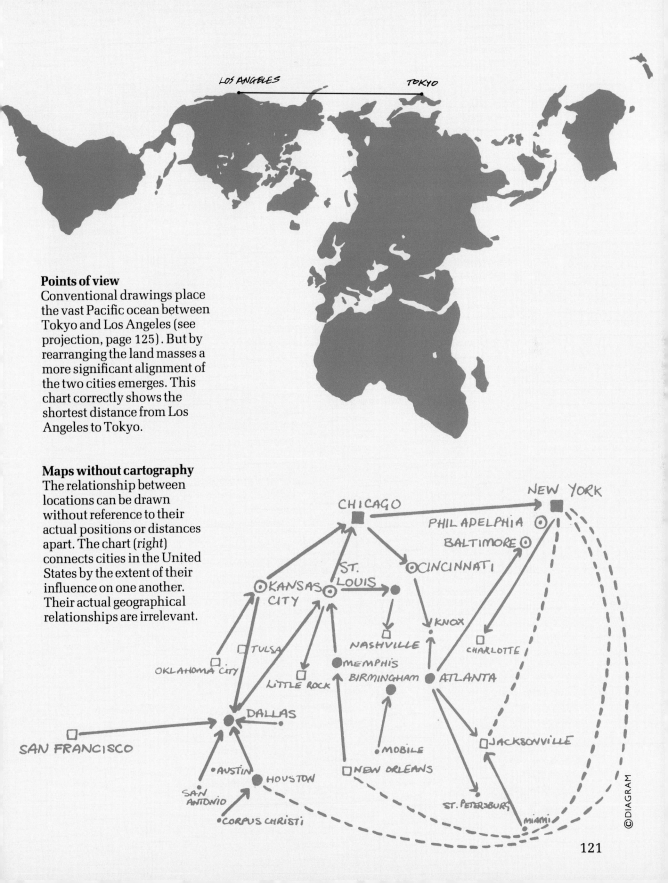

LOS ANGELES — TOKYO

Points of view
Conventional drawings place
the vast Pacific ocean between
Tokyo and Los Angeles (see
projection, page 125). But by
rearranging the land masses a
more significant alignment of
the two cities emerges. This
chart correctly shows the
shortest distance from Los
Angeles to Tokyo.

Maps without cartography
The relationship between
locations can be drawn
without reference to their
actual positions or distances
apart. The chart (right)
connects cities in the United
States by the extent of their
influence on one another.
Their actual geographical
relationships are irrelevant.

NEW YORK
CHICAGO
PHILADELPHIA
BALTIMORE
CINCINNATI
ST. LOUIS
KANSAS CITY
KNOX
TULSA
NASHVILLE
CHARLOTTE
OKLAHOMA CITY
MEMPHIS
LITTLE ROCK
BIRMINGHAM
ATLANTA
DALLAS
SAN FRANCISCO
JACKSONVILLE
AUSTIN
MOBILE
SAN ANTONIO
HOUSTON
NEW ORLEANS
CORPUS CHRISTI
ST. PETERSBURG
MIAMI

©DIAGRAM

121

Map projections

Because the earth is a sphere, its curved surface cannot be depicted with total accuracy on the flat surface of a map. So we have to devise some system – called projection – of converting the convex surface to a plane one. A projection of the earth has three possible properties (although only two can be maintained in the same map):

1 Distances between points are an accurate ratio of their physical location.

2 Areas of surfaces are an accurate scaled reduction.

3 Shapes around areas are correctly depicted.

Cartographers have access to a wide variety of map projections, and a collection of atlases will soon reveal their advantages and disadvantages.

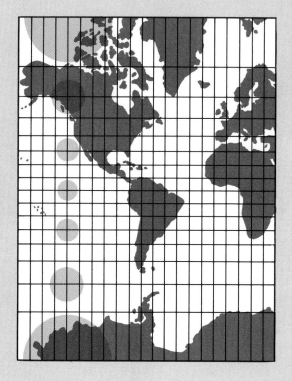

Distortion
The Mercator projection (detail above right) is the most common, but contains a very serious distortion. The circles on the chart represent equal areas but on this projection show great distortions toward the north and south.

Methods of projection
There are four main types of projection. Each is a compromise, offering a solution whose features are the result of the method used. For normal chart design, you need not construct your map by a projection method, but knowing the qualities peculiar to each helps you evaluate their aptness.

1 Azimuthal or zenithal
The earth's surface is projected onto a flat surface. This method produces increasing distortion toward the outer edges.

2 Cylindrical
The earth's surface is projected onto a cylinder, which is then unrolled.

3 Conical
Part of the earth's surface is projected onto a cone-shaped surface, which is then unfolded.

4 Mathematical or calculated
Used for world maps whose design results from plotting information onto a grid. These projections are very varied, but produce features that are often unfamiliar.

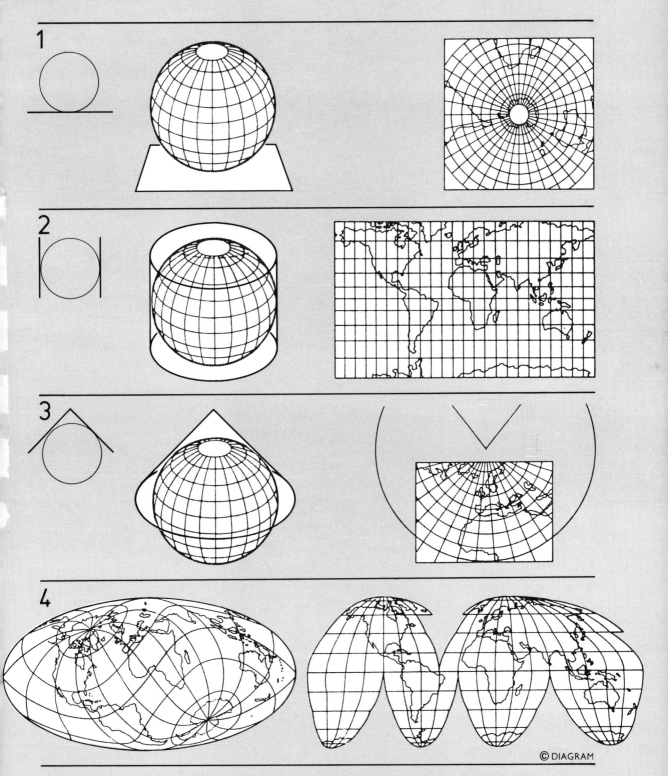

Global view

Very often a simple drawing of a globe, with the relevant land surface facing the reader, can be more effective than a map projection. Constructing such a view is simply a matter of transferring the shapes from any flat projection onto a drawing of a hemisphere.

Transferring the information
Using a world map, transfer the network of lines from a flat projection to a global one. Both must have a common structure of vertical and horizontal lines, and spaces must cover the same number of degrees. The projection (*right*) and three views (*below*) have 15° intervals.

Selecting your view (*below*)
Place the important areas of your map in the central area of the globe, matching a vertical central line with one in middle area of the relevant land masses on the flat projection.

Distortions (*opposite*)
Transferring information within the squares produces distortions, as shapes curve away. This suggests the illusion of spherical surfaces.

Selected view
North America placed in the center of the view (*left*) helps you judge its true area against the curvature of the earth.

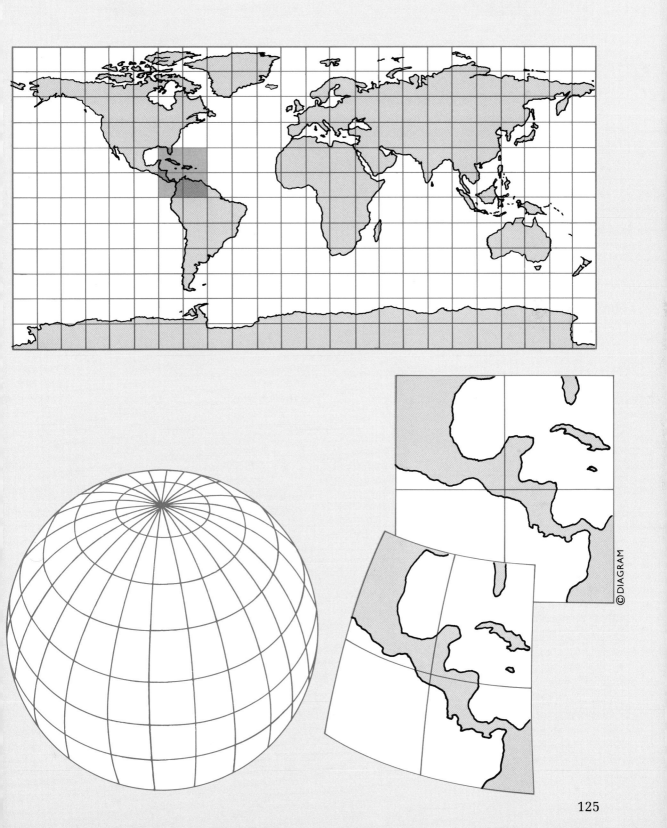

Simplifying maps

Maps used as charts do not need fine cartographic detail. Their purpose is to express ideas, explain relationships, or store data for consultation. Keep your maps simple. Edit out irrelevant detail. Without distortion, try to present the facts as the main feature of your map, which should serve only as a springboard for the idea you're trying to put across.

Simplifying maps
Detailed information on coastlines is seldom needed for a map designed to be used as a chart. Edit out irrelevant detail and concentrate on illustrating the essential message.

Our view of places
In this map of New York's Manhattan Island (*right*), which shows north at the top, Grant's Tomb (**A**) is correctly shown to be farther east than the U.N. Building (**B**). But in the more convenient version (*opposite*), where north is not at the top, the Tomb appears to be on the west.

Mastering shapes
Few basic projections fall within copyright, but publishers do copyright the information placed on their maps. One simple way to get hold of the basic shape of a map is to overlay your chosen source with transparent gridded paper. Then, on an additional overlay draw the outline as an interpretation of the gridded structure. The two sketch maps (*right*) were devised by this technique.

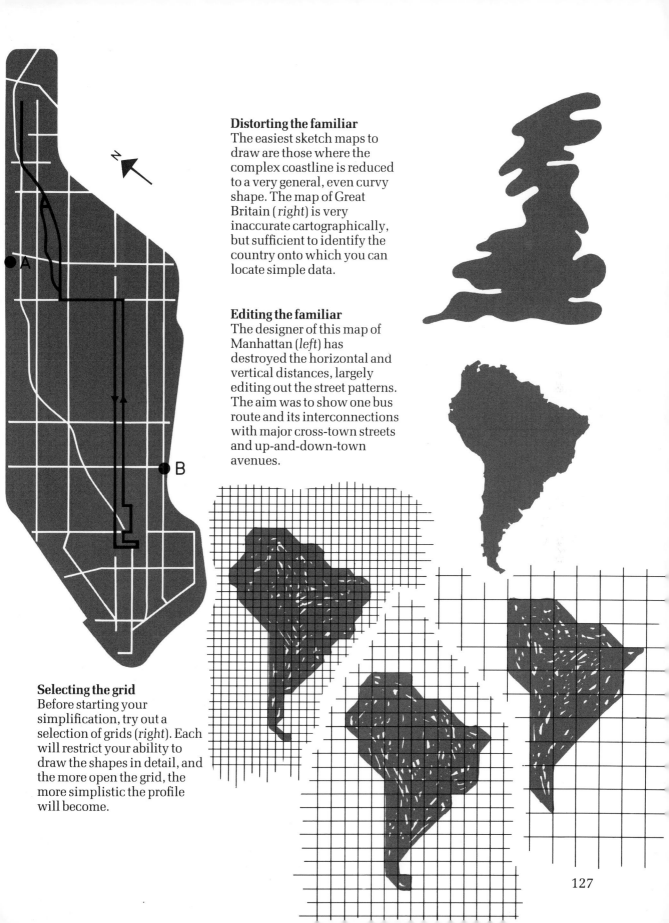

Distorting the familiar
The easiest sketch maps to draw are those where the complex coastline is reduced to a very general, even curvy shape. The map of Great Britain (*right*) is very inaccurate cartographically, but sufficient to identify the country onto which you can locate simple data.

Editing the familiar
The designer of this map of Manhattan (*left*) has destroyed the horizontal and vertical distances, largely editing out the street patterns. The aim was to show one bus route and its interconnections with major cross-town streets and up-and-down-town avenues.

Selecting the grid
Before starting your simplification, try out a selection of grids (*right*). Each will restrict your ability to draw the shapes in detail, and the more open the grid, the more simplistic the profile will become.

127

Tones and textures on maps

Covering a map with a range of tones, colors, or textures – to indicate variations in values or features – can be difficult. The method of distinguishing changes depends on several factors. These include the means of preparing the artwork, size of detail, drawing techniques available, and the use of the artwork. Before starting final artwork, test your technique on a small sample.

Differentiation
The two charts (right) use the same technique of applying dry transfer textures to distinguish different features.
1 This shows the degrees of one activity.
2 Location of a number of different activities.

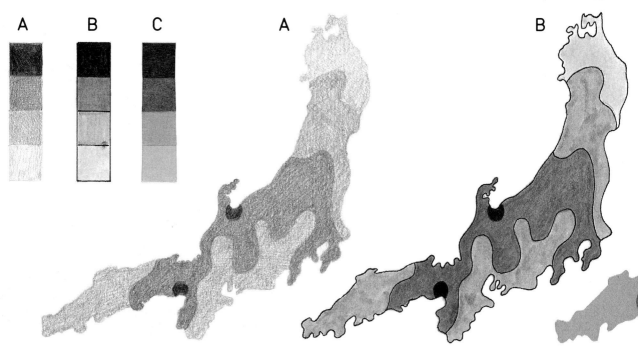

2

Vegetation

Hochgebirge
Wüsten
Trockensteppen
Busch- u. Grassteppen
Trockenwälder
Savannen
Hartlaubgehölze
Laub- u. Nadelwald
Tropischer Urwald
viel Feld- und
Plantagenwirtschaft

0 500 1000 2000
km

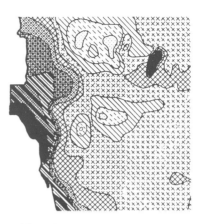

	0 - 10
	10 - 20
	20 - 30
	30 - 40
	40 - 50
	50 - 60
	60 - 70
	70 - 80
	80 - 90
	90 - 100

Range

Distinguishing a range of values is achieved by filling areas between "isolines" with a flat tone. All points on an isoline line have equal value, while the intervening area has values between the two. Normally, darker tones indicate high values, lighter tones low values.

Hand-laid tone

Before coloring in areas, test the range of values so that your key can have clearly distinguishable tonal strengths. This is essential if the design is to be reproduced. Once away from the key, it may be difficult to make out differences between tones of similar value.

Working in pencil (A)

Use strong paper with a good surface grain. Build up each area slowly, rubbing pencil carefully over it to ensure an even texture.

Working in paint (B)

Using thick paper draw the coastline and the boundaries between tones in strong pencil or ink. Mix enough ink or paint to apply each value over all the necessary areas and on the key. Work from lightest to the darkest colors.

Using colored paper (C)

Possible only when shapes are simple, with no complex interlocking elements. To achieve a flat abutment, cut through the two adjacent colored papers, remove surplus, and interlock the results.

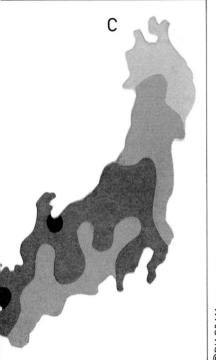

C

©DIAGRAM

Tones and textures

There is a variety of methods of preparing tonal charts for publication. Before beginning a method you must discuss with your printer how he would prefer the artwork. Some methods may be easier to do, but will prove costly for the printer to originate. Try to see other printed work prepared by the same method as the one you intend to use.

Dry transfer methods (*right*)
This means applying textures by cutting out individual areas of a preprinted plastic sheet and sticking them onto a key-line drawing. The technique and possible disadvantages are explained on pages 164–165.

Spraying (*right*)
For this technique you need to have experience of using an airbrush. This is an implement that sprays a fine layer of paint onto the surface of your drawing. You first cover the surface with an adhesive clear plastic, then cut away the areas you wish to spray. Normally the tones are applied by starting with the lightest and building up to the darkest.

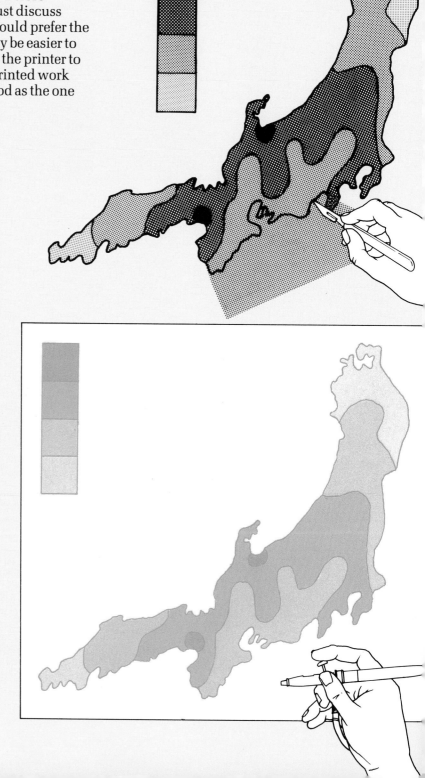

Overlays (*below*)
First draw a base map. Then on a series of plastic film overlays mask (fill in) the areas of each value with opaque plastic or ink. No two values must be adjacent, although additional values can be achieved by masking the same area on two overlays and producing an overprinting of two areas.

Indicating tones (*right*)
If the printer agrees, you can simply draw the outlines and indicate in blue pencil or on an overlay the value of tones to be inserted photographically. The method is easy to do but costly to originate. Very often too it allows the opportunity for errors in placing the correct tones.

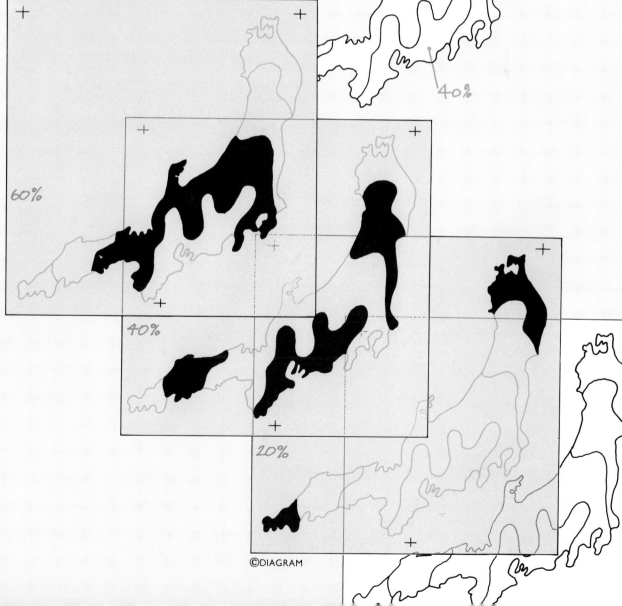

©DIAGRAM

Locating points

Maps containing marks that indicate a variety of features at specific locations are easy to produce and often revealing for the reader. You can use dots, numbers, and shapes, with or without keys. The basic map must always be simple and devoid of unnecessary detail. There should be no ambiguity about what happens where. The six maps below show a number of different methods of plotting information.

Local knowledge
The chart (*right*) shows the sympathies of Vietnamese villages during the Vietnam war. It is based on surveys made by American army intelligence. Each gradation has a different alphabetic letter. Such maps were revised every week, so a computer-print technique was used to plot the information.

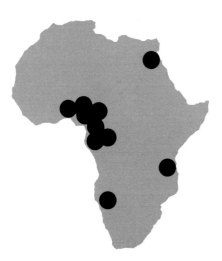

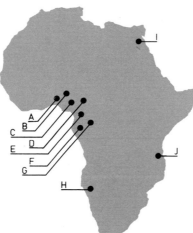

Methods of identification

1 Location by dot
Easy to draw but produces crowding if dots are too big. No key needed – they offer an impression of the overall pattern of activities.

2 Keying the dots
The dots are connected by fine lines to letters, words, or numbers. This requires careful organization to avoid tangled link lines.

3 Symbols
Each symbol represents a different activity at a particular location. They can be hand drawn, dry transfer, or photoprints.

Factors to consider
Before choosing a method of producing the chart, you need to ask a number of questions about the procedures involved. If possible, sketch a solution at the required final size. This helps to reveal major problems of congestion and identification before you start on the chart itself.

- What is the purpose of the map? To show general distribution or to serve as a retrieval store for the reader?
- How do you "make the chart"? (What drawing technique?)
- Is the map in the form of data or of edited cartographic sources?
- What will you do with the final artwork? Reproduce it? Make a slide? Put it on display?
- Who is the chart for? Can they understand specialized data?
- Do you have a method of accurately transferring the information onto another map?
- Do the locations need to be identified by name, either on the map or in a key?
- Does the information carry more than one factor? Is its value, type, frequency, or some other feature important?
- How do you apply the dots?
- Is there congestion? Would an enlarged detail of certain areas help?
- Can the map stand without labels? If not, how do you apply them?

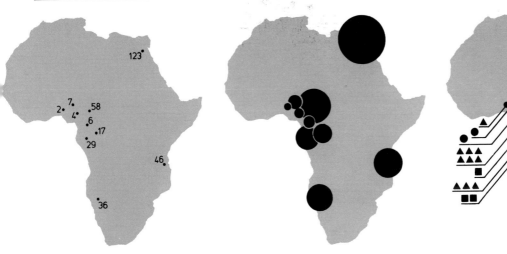

4 Dots and values
This involves evaluating each activity and placing a number alongside. It can be difficult with clusters.

5 Valuation dots
The size of each dot varies according to the value it represents. This can cause congestion and obscure the locations.

6 Symbol and value
A number of similar symbols are used to depict values. This can lead to congestion and often misrepresents the true areas of activity.

Adding values

Adding to a chart information about the quantities occurring at precise locations presents various problems. You need to be able to calculate the changing values of the shapes; and you need to be able to locate these on a chart without congestion or obscuring items. Most importantly you need to make it absolutely clear where the activities occur.

The charts (*below*) use three methods to portray the same information – squares, circles, and volumes. Each is intended for the same locations, so you can judge the problem of placing different shapes on the map. Each provides a key to the proportional increases to help you weigh up the value representation of the shapes.

Squares
Squares are the easiest to calculate and put on a map. But the reader may easily misinterpret their location. Do they indicate the exact point by their center, base, or corner? (To calculate squares use formula, page 76).

Scales
The three scales (*below*) provide an indication of the growth of values from ten upwards. Use them on your own charts because these ratios are constant for any chart. The nearby chart shows two values, **A**-10 and **E**-250, so you can judge the range of values by each method. Always include an accompanying scale.

Circles
These are harder to calculate (see p. 76 for formula). The center of each is usually the location of the activity. Circles are also harder to 'read' than squares, and working out the values of two circles of similar size can be difficult.

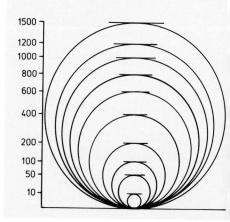

Segregation

The simplest and cleanest way of adding information is to put charts indicating value away from the map area and link the location with the value by lines. This allows space for labels and avoids congestion.

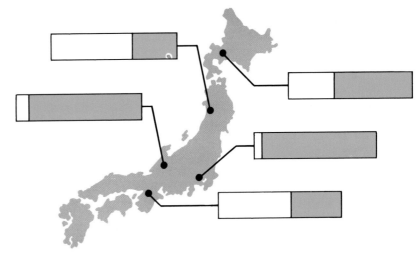

Spheres

These are a very complex way of representing values, and hard to calculate (see page 92 for formula). Spheres do not increase at the same visual ratio as circles, so larger ranges of values can be incorporated. This method can also create some doubt as to where the exact point of activity occurs. Is it at the center or on the base? Remember, spheres are very difficult to draw satisfactorily. Unless drawn well they can be mistaken for circles.

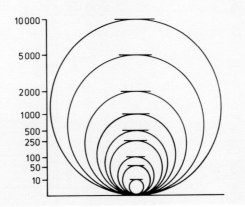

©DIAGRAM

Flow maps

Superimposing onto maps information about the movement of activities or about connections between points is a very common chart form. Lines connecting locations on a flow map must be shown as more important than the base map. These lines should stand out, either by strength of color, or by tone or thickness. When dealing with a number of different routes, choose conspicuously different lines.

Types of line
1 Following the natural course of the geographical features. The routes are usually thin and twist among the contours. Rivers, roads, and railroads form the main arteries of communication.
2 Superimposed grid. Each point is linked along a superimposed matrix, and the lines move toward their destinations vertically and horizontally.
3 Direct link. Straight lines run from origins to destinations.
4 Abstract. The real locations are abandoned and rearranged around the source. Thus an impression of a network is produced irrespective of actual distances and routes.

Technical drawing aids
To achieve a smooth line drawn by hand, use French curves (see page 154). Sections of the curve are drawn matching the edge of the template.

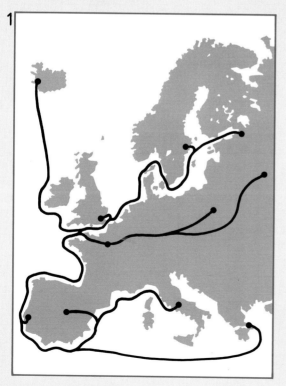

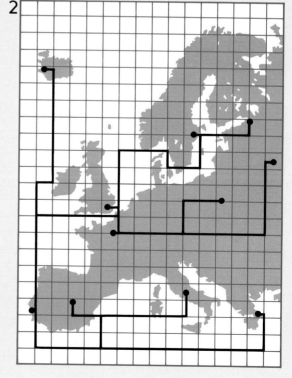

Hand-drawn lines

For most purposes designers use a technical pen, which produces a line of constant thickness. For other thicknesses you need other pens. These tools work better on smooth surfaces, because rough ones can cause the line to blotch. Try to draw lines of a consistent thickness.

Dry transfer lines

These are obtainable in rolls, which you then apply to your design with a plastic dispenser. The method guarantees an even thickness of line, but make sure you always select simple types.

3

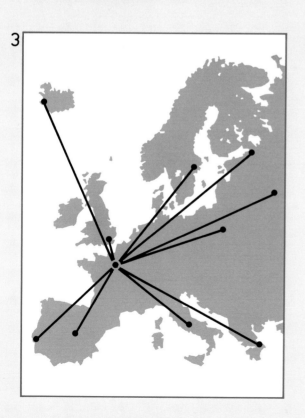

4

© DIAGRAM

flow maps

Before beginning the flow map, you must decide what is the main purpose of the chart. Do you wish to show actual links, generalized links, or quantitative carrying links? Can the routes appear without the map? What is the impression you want to create with the map?

Types of route
The chart (*right*) shows specific links influenced by the geographical features. The chart (*lower left*) shows generalized routes. The chart (*lower right*) shows quantitative amounts from each source and the cumulative value of all the routes. Thicker lines mean more traffic.

Routes without maps

The chart (*right*) shows the surface quality of roads in northern Germany. The various types of tone indicate cobblestones, concrete, bituminous, and other forms of road surface. The width of each route indicates the width of road. The chart uses two scales, one for distance and one for road width. During World War II this chart was extremely important because it indicated possible obstacles to the movement of heavy vehicles.

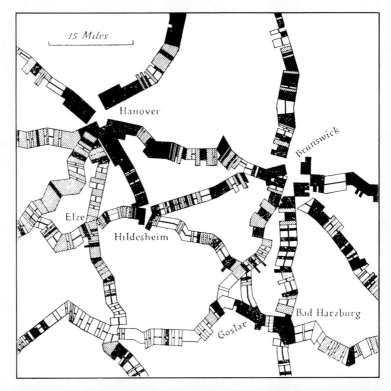

Abstract maps

The detail of the Tokyo subway system (*right*) shows the stations and routes for the central city area. Public-transport maps often abandon cartographic formalities and construct their relationships on a geometric grid. This technique allows the sequence of points on the route and the points of intersection to be correct, but not their actual distances apart or their relationships to other stations on other lines.

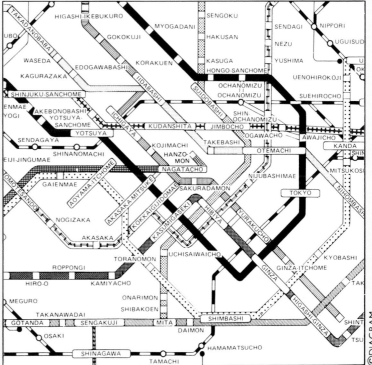

139

Adding three dimensions

Adding the appearance of the third dimension can greatly improve the look of a chart without necessarily introducing distortions or inaccuracies. The technique is easy to master and surprisingly successful at indicating solid and open areas where lines can easily be misinterpreted.

Building walls
Enhancing a building plan gives the walls a sense of depth.
1 Trace on an overlay the major room divisions.
2 Do a second tracing on the same overlay, redrawing the design at a displaced position.
3 Connect all corners, remove overlaps.
4 Thicken top edge and add shadows.

The same plan can be used to originate a variety of solutions (two examples *below*) by changing the position of the original plan when beginning the tracing.

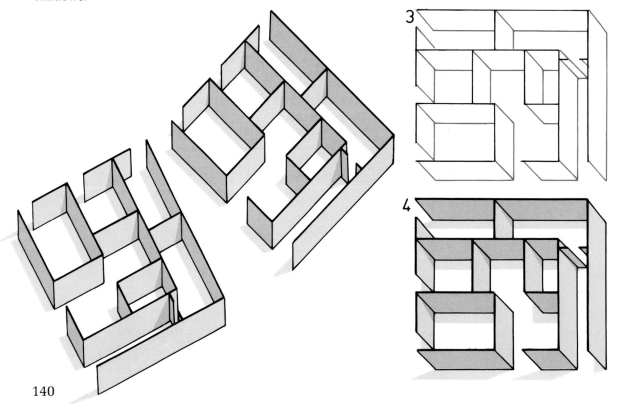

140

Map thickness

You can add interest to maps by thickening the coastline, without changing the projection.

1 Trace the original map onto an overlay.

2 Move overlay down by an amount equal to intended thickness and retrace.

3 Ink in exposed side of coastline and remove obscured side.

Three-dimensional links

Another way to make normal maps more interesting is to add leaping lines. This is achieved without any distortion to the map, but care must be taken not to cover the base information.

1 Using French curves (see pages 136–154), draw a curve between two points on the map.

2 Repeat the curve, setting the second line to the left or right by an amount representing the width of the line.

3 Repeat, lowering the curve to represent the thickness.

4 Construct arrows on the ends to indicate directions.

5 Add shadows to help create the illusion of space.

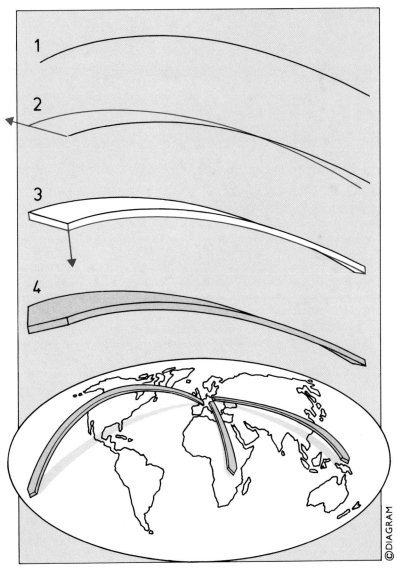

Changing the viewpoint

Presenting maps from other than a flat plan view can offer exciting ways of depicting information. Converting a map is a relatively simple task but placing information on the new projection requires you to consider dangers of congestion and problems of identification.

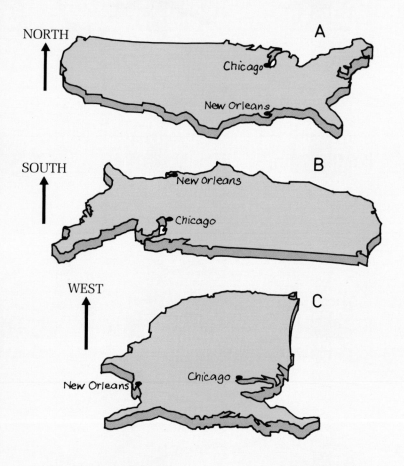

NORTH

Chicago
New Orleans

A

SOUTH

New Orleans
Chicago

B

WEST

New Orleans
Chicago

C

Plotting the chart
1 Begin by selecting a simple outline map of the area you require.
2 Superimpose a grid of regular squares, numbering the base squares A, B, C throughout and the side squares 1, 2, 3, etc.
3 Draw the front edge of the new view as a line of similar length to the length of the grid and then project back the grid using either one point or two point perspective.
4 The new recessional grid can then be used to plot the outline of the map in its new view.
5 If vertical values are to be added, select a scale which comfortably allows the longest and smallest values to fit well on the chart.
6 Place each bar on the point where they occur.

Problems
● Locating bars in a clustered area, which obscures them or their place or origin
● Having bars with too wide a range of values
● Including too many values and presenting a forest of bars
● Identifying the bars for the accompanying key

Exploring views
Once the method of conversion has been mastered, then you can vary the viewpoint to explore changing effects of presentation.

A Looking north
B Looking south
C Looking west

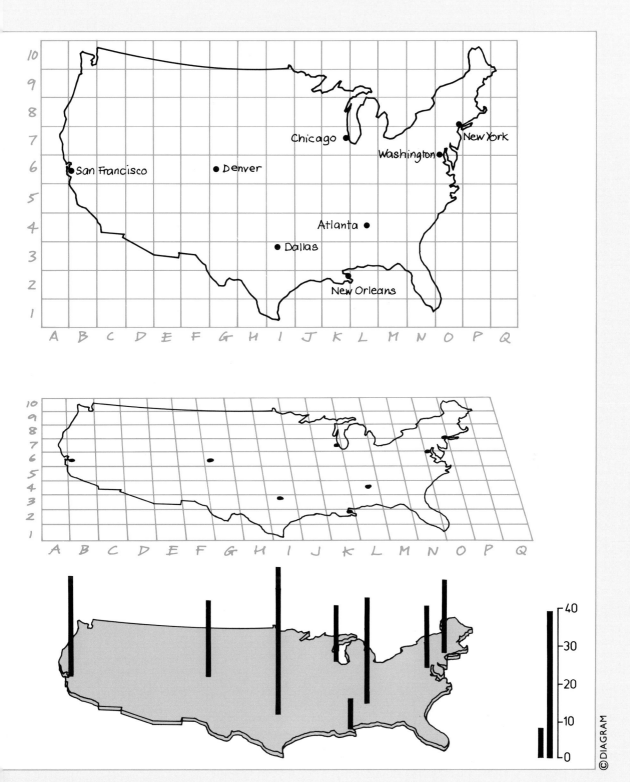

143

Three-dimensional maps

Three-dimensional maps have become more available with the use of computer graphics. Making your own 3-D maps can take time, however, and the results often obscure the information you wish to put across. All the same, the effort required to produce a 3-D map can be well worth it if the end result produces a spectacular and memorable solution.

Networks
These denote the criss-crossing of a series of lines that undulate in accordance with the information they describe (*above*).

Stepped relief
Drawing of New York (*above right*) depicts rentable value of offices. The taller the area, the higher the rent.

Constructing stepped relief
You can make a stepped relief map by using an original source where the values are described by lines, or "isolines", encircling areas of equal value.
1 Mark a scale representing heights of steps.
2 Mark on overlay a point against one of the intervals, copy outline of highest area.

3 Move overlay up one interval and trace same area in new position, linking the sides and removing parts obscured by the step. Trace the second area.
4 Move the overlay up one interval, repeat the procedure.
5 and 6 Continue till you've drawn all the levels.

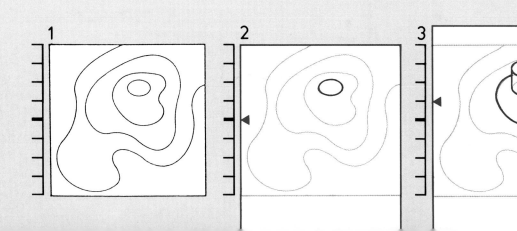

Profile relief

Using "isoline" map (*right*) you can make a series of sections revealing features of the relief.

1 Draw horizontal lines on an overlay to represent the increasing heights of values. Place map under overlay and project upward verticals at points where edges meet. The interception of isoline values and similar horizontal values produces points that reveal, when connected, the profile of the section.

2 and 3 Repeat procedure for a selection of sections.
4 Redraw these sections in sequence at a regular recession projection (*above right*).

The resulting series of sections reveals the configuration of the surface of the isoline map.

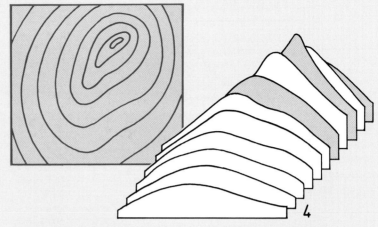

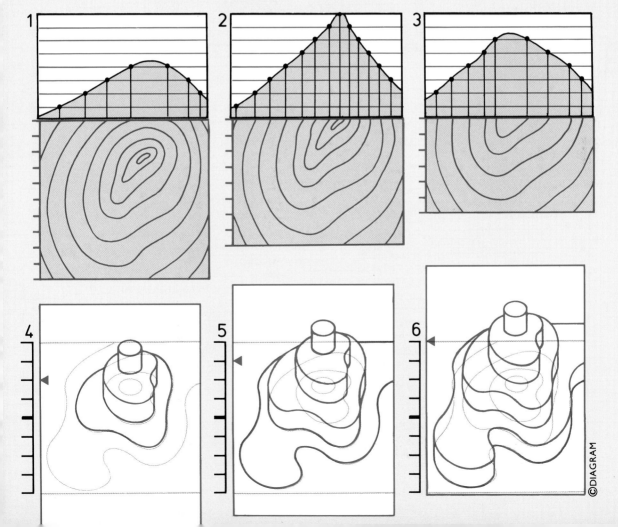

©DIAGRAM

Distorted maps

The real shape of a country remains virtually constant. Only from unusual projections do you get variants of the normally recognizable shapes. Playing with the shapes to form charts that represent particular relationships but retain an element of the original features is often more fun than useful. Evaluating differing-sized shapes is difficult if the shapes themselves are different.

Types of distortion
The four charts on these pages have been constructed by applying different methods of distortion. To help compare the results against the normal cartographic shapes, three places have been identified on each chart and its accompanying key map.

Building blocks
The chart (top right) builds up the shape of France by allocating to each province a number of dots equal to representing how many members it has in government.

Area equals number
Normal divisions on a map represent areas of surface. The chart (right) tries to retain the boundaries of the United States, but shows their size in proportion to population. So New York, a small state with a large population, appears bigger than Texas, a huge state with a small population. These two techniques are useful if you can manage to retain an approximate resemblance to the original shapes.

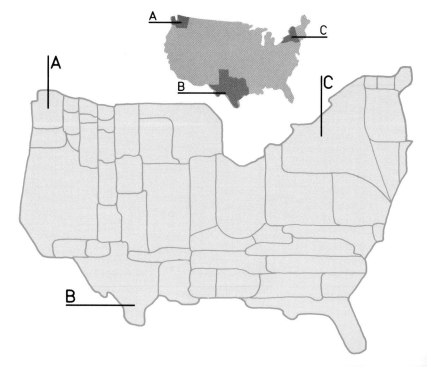

Time equals distance

The chart of the British Isles (*above*) shows how long it takes to travel by public transport from London to the coast. Each circle represents one hour's travel. Thus Holyhead (**A**) is nearer in miles to London than either Sunderland (**B**) or Inverness (**C**), but farther away in traveling time.

Area equals value

The national boundaries of the countries of South America are considerably distorted in the three maps (*below*) in order to represent a number of differing relationships. Each map shows how individual land areas can be enlarged or

reduced to express particular statistics. Comparison with the key map shows just how striking this form of distortion may become.

Part Six

PRODUCING YOUR CHART

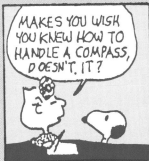

Your work area

If you plan to produce charts, diagrams, or maps, or similar graphic material on a long-term basis, then consider creating a working space where you can concentrate and keep all your materials and tools.

Some useful points to follow:
- Light should fall from the front or left (if you are right handed)
- Choose a comfortable, adjustable chair, preferably of the swivel type
- Choose a solid, flat desk or table with space for a drawing board and tools

- Buy sound, serviceable equipment, not necessarily expensive, but avoid cheap, poor tools, which will not last
- Use space efficiently. Equipment must be within easy reach and returned to its proper place after use. Organize tool containers and label them. Don't allow clutter to build up
- Keep your drawing-board surface protected and clean
- Keep equipment in good condition. Clean tools often, store them properly and discard old unusable ones

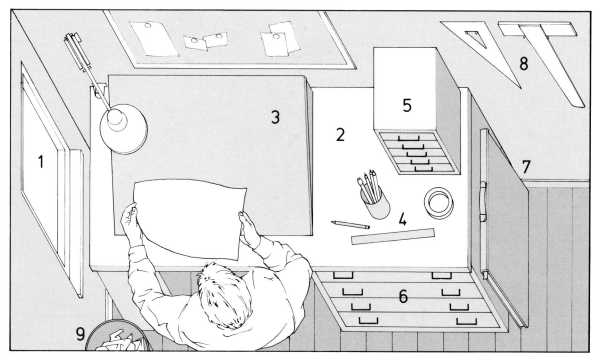

Permanent working space
The area (*above*) illustrates a serviceable basic layout:
1 Good sources of light, both natural and artificial.
2 A steady, flat surface on which to put drawing board, tools, cutting board, etc.
3 Drawing board, at an angle, to avoid having to lean over your work.
4 Tools and equipment kept within easy reach.

5 Store cupboard for small tools, notepaper, etc.
6 Plan-chest for storing large paper and artwork.
7 Space for storing portfolio, cardboard, rolls of drafting film, etc.
8 Space to keep large work tools carefully.
9 A bin for waste paper.
Points of cleanliness:
- Keep water jars and drinks off your drawing board

- Don't sharpen pencils over your work
- Avoid sliding objects across your work surface
- Never use your work surface as a cutting board
- Cover your work when you finish each day
- Never let scrap or unwanted rubbish build up on your desk

Basic drawing board

A good drawing board is essential for good work. It need not be expensive – a solid, flat, strong, wooden board with straight edges is perfectly usable. To avoid having to lean forward, prop it up at the back with bricks or strips of wood, or buy an adjustable device.

Working square

You must, when drawing artwork, have the capacity to keep your work square, or 'true'. There are many drafting devices available to attach to your board, the simplest and cheapest way is to use a T-square. Ensure that at least one side of your drawing board is absolutely straight. Use the T-square against this edge keeping the two surfaces in contact. The next step up from the T-square is parallel motion which slides up and down the board attached to a system of wires and wheels at the side.

Surfaces

Before you use your board, attach a piece of smooth paper or thin board to its surface, using clips or tape. This will improve and protect the quality of the surface. The card can be replaced when worn or dirty. Thicker, permanent plastic covers can be purchased.

Clean work

Two useful pieces of equipment to have around are pounce powder (dusted on to paper or film and brushed off to prepare the surface) and a drafting brush (or household paintbrush), to brush away dirt and dust particles.

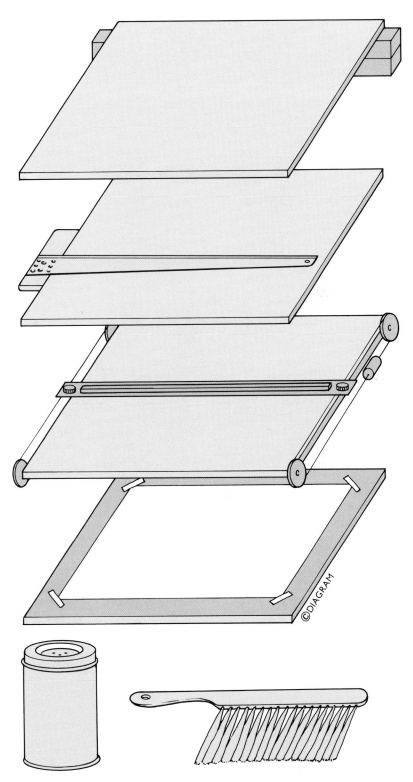

©DIAGRAM

Drawing tools

Before you start drawing, experiment on various surfaces with different pens and pencils. If your chart is to be reproduced, test the quality of the lines by photocopying samples. Technical pens soon repay their cost and the time needed to develop the skill to use them. Begin with a scrap of paper before using a pen on a piece of work, otherwise you may get blots.

Colored pens and pencils

Colored pens and pencils (*top right* and *opposite*) are not usually used for charts intended for reproduction. When making single charts (for example for display) the wide variety of colors available can aid clarity and increase the visual appeal of your work. Useful for drawing lines and filling in small areas are:
1 Colored pencil.
2 Wax crayon.
3 Colored felt-tip pen.
Suitable for filling in larger areas of color are:
4 Marking pen.
5 Brush.

Other pens and pencils

(*right* and *opposite*)
1 Pencil. Available in a wide variety of hardnesses, from 9H (the hardest) to 8B (the softest). The most useful ones for drafting and plotting are from 4H to HB. Always sharpen your pencil with a scalpel, and use a sand block to keep the tip pointed. Sharpen away from your work.
2 Refillable (propelling) pencil. A screw mechanism moves the lead through the holder. Available in blue, red, and black.
3 Ballpoint pen.
4 Fine-line felt-tip pen. These four are useful for drawing charts not intended for reproduction, and for preliminary plotting when producing artwork for reproduction.
5 Fountain pen.
6 Ruling pen. Useful for drawing lines and, when fitted to compasses, circles. It must be held vertically, and is not suitable when rapid changes in direction are needed, as in lettering. The gap between the two blades is filled with a small quantity of ink from a dropper. Make sure no ink gets onto the outside of the blades.
7 Technical pen. Available in a range of nib widths, these are the best pens to use for reproduction quality artwork. The tip is very delicate, so don't use it for rough work. Always hold the pen lightly, so that it does not scratch the paper, and try to move it at an even speed as this helps to keep the quality of the lines consistent. For the best results, hold the pen upright.

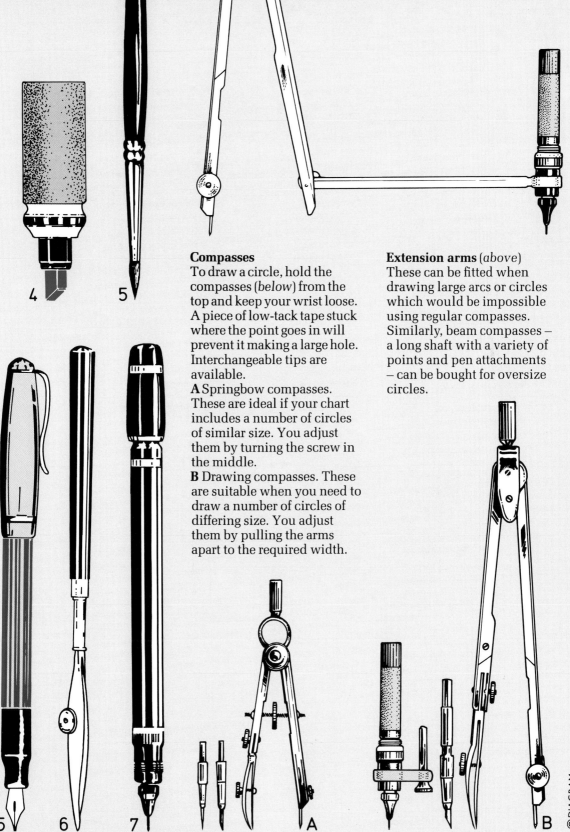

Compasses
To draw a circle, hold the compasses (*below*) from the top and keep your wrist loose. A piece of low-tack tape stuck where the point goes in will prevent it making a large hole. Interchangeable tips are available.
A Springbow compasses. These are ideal if your chart includes a number of circles of similar size. You adjust them by turning the screw in the middle.
B Drawing compasses. These are suitable when you need to draw a number of circles of differing size. You adjust them by pulling the arms apart to the required width.

Extension arms (*above*)
These can be fitted when drawing large arcs or circles which would be impossible using regular compasses. Similarly, beam compasses – a long shaft with a variety of points and pen attachments – can be bought for oversize circles.

4

5

5

6

7

A

B

©DIAGRAM

153

Aids to accuracy

Accuracy is the basis of all good charts and diagrams, and tools that enable you to achieve the highest standards are invaluable. Time and care should be spent plotting correctly before you begin to draw. Use the same tools to give a professional appearance to straight lines and curves in your final artwork. Keep all equipment in good condition and always store it away when not in use.

Don't spend large amounts of money on what may seem to be attractive tools, but which are unfamiliar, or which you don't have confidence about using. Plastic surfaces tend to collect finger marks and grease, which can be removed by wiping off regularly with a cloth dipped in methylated spirits or lighter fuel.

Straight lines
Charts must be drawn on a flat surface, your drawing board (**1**). It should be free of all unessentials while you are working. Horizontal lines are drawn with a T-square (**2**), a ruler (**3**) or parallel rules (**4**). Vertical lines are obtained by using the upright edges of set squares (**5**, **6** and **7**). Lines drawn at an angle are produced either by a 30/60 degree square (**5**) or a 45/45 degree square (**6**). An adjustable set square (**7**) gives you a range of constant and different angles. NEVER use a measuring tool as a guide for cutting – it will be damaged beyond repair.

Curves
To the beginner, drawing curves may seem difficult; professional artists use a range of curved plastic templates which can be matched to, and used to continue, a variety of arcs. A few complex curves (French curves) will provide enough arcs to meet most needs.

Templates

Oval and circle templates come in many sizes. Circle templates save time and can be more accurate than compasses for drawing a series of similar small circles. Oval templates are available in wide ranges of sizes and of major to minor axis ratios.

Units

Rules with different units of measurement – metric, imperial, specialist – can be used to calculate lengths of charts. The rule (*right*) enables you to measure up to 1/100 in. You can draw the grid yourself by dividing up a row of parallel lines.

Calculators

Inexpensive pocket calculators are invaluable in saving time and ensuring accuracy. Modern print-out graphic calculators can give you quick visuals of pie and bar diagrams or graphs, but most cannot yet produce images of printable quality.

Grids and arcs

Collect graph papers with varying scales for plotting charts on tracing paper. Make reduced photostats of these so you have a variety of grids. Protractors are usually marked in degrees, so use the formulas on page 79 to calculate segments in pie charts.

Surfaces

The surface and type of material you use will greatly affect the quality of your drawings. You can work on opaque or transparent material, on paper, card or plastic. You can use expensive or cheap materials and your surface can be lighter (usually white or cream) than your drawing, or darker (colored papers and boards).

Transparent surfaces
Transparent papers or plastics can be put over grids, graph paper, or already constructed designs.
1 Thin, inexpensive tracing paper is very useful for provisional design sketches. Each solution can be devised over a previous one.
2 Commercial draftsman's tracing paper is stronger, smoother and often clearer than the cheaper varieties. It wears better, especially if you are using hard pencils.
3 Semi-transparent plastic or waxed linen are used by architects, engineers, technical draftsmen and designers for final drawings. These materials are very strong, do not shrink or stretch, and ink lines can be scratched out to make revisions.
4 Clear plastic surfaces are glass-like and difficult to draw on as they are not absorbent. For chart making, they are mainly used as overlays on which to stick translucent color film, or dry-transfer lettering.

Opaque surfaces
Designers often use rolls of cheap layout paper for sketching out ideas and designs, but it has a rough surface which tears easily and does not take pen marks comfortably. It buckles with moisture, so is not really suitable for use with paints or inks.

Cartridge
Smooth cartridge stationery paper, drawing papers and artists' papers are ideal for your final drawing. They must be stored flat.

Boards
Designers' boards are good strong surfaces but they are expensive, so planning must be done on cheaper papers.

Adhesives (*right*)
Avoid spray adhesives as they are dangerous to you and the environment.
1 Secretarial glue-sticks are good for quick tasks.
2 Scotch tape can be removed without damage.
3 Petroleum extract glues, which come in tubes or tins, can be dissolved with gasoline or lighter fuel for the easy re-positioning of artwork
4 Gummed backing, which comes in rolls, is clean and convenient to use, and can be lifted without damage.

Colored boards and papers
Collect many different types of colored paper and explore the possibilities of their different surfaces, so you avoid using inappropriate ones.
1 Metallic coated papers are bright and good for use as small cut-outs, but unsuitable for painting or drawing.
2 Colored crayon papers are stocked in large ranges of colors. The rough surface is excellent for crayons, but will not take inks and fine lines.
3 Colored boards are firm and strong as the base board for charts, but expensive.
4 Industrial wrapping papers, wall papers and commercial tissue papers, although seldom suitable for drawing on, are a source for colors and textures.

Clear plastic (*right*)
Sheets of clear or colored plastic provide overlays on which to stick, or paint, textures or colors for removable areas on a chart. Store between sheets of tissue paper.

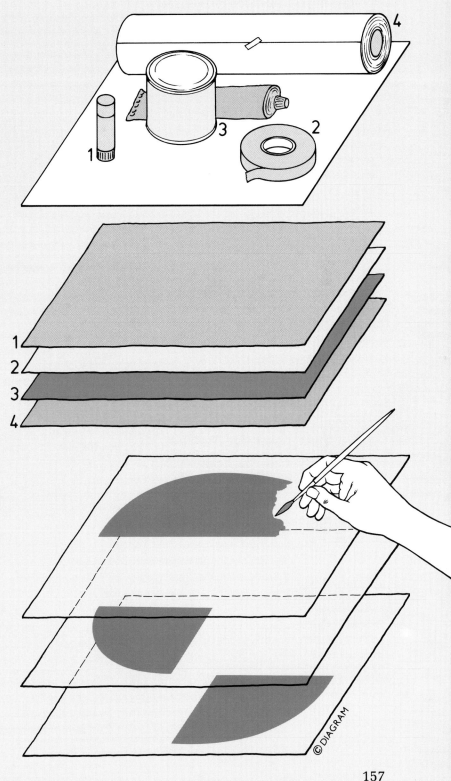

© DIAGRAM

157

Changing the size

During the construction of a chart you may need to change the size of part or all of it; detailed diagrams are easier to build on a large scale, using correct proportions, and then reducing them before adding text or color. Mechanical or hand-drawn methods can be used; the simplest is to get an inexpensive photocopy from a machine able to enlarge and reduce, and then to trace off the major elements at the correct size. As a rule of thumb, remember that the diagonals of both the original and the new size will have a common angle.

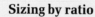

Geometric method
All rectangles with the same proportions have a common diagonal. This principle can be used to establish any new size, given the required width or height. For example (*above*), to find the enlarged height when you know the width, trace the rectangular shape of your original onto tracing paper and extend the diagonal out from one corner. Extend one of the width lines of the original to the desired new width. Then draw a line up from the end of the new width line to the extended diagonal. This last line gives you the height of the new rectangle.

Sizing by ratio
Using a proportional slide-wheel (*above*), locate the height of the original on the center disk and rotate it so that it corresponds with the desired new height. With the disk set in that position, all other proportions can be read off from the outer disk.

Proportional dividers (*right*)
Place points (**a**) over your original and adjust the center screw up or down, so that the distance between the points (**b**) is the correct new dimension. With the center screw set in that position, any distance between points (**b**) will be the correct proportional change of any distance between points (**a**).

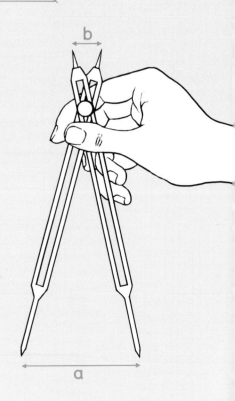

Using a grid (squaring up)

Place tracing paper over your original and draw a grid of squares all over it. Redraw the same grid at the desired new size. Carefully copy the major elements of the original onto the new grid, square by square. Greater accuracy can be achieved by turning the original upside down, making it unfamiliar; then you will copy only what you see and not what you remember. Intricate areas can be enlarged more easily by subdividing the grid and repeating the process.

© DIAGRAM

Using a projector (*right*)

This consists of a movable base plate, a movable lens and a flat glass plate. Place the original on the base plate and adjust it and the lens, so that the image which appears on the flat glass screen is the desired size. Then trace this off using tracing paper.

159

Construction skills

Constructing charts and diagrams may sometimes involve the use of unfamiliar drawing methods. Start with the proper tools and try out the method before you use it. If you make mistakes, try again. Rather than follow a procedure you don't understand, choose a simpler structure for your diagram. Geometric shapes comply with mathematical formulas, so a knowledge of these will help you to draw any shape you need.

Dividing a line
To divide a line (**A**) or any distance between two points into equal parts (12, in example *right*): Extend the points to be divided into two parallel lines (**B**). Position a ruler so that zero meets one line and 12 the other. Mark off from the ruler the units, and project back (**C**) to the original line.

Ellipses
Drawing ellipses, or ovals, is easy if you use templates. These are made in a variety of sizes, with a wide range of ratios between minor (short) and major (long) axes. In order to construct an ellipse you need to know the length of both axes. Two methods are shown (*above*).

1: Draw major axis **AB** and minor axis **CD**. Draw a line on a slip of tracing paper and mark **EG** equal to half **AB**, and **FG** equal to half **CD**. Keeping **E** on the minor axis and **F** on the major, prick through the tracing paper at **G** and continue around until the ellipse is complete.

2: Draw axes **AB** and **CD**. Add rectangle **FBEC**. Divide **BE** and **BF** into the same number of parts (here, four) and draw **C1**, **C2**, and **C3**. From **D** draw **D1** to meet **C1**, **D2** to **C2**, and **D3** to **C3**. Draw curve from **C** to **B** through these intersections to form one quarter of ellipse. Repeat for the remaining quarters or complete by symmetry.

Spirals

There are various types of spiral, each with its own method of construction. The simplest are drawn with compasses, the more complicated involve plotting a number of points that when joined together form a more 'realistic' spiral. The construction of two types is shown (*above*).

1: Draw line **AB** and divide it into twice as many equal parts as you need convolutions (here, six parts for three convolutions). Bisect line **34** to find point **O** and, using **O** as center, draw semicircle of radius **O3**. Then, with **3** as center, draw semicircle of radius **34**. Repeat, gradually increasing the radius – using **O** and **3** alternately as centers – until you complete the spiral. You can continue indefinitely by extending line **AB** and plotting new points along it.

2: Draw circle with radius **OA**. Divide **OA** into the same number of equal parts as you require convolutions (here, two) to give point **a**. Divide circle into eight equal sections by drawing radii **OB**, **OC**, **OD**, etc, and divide **Aa** into the same number of equal parts. With compass set at distance **O7**, mark point **b** on radius **OB**; reduce compass width to distance **O6** and mark point **c** on radius **OC**. Continue until you have marked distance **O1** as point **h** on radius **OH**. Using these points, you can now draw the spiral by hand or by using French curves. To form the second convolution, divide **Oa** into eight equal parts and continue the process as above.

Drawing corners (*right*)
Drawing boxes or squares with pen or dry transfer lines is easier and neater if you overdraw the lines, then paint out or scratch off the excess (**A**). To construct round-cornered boxes (**B**), draw the arcs in the correct position first, then join up and scratch off the excess.

© DIAGRAM

161

Projections

Drawing subjects by a regular projection means that a 'true' but not necessarily realistic image can be constructed. Basic laws controlling each method enable you to build your image to a pre-determined set of rules. Certain types of projection, for example isometric, can be constructed using standard grid papers (see pages 180-183).

Constructed projections
In geometric projections all the elements in a drawing are to a common and constant scale, i.e. relationships are correct. There are three major types: orthographic, either single view (axonometric, **A**) or multi-view (normal plan and elevation drawings); oblique (**B**), in which one surface is parallel to the picture surface; and perspective (**C**), where there is a single view, which results in distortion of the receding surfaces.

A Axonometric projections
The object is viewed from above or below; all surfaces are set at an angle to the picture surface. The angle of apparent tilt determines which of the three types is used.
1 A cube drawn in isometric projection has sides of equal length, and surfaces at an equal angle of tilt to the picture surface.
2 Dimetric: Tilt is along the vertical plane and only two of the surfaces are the same size.
3 Trimetric: Tilt is along both vertical and horizontal planes. All sides are different and at different angles to the horizontal. The number of positions is infinite.

B Oblique projections
One face of the cube is drawn parallel to the picture surface. The other sides are drawn at any angle. Sides and features are drawn to a common proportional scale.

Regular geometric projections (*left*)
You can use set squares to obtain a constant angle by combining two set squares of similar angles or differing angles. The 30°/60° and the 45°/45° set squares when set together can produce angles of 15°, 30°, 45°, 60°, 75°, and 105°.

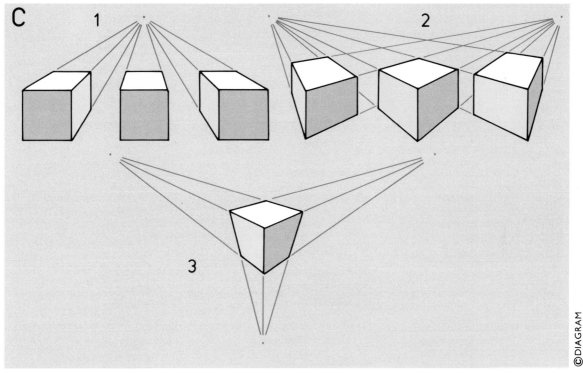

©DIAGRAM

C Perspective
Drawings produced in perspective create a more realistic image than any other form of projection. They are constructed on the assumption that there is a single point of view and a constant level of observation. There are three methods of perspective.

1 Parallel perspective (one point). The object has vertical sides, a front face flat to the picture surface, and a single vanishing point.

2 Angular perspective (two point). The object has vertical sides and two vanishing points.

3 Oblique perspective (three point). The object does not have vertical sides because all faces are constructed by reference to three vanishing points.

Tones and textures

Mechanical dry-transfer tonal screens are useful to anyone wanting to produce diagrams or charts. They can be used to differentiate areas, make complicated line diagrams easier to 'read', give block diagrams or pie charts a three-dimensional effect, and give your designs a professional quality. They come in dot or line types in a wide range of tones (density) and dot or line sizes, and there is a variety of special application types. The texture comes in the form of a sheet of self-adhesive film which, after being cut to roughly the correct size, is peeled from the backing and rubbed down. Store sheets in closed drawers, otherwise they spoil quickly and gather dust, which makes them unusable.

Selecting a texture (*below*)
A large range of texture and tones is available. The most commonly used screens are dot and line screens. The tonal value is specified as a percentage of black (**1**) and as the number of lines, or lines of dots, to the inch (**2**). Many special application types can be bought, a few of which are shown (**3**)

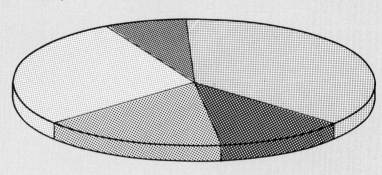

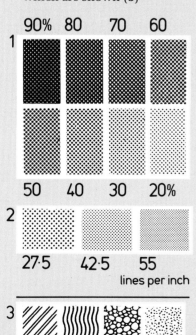

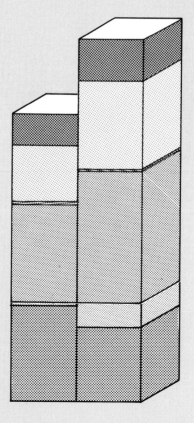

Spacing the tones (*above*)
When using dot or line screens on a diagram where many areas touch each other, you should take care to use a wide range of tonal values (percentage screens), and to position tones that are similar in value away from each other to prevent confusion. This will give you a well balanced effect that is easy to read.

Small areas
If your diagram or chart has small or thin areas, it is best to arrange your tonal scheme so that those areas are left white or filled in solid black; dot screens and textures do not 'read' when used in too small a space, as the example (*left*) shows.

Reductions (below)

When producing a design for publication and drawing the artwork enlarged, be careful in choosing the tones you want to use. Try and avoid screens with a small dot size, and avoid both the lighter (5–10%) and darker (70–90%) tonal values; lighter values can disappear completely when reduced and darker ones tend to fill in and appear black. Reduction can also make tones which are noticeably different on the original artwork seem closer in value.

So, preferably work with a clearly graded range of values between, for example, 10–60%, and use a large enough dot size.

Applying the overlay film (right)

1 First complete your drawing.

2 Lay over it part of the texture sheet with its backing between your work and the film tone. With a scalpel cut out roughly but not wastefully the area required. Remove the backing sheet and the unused parts of the tone with care. Put the shaped area of tone over your work and gently rub down in the center only. Do not get dirt on the film.

3 Carefully cut around the area of tone you want.

4 Burnish all over, using a strong, clean, smooth tool such as the edge of a plastic ruler, rubbing down on spare paper between the film and the ruler.

5 Establish the absence of dirt, and begin to overlay a second, different film texture. The final result will have strong black containing lines and a variety of tones in positions you want.

Avoid laying down over large areas.

©DIAGRAM

165

Annotation

Good graphics can be spoiled by bad annotation. Labels must always be subservient to the information to be conveyed, and legibility should never be sacrificed for style. All the information on the sheet should be easy to read, and more important, easy to interpret. The priorities of the information should be clearly expressed by the use of differing sizes, weights and character of letters.

Identifying difficulties
On the small map (*right*) are 23 countries. If labels were used, the result would be congestion and confusion. The key numbers help link in the locations with the matrix chart below. For clarity, identifiers are better grouped in rows or clusters.

Technical difficulties
How you put the names and values on your charts very much depends on the method you use to produce your drawing. The example (*left*) has five major faults:
1 Dry-transfer mechanical tint laid over stuck-down annotation (proofed type), which leaves shadows.
2 Dry-transfer letters laid over dry-transfer tint, which produces broken and illegible letter forms.
3 Uneven lines of dry-transfer letters.
4 Cut-out labels stuck over a tint background. This produces white shapes which confuse the land/sea pattern.
5 Stuck-on labels obscuring cartographic detail.

Economic groupings

OAS	LAFTA	CACM	
			1. Argentina
			2. Barbados
			3. Bolivia
			4. Brazil
			5. Chile
			6. Colombia
			7. Costa Rica
			8. Dominican Republic
			9. Ecuador
			10. El Salvador
			11. Guatemala
			12. Haiti
			13. Honduras
			14. Mexico
			15. Nicaragua
			16. Panama
			17. Paraguay
			18. Peru
			19. Trinidad and Tobago
			20. USA
			21. Uruguay
			22. Venezuela
			23. Cuba

＊ (expelled 1962)

OAS Organization of American States

LAFTA Latin American Free Trade Association

CACM Central American Common Market

Uniformity of annotation

The newspaper chart (*right*) uses simplified flags to represent countries in seven diagrams. The first small map establishes the identity of the flags, which can then be used as labels elsewhere.

Scales (*below*)

It is very important that scales on charts be subordinate to the information. Numerical values and unit names should appear horizontal. Wherever possible, large unit values should be reduced to low common denominators which can be explained in a key. The appearance of large values with duplicated zeros, whether typeset or produced by dry-transfer, over-emphasizes the scale.

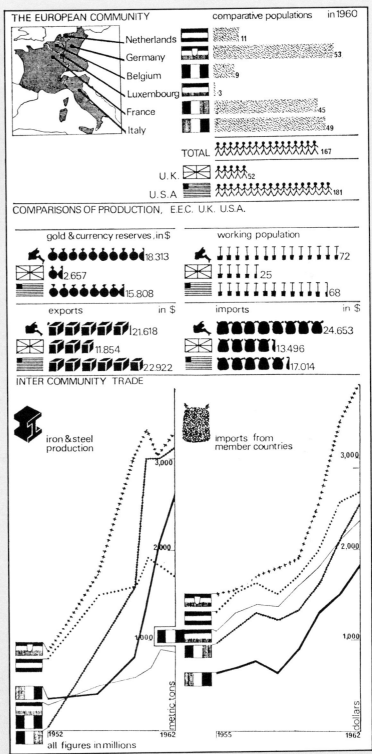

THE EUROPEAN COMMUNITY — comparative populations — in 1960

Netherlands 11
Germany 53
Belgium 9
Luxembourg 3
France 45
Italy 49

TOTAL 167
U.K. 52
U.S.A 181

COMPARISONS OF PRODUCTION, E.E.C. U.K. U.S.A.

gold & currency reserves, in $
18.313
2.657
15.808

working population
72
25
68

exports in $
21.618
11.854
22.922

imports in $
24.653
13.496
17.014

INTER COMMUNITY TRADE

iron & steel production

imports from member countries

3,000
2,000
1,000

1952 — 1962 — metric tons

1955 — 1962 — dollars

all figures in millions

©DIAGRAM

167

Using lettering

All charts, diagrams and maps need text, as the previous pages show. Whether it is just labeling, adding information and details or whether it is playing a more important role (such as an explanation), the text should be designed as an integral part of the chart. Do this at the rough stage, rather than find that the artwork is tight for space. Many points have to be considered: the size and style of lettering, its color and the background against which the words appear. How is the title to be produced: freehand, template, dry-transfer or typeset? Will the text be put directly onto the artwork? If not, what method will be used to stick it down? Don't mix too many styles. Find the best letter size for the bulk of the text and make headings, sub-headings, labels and notes relatively larger or smaller as necessary. Keep the layout simple.

Factors to consider
Five factors affect your choice of lettering:
1 Style – the essential character of the letter forms. There are thousands.
2 Weight – the thickness of each letter stroke, compared with its overall size.
3 Character – each letter form can be produced in a variety of ways: roman (upright), italic (slanting), condensed (squeezed up), and extended (opened out).
4 Size – lettering comes in various sizes.
5 Color – do you have a choice of more than one?

The simple, clear diagram (*left*) illustrates the use of these five factors:
1 The main title is in a different style from all the other words on the chart.
2 The sub-heading is in two weights, bold and light.
3 The 'source' text at the bottom is in both roman and italic, and the country names are in condensed.
4 The title, sub-heading and source of information are in three different sizes.
5 The values above the bars are in a second color.

BANANA PRODUCTION
Central America, 1983 (thousands of tons)

1250 Honduras
1080 Panama
1010 Costa Rica
580 Guatemala
150 Nicaragua
20 Belize

Source: *Atlas of Central America and the Caribbean.* Macmillan

168

1

3

5

2

4

6

©DIAGRAM

Figure and ground

Effective results can be achieved by placing your lettering against different backgrounds. What you do will either emphasize the text or subdue it, as you can see from the six examples (*above*).

1 Black on white
2 White on black
3 Gray on a color
4 Color on gray
5 Black on gray
6 White on gray

Positioning

To avoid problems, work out where you will put your lettering in the rough draft. The examples (*below right*) illustrate four ways of labeling a simple bar diagram.

1 A bad solution. If the town names were longer, or the bars shorter, the labels would not fit.
2 The labels appear to lengthen the bars.
3 Much clearer, but hand-drawn labeling would have to be done backwards, in order to be in the right position.
4 The best solution; easy to read and to implement as both bars and words range from the same line.

Letter spacing (*right*)

This is always a problem when hand-lettering or using dry-transfer lettering, but there are no strict rules. Good letter spacing is always done by eye, but here are some tips. Rounded letters, or those without vertical strokes, can be closed up and their counters (the areas inside and surrounding the letters) can be overlapped for a pleasing effect. Adjacent straight-sided letters should be opened up to prevent a crowded impression.

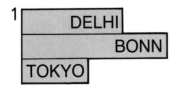

1

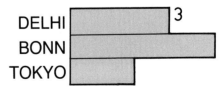

3

2

4

Hand lettering

Hand lettering can mar the overall effect of your chart. Any unevenness will look amateurish. But there are a few devices which can help. Large letters can be drawn against a grid; medium size or small letters can be drawn between ruled lines. All sizes can be produced using easily available stencils. Before attempting hand lettering, study existing examples to gain a knowledge of letter proportions and letter and word spacing.

Basic alphabets
The alphabet (*above right*) is based on a grid of squares. Each stroke of each letter is plotted against the grid, which can be put under tracing paper and each letter formed from the structure of the square. This method enables you to enlarge or reduce the letters (**1**, **2**) by changing the size of the grid. To produce a variation of a regular shape, you can replot on a distorted grid, increasing the ratio of height to width (**3**), or vice versa, or on a sloping grid (**4**). Use this technique for large lettering or display words.

Position and size
Before attempting any hand lettering, plan the position and size of the words first, drawing all text freehand on a traced drawing of your design or on a tracing overlay. Pay attention to the relative importance of the information, and use different size, weight and character to achieve a correct balance.

Guide lines (*above*)
For hand lettering smaller than display size (e.g. in keys, labels and subtitles), use a blue pencil (invisible on reproduction) or a hard, light one to draw parallel lines to guide height and verticals. Italic (slanted) lettering is produced by adding angled lines to your rules. Draw letters lightly in pencil first to aid accuracy.

Stencils and templates

Both hand-held stencils and template letter guides are useful for hand lettering. Single-letter templates (*above*), intended for use with stencil brushes and ink (although fine felt-tip or technical pens are better),

are good for large letters, although they tend to have a rather mechanical quality. The plastic or metal letter guides (*above*), are better for everything except small text, are available in many sizes and are usually colour coded to match a

variety of technical pen nib sizes, making different weight lettering possible. These tools are designed so that the actual templates are slightly raised above the drawing surface to prevent ink seeping under as you work.

©DIAGRAM

Dry-transfer lettering

Using dry-transfer or rub-down lettering is a relatively cheap way of applying words to a chart. Some is available in most stationers, but art suppliers stock an enormous variety of sizes and styles, in black and white and even in color. You need practice to achieve correct spacing and straight lines, but if done properly your work will look more professional. Correction is easy and there is flexibility and variety in use.

Available styles
Art suppliers stock a great variety of typefaces in a wide range of sizes and colors. For charts and diagrams where clarity is important, use only sensible, legible styles (see examples *right*). Base your choice on the space available, the amount of text needed, and whether your chart is to be seen from a distance or close up. For headlines and titles, a strong, bold typeface is important.
Rules (*right*)
Most dry-transfer manufacturers supply rub-down rules in a range of thicknesses and also a variety of corner devices, which can be used to produce a sharp image if quality drawing tools are not available.
Symbols and arrows (*right*)
Any chart or map can be enhanced with the addition of symbols, whether pictorial or abstract. Sheets of rub-down symbols are easy to apply and will improve your final artwork. A great number of different types can be purchased.

abcdefghijklmnopqrstuvwx
ABCDEFGHIJKLMNOPQRS
1234567890 æøßÆØ &?!£$
abcdefghijklm 1234567890
ABCDEFGHIJKLMNOPQ
abcdefghijklmnopqrstuvwxyz
ABCDEFGHIJKLMNOPQRSTUVWXYZ
abcdefghijklmnopqr 123456789
ABCDEFGHIJKLMNOPQR
abcdefghijklmnopqrstuv
ABCDEFGHIJ123456789
abcdefghijklmnopqrstuvwxyz
DEFGHIJKLMNOPQRSTUVWX

Guide lines
Achieving a straight line of rub-down text is not as easy as might be expected. First, draw a guide line with a light pencil a few millimeters below your planned line of text. Position the sheet of lettering so that the small guide points just below each letter sit on your guide line (*right*) and rub down. The line can be erased afterwards.

Rubbing down
Position the letter with care and, using a blunt tool or a burnisher, gently rub over the surface until the letter starts to come away from the plastic sheet, and keep rubbing until the letter is transferred to your artwork (*right*). Continue until you have a full word, remove the lettering sheet, then place tracing paper over the work and rub hard with a fingernail or a burnisher.

Large sizes
When applying large letters, press each one down firmly with the fingertips before finally rubbing down to ensure the letter remains in position and does not crack.

Correcting
Rub-down lettering is best done on smooth art board or plastic film. Mistakes can then be easily erased by scratching off with a scalpel or a razor. Alternatively, put a piece of drafting tape over the unwanted letter, rub down and carefully peel off, bringing the letter with it (*right*).

GILL SANS

AAAAA AAAB CC
DDDEEEEEEEE
EFFFGGG HHH
KKKLLLLLLL M
NNNNNN
PP RO

GILL SANS AAABBBC
AAAAA
DDDE
EFFFGG
KKKLLLLL

GILL SANS
AAABBC
DDEEF

FEA

©DIAGRAM

Typesetting and typewriters

If your chart requires a lot of labeling, or if you need to prepare artwork, you can achieve a pleasing result with a typewriter or, better still, by using a typesetter. Although more expensive than dry transfer lettering or typewriting, typesetting will give you an opportunity to choose from a wide range of styles and sizes and will improve the quality of your work. Contact a typesetter for a catalog. This will give examples to help you decide on the many points to be considered when ordering typesetting: typeface, size, style, weight, measure, linespacing (leading) and letterspacing. The manuscript that goes for setting must be clear and legible, preferably typed, with all typesetting instructions properly indicated. When you get proofs, check for spelling mistakes, and make sure that all your instructions have been followed. If there are any errors, photocopy the proof and mark all the mistakes, then send this copy to the typesetter so he can implement the corrections.

abcdefABCDEFabcdefgABCDEFG
abcdeABCDEabcdeABCDE
abcdeABCDEabcdefABCDE
abcdeABCDEFGabcdeABCDE

Typefaces (*left*)
Normally you are restricted to the range of typefaces held by your typesetter. Remember that the same copy set in the same size and letterspacing but in a different typeface will occupy different lengths of line because of the differing features of the letterforms.

6	abcdefghijklmn ABCDEFGHIJKLMN
7	abcdefghijklmn ABCDEFGHIJKLMN
8	abcdefghijklmn ABCDEFGHIJKLMN
9	abcdefghijklmn ABCDEFGHIJKLMN
10	abcdefghijklmn ABCDEFGHIJKLMN
11	abcdefghijklmn ABCDEFGHIJKLMN
12	abcdefghijklmn ABCDEFGHIJKLMN
14	abcdefghijklmn ABCDEFGHIJKLMN
16	abcdefghijklmn ABCDEFGHIJKLM
18	abcdefghijklmn ABCDEFGHIJKL
20	abcdefghijklmn ABCDEFGHIJ

Type sizes
Type sizes in the Anglo-American system are measured in units called points. European typesetters use ciceros, which are slightly different. The examples (*left*), actual size, show the typeface Gill Sans Bold set in sizes from 6pt to 20pt.

Type measure
Line lengths are measured in units called picas or ems. The type scale (*left*) shows picas (**A**) and inches (**B**) for comparison.

Type style

Most typefaces are available in a range of styles. The examples (*right*) are different styles of Univers.
1 Regular (roman)
2 Italic
3 Condensed
4 Extended

Type weight

Typefaces come in a variety of weights as well as styles. The examples (*right*) show Gill Sans set in the same size but different weights.
a Light
b Regular
c Bold
d Extra bold

Linespacing and alignment

Linespacing, or leading, is the amount of space between lines. This is measured in points; the higher the number, the wider the gap. For example, 10 on 12pt refers to 10pt text with a two-point space between the lines. Alignment refers to the shape formed by the edge of a set of lines. They may range with each other or be uneven or ragged. Examples (*right*) are set in Franklin Gothic Condensed.
1 9pt solid (9pt on 9pt), ranged left, to 11 picas maximum measure.
2 9pt on 10pt (one point leaded), ranged right, to 11 picas maximum measure.
3 9pt on 11pt (two point leaded), justified (both edges aligned, lines of equal length), to 11 picas maximum measure.
4 9pt on 13pt (four point leaded), centered, to 12 picas maximum measure.

1 abcdefghijkl ABCDEFGHIJKL

2 *abcdefghijkl ABCDEFGHIJKL*

3 abcdefghijklmn ABCDEFGHIJKLMN

4 abcdefgh ABCDEFGHIJ

a ABCDEFGHIJKLMNOPQRSTUVWXYZ&!?".,
abcdefghijklmnopqrstuvwxyz£1234567890

b ABCDEFGHIJKLMNOPQRSTUVWXYZ&!?".,
abcdefghijklmnopqrstuvwxyz£1234567890

c ABCDEFGHIJKLMNOPQRSTUVWXYZ&!?"
abcdefghijklmnopqrstuvwxyz£1234567890

d ABCDEFGHIJKLMNOPQRSTUVWXYZ&!
abcdefghijklmnopqrstuvwxyz£123456

1 If your chart requires a lot of labeling, or if you need to prepare artwork, you can achieve a pleasing result with a typewriter or, better still, by using a typesetter. Although more expensive than dry transfer

2 If your chart requires a lot of labeling, or if you need to prepare artwork, you can achieve a pleasing result with a typewriter or, better still, by using a typesetter. Although more expensive than dry transfer

3 If your chart requires a lot of labeling, or if you need to prepare artwork, you can achieve a pleasing result with a typewriter or, better still, by using a typesetter. Although more expensive than dry transfer

4 If your chart requires a lot of labeling, or if you need to prepare artwork, you can achieve a pleasing result with a typewriter or, better still, by using a typesetter. Although more expensive than dry transfer lettering or

Typewriters

Typewriters can produce clean text that is good enough for simple charts. Use clean, white paper with a backing sheet and ensure that the keys are free from dirt. There are two kinds of typewriter – standard and executive. The latter often have interchangeable typefaces, known as golf balls.
a Standard pica
b Standard elite
c Executive model

a ABCDEFGHIJKLMNO
abcdefghi 123456

b ABCDEFGHIJKLMNOPQR
abcdefghij 12345678

c ABCDEFGHIJKLMNOPQR
abcdefghij 12345678

©DIAGRAM

175

Using symbols

The easiest way to create good symbols is to use a drawing style you can produce with confidence, where required, and repeat consistently. When duplicating symbols, you can use a stencil blockprint, a photoprint or a dry-transfer method. Symbols that are purely decorative are best drawn independently and then pasted onto your chart.

Duplication
A convenient way to duplicate symbols is to hand-draw them (*above right*). The design must be simple, and you should avoid trying to replicate each symbol exactly; if anything, go for deliberate irregularity. Rubber stamps will provide numerous duplicates (*right*). Again, simplicity avoids problems.

Factors to consider when using symbols

- The subject of the chart should be apparent from the choice of symbols.
- The symbols should be clear and easily identifiable.
- The symbols for each category should be clearly distinguishable from all the others, but the styles must be similar.
- All the rows of symbols must have a similar weight of drawing, so that each, although different, is not dissimilar in strength or size.
- Each individual symbol must represent a single unit or simple multiples of a unit.
- Smaller values than the symbol can be represented by part of a symbol.
- The numerical values of the symbols must always be presented in a key.
- Each row of symbols must be accompanied by the total numerical value of the group.
- Symbols used decoratively must not dominate the quantitative information.
- Wherever possible, the symbol must be reduced to its simplest form, without details and unnecessary elements on the drawing.

©DIAGRAM

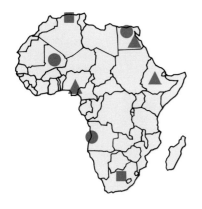

Abstract symbols (*left*)
On maps and matrices it is advisable to use simple abstract symbols, which are easier to repeat than complex pictorial ones; on maps it is less confusing to indicate locations with a small abstract sign, than with a pictorial one.

```
12  xxxxxxxxxxxx
 9  ooooooooo
 7  wwwwww
 6  ssssss
 3  nnn
```

Existing symbols (*left*)
Your typewriter can be used to produce symbols which are simple and to your own design, especially in rows of repeated characters, or in an overall grid, into which you can plot information with a pen or pencil.

Representative symbols
The style of a symbol is a matter of taste, or the ease of duplication. Statistics on humans can be represented by a simple matchstick form, or crude outline, and race, age, or sex, can be shown by emphasizing uniform, garments, comparative size or shape (*left*). Avoid fussy or over-detailed forms.

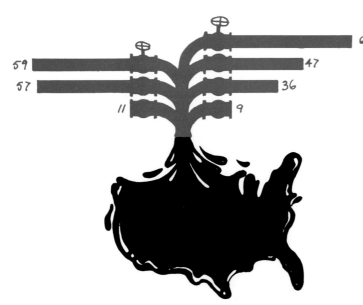

Decorative symbols
Recognizable elements on a design can identify the subject quickly and embellish the presentation. The idea for this design (*left*) is by Nigel Holmes; it cleverly uses an oil spill in the shape of the USA, and oil taps on the ends of bars to represent oil production.

177

Drawing for reproduction

All charts made as artwork to be printed are produced in much the same way, using the following step-by-step method. Begin at step 1, and do not tackle the next step until you have completed the one you're doing. Keep the work tidy and clean, checking each stage as you go along. Work carefully and slowly to avoid errors.

Table 1 shows the percentage of the different types of crime reported to the police in the year ending December 1982.

Cases involving	Percentage
Property	64
Motor vehicles	18
Loitering with intent	9
Offenses against the person	9

1 Sort out the data and decide on the best way to illustrate the information. Don't always go for the obvious solution. Try to make your graph interesting by using unusual layout or by adding symbols or tones. But beware of complicating it so much that it becomes unreadable. Do as many roughs as you want, until you have a satisfactory solution. Make sure you've left enough room for annotation and symbols.
2 When you've decided on a design, plot it accurately, using a hard pencil on tracing paper or crisp white paper taped to a smooth board. Make sure you keep within the maximum area available to you. Check that you've included all details, that the data is correctly plotted, and that you've left enough space for the labels. If you are going to hand-letter the labels, draw yourself some guide lines in the correct position.
3 Tape a sheet of plastic drafting film firmly over your drawing. Trace off all the lines you want to appear on the final copy using a good technical pen and black drawing ink. Mistakes can be scratched off with a sharp scalpel.

4 Carefully add any mechanized tints needed, ensuring that you have a wide range of tones (see pages 164–5).

5 Add the annotation. If it is to be hand-lettered, you can do this straight onto the drafting film using guide lines drawn at the tracing stage (pages 170–1). Dry-transfer lettering, typesetting, or typewritten text can be carefully cut out and pasted on using a rubber solution or a variety of other methods, but avoid the use of spray glue. Draw in indicator or "leader" lines where necessary. Check with T-square or set square that all annotation and labels are straight. It may be helpful to use a scalpel to position small pieces of text.

6 Clean off any glue or dirt using artgum or a tissue with lighter fuel. You can also scratch off any dirt or unwanted ink with a scalpel. Check that the chart works, and compare it with your original sketch.

7 Add symbols or embellishments. These are best drawn separately and pasted on. If they are to appear in a second color draw them onto another piece of drafting film, using register marks to indicate the correct position of one piece of film over another. Indicate on each piece of film in which color you want it printed. If you have any queries concerning color, consult your printer.

TYPES OF CRIME : 1982

% of cases involving

property 64%

motor vehicles 18%

loitering with intent 9%

offenses against the person 9%

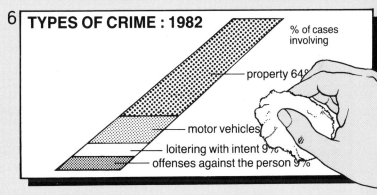

TYPES OF CRIME : 1982

% of cases involving

property 64%

motor vehicles

loitering with intent 9%

offenses against the person 9%

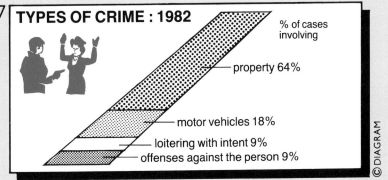

TYPES OF CRIME : 1982

% of cases involving

property 64%

motor vehicles 18%

loitering with intent 9%

offenses against the person 9%

©DIAGRAM

square grid

diagonal grid

isometric grid 1

isometric grid 2

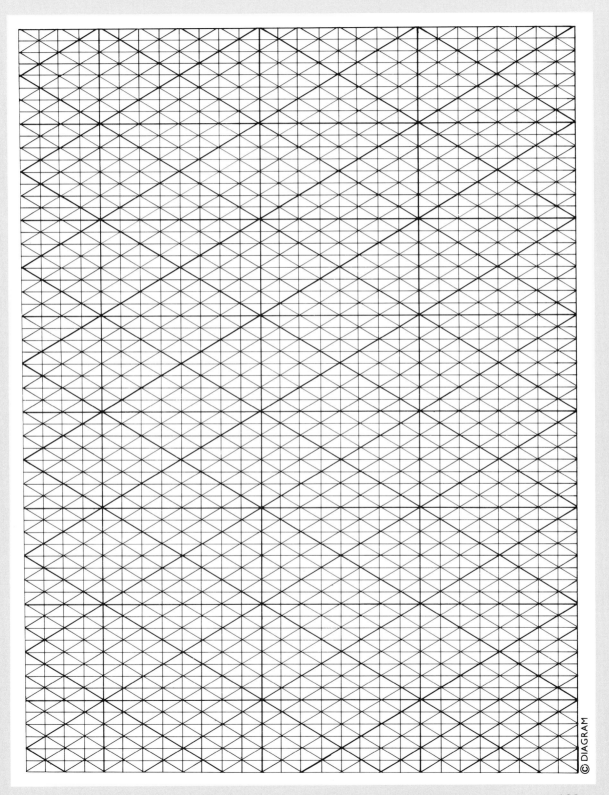

semi-log grid

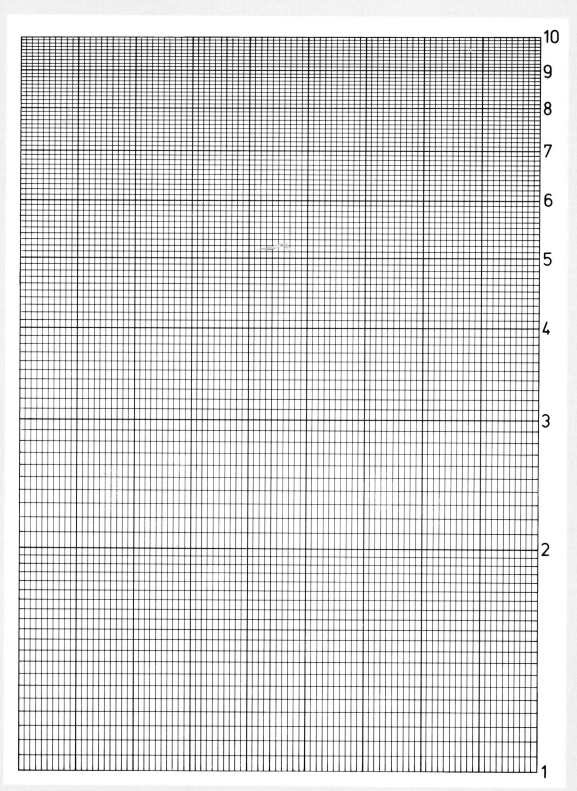

log-log grid

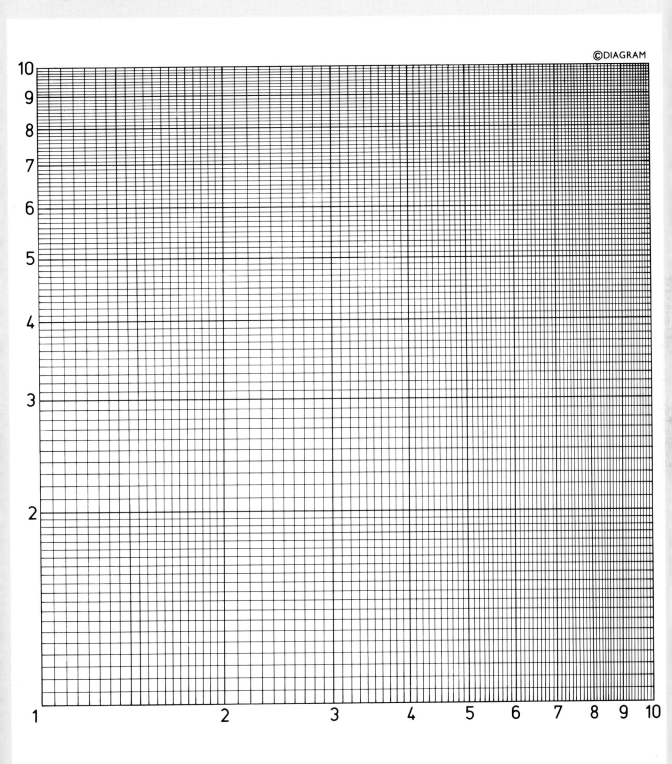

©DIAGRAM

triangular coordinate grid

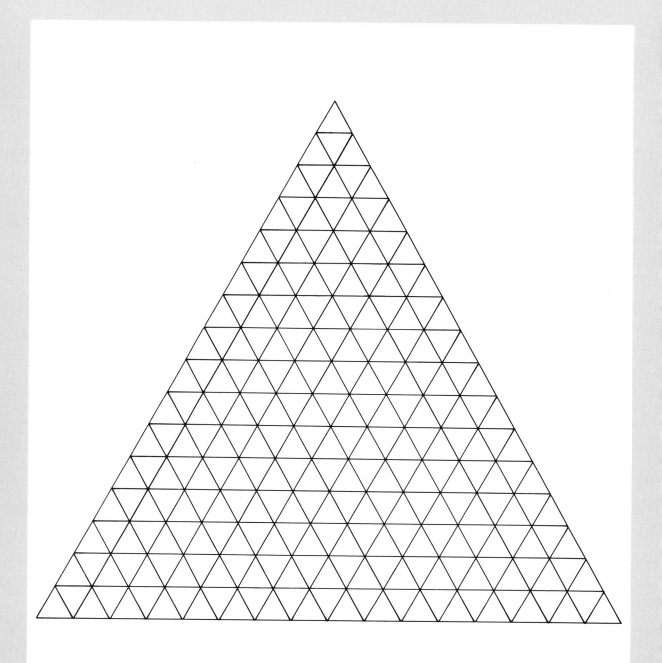

curved triangular coordinate grid

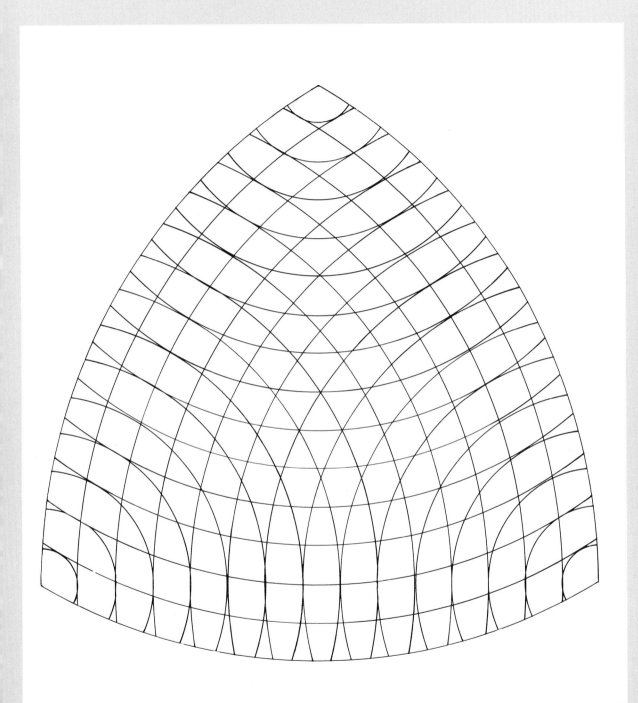

bar grids

Index

index

The Horribly Hungry Gingerbread Boy

The Horribly Hungry

Gingerbread Boy

A San Francisco Story

Elisa Kleven

Heyday, Berkeley, California

Library of Congress Cataloging-in-Publication Data

Names: Kleven, Elisa, author, illustrator.
Title: The horribly hungry gingerbread boy : a San Francisco story / Elisa
 Kleven.
Description: Berkeley, California : Heyday, [2016] | Summary: When Shirley's
 gingerbread treat leaps out of her lunchbox and begins gobbling everything
 in sight, a wild chase ensues through the neighborhoods of San Francisco
 as Shirley tries to stop her creation from eating up the whole town.
Identifiers: LCCN 2015037881 | ISBN 9781597143523 (hardcover : alk. paper)
Subjects: | CYAC: Stories in rhyme. | Gingerbread--Fiction. |
 Cookies--Fiction. | Baking--Fiction. | Friendship--Fiction. | San
 Francisco (Calif.)--Fiction.
Classification: LCC PZ8.3.K6795 Ho 2016 | DDC [E]--dc23
LC record available at http://lccn.loc.gov/2015037881

Book Design: Rebecca LeGates

Orders, inquiries, and correspondence should be addressed to:
 Heyday
 P.O. Box 9145, Berkeley, CA 94709
 (510) 549-3564, Fax (510) 549-1889
 www.heydaybooks.com

Printed in China by Regent Publishing Services, Hong Kong

10 9 8 7 6 5 4 3 2 1

To Marc and Molly and Mae

Early one morning, bright and cool,
Shirley packed her lunch for school.

"Some pizza will be
good to munch
and carrot sticks are
fun to crunch.

But what about dessert?"
 she thought.
She searched the cupboards,
 pans, and pots.
"There doesn't seem to be a lot,
just raisins and some old
 Red Hots,
just flour, sugar, butter, spice....

7

I know! I'll bake up something nice."

And there he was,
 all warm and done,
a fragrant fellow,
 sweet and fun.

Shirley ate a few small crumbs,
then bit the corner off his thumb.

"Oh, boy, you'll be a great dessert!"
Her cookie looked a little hurt.

And later on, at twelve o'clock,
he gave poor Shirley quite a shock
when, standing up, he licked his lips
and said, "I liked your carrot sticks!
And your pizza—it was yummy.
But it barely fills my tummy!"

Then, quick as
 popcorn in a pan,
he jumped away,
 and off he ran!

"Hey you," cried Shirley. "Stop! Come back!"
"No way!" he said. "I'm not your snack.
I thought you'd be my friend, but no,
you bit my thumb—what next, my toe?
I'm not your little ginger treat,
and soon I'll be too big to eat!
I'm off to find more lunch, you see.
Run, run, run, but you can't catch me!"

Shirley tried to chase him down, but off he ran around the town,
raiding markets, robbing shops,

snatching plums and lollipops,

gobbling grapes
and gooey noodles,

14

grabbing bones
away from poodles,

15

guzzling shakes and munching steaks,

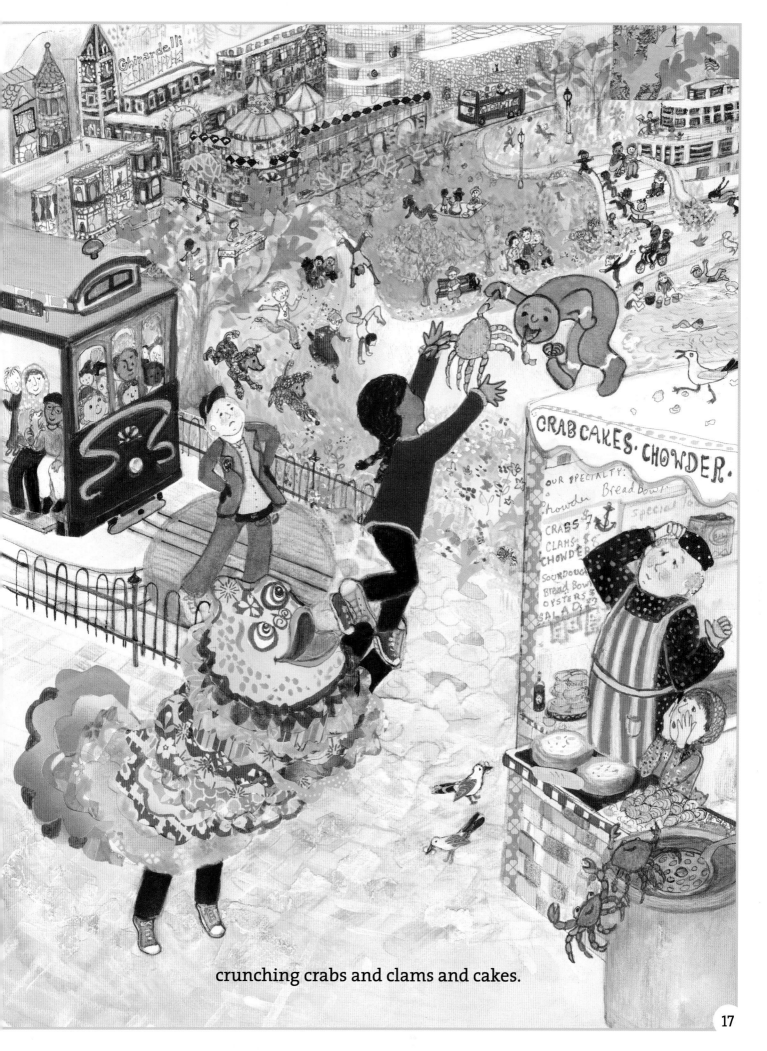

crunching crabs and clams and cakes.

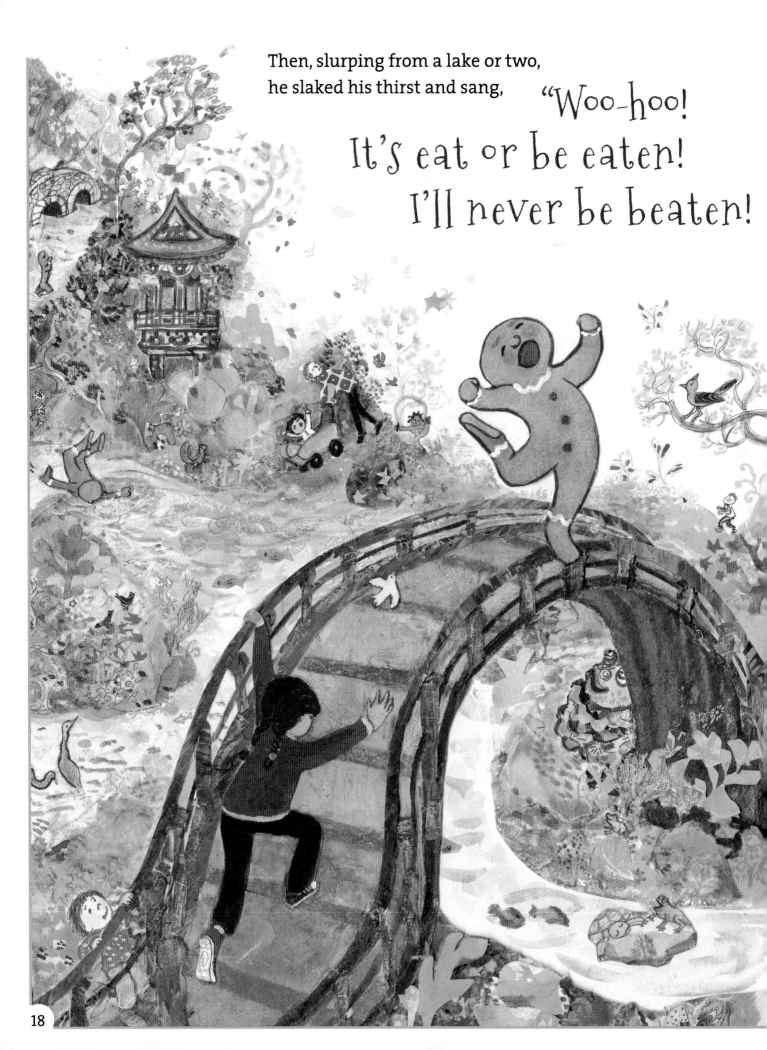

Then, slurping from a lake or two,
he slaked his thirst and sang, "Woo-hoo!
It's eat or be eaten!
I'll never be beaten!

Run, run, as fast as you can.
I'm the Horribly Hungry
Gingerbread MAN!

I'll eat a frosted
flower-house,

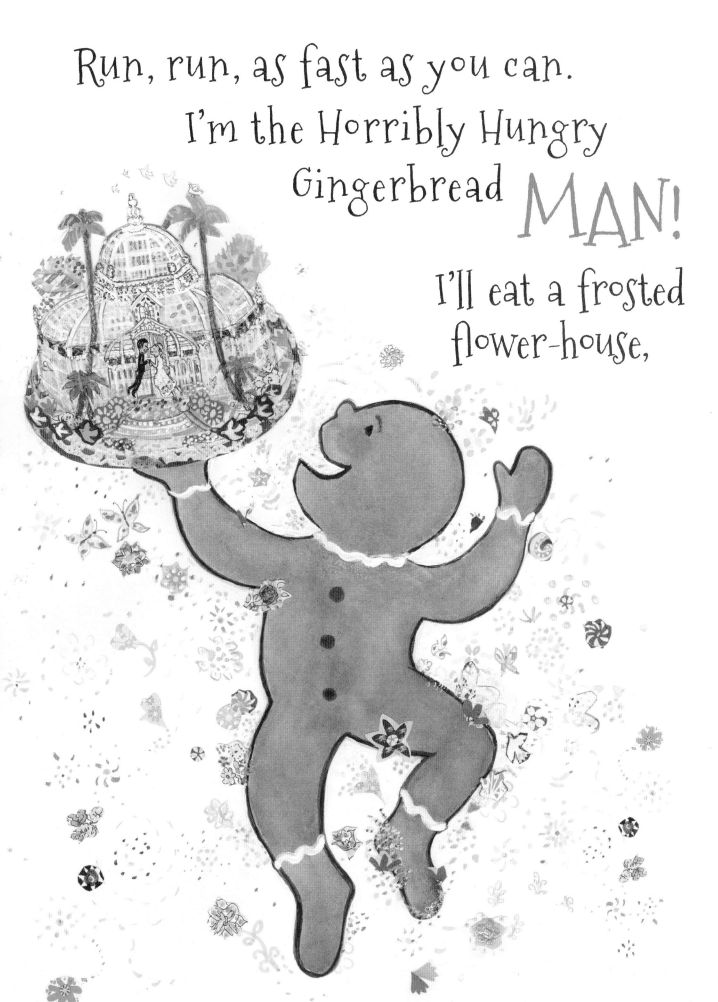

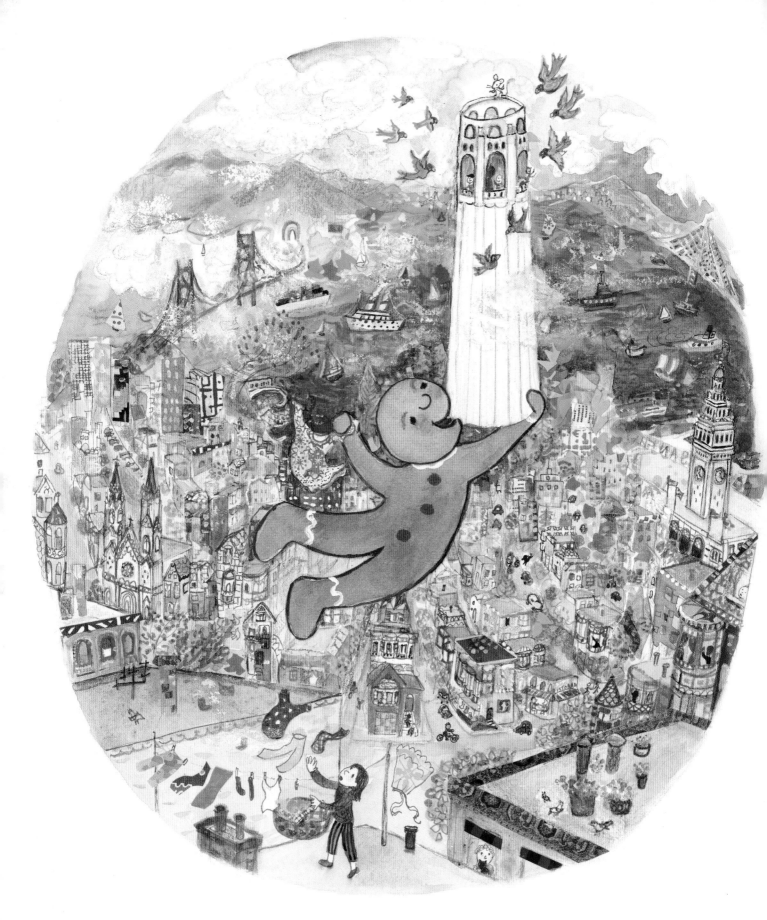

a blouse, a tower, and a mouse!

I'll eat a ribbon-candy street
and spoon up fog like
cream of wheat!

I'll chomp a gleaming golden bridge.

22

I'll bite the highest mountain ridge!

23

I'll grind
your redwoods to a pulp.

I'll drink your bay in one big gulp!

And if you try to make me stop,
I'll swallow the sun like a butterscotch drop!"

The people shrank away in fear,
but Shirley shouted, "Listen here!
I mixed and stirred and rolled you out.
I made your eyes; I made your mouth.
I'm glad that you can shout and sing,
but it's rude to gobble everything!
My ginger boy, you have to stop.
You're so puffed up, I think you'll pop!
And then you'll be just cookie crumbs,
no arms or legs or head or thumbs."

The gingerbread boy looked quite sad.
"Then you will eat me, and be glad."

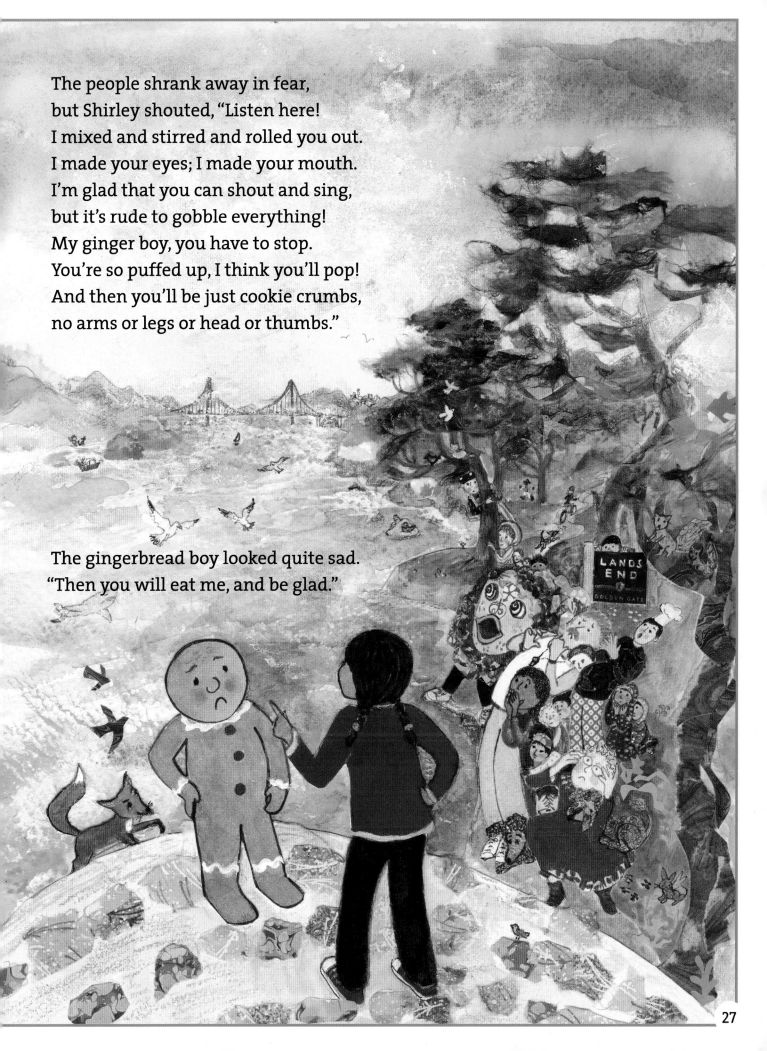

"Oh no," said Shirley, "I'll be blue,
because I'd rather play with you.
I've never made a treat, you see,
who runs around and talks to me.
I only wish you'd be polite
and stop to think before you bite."

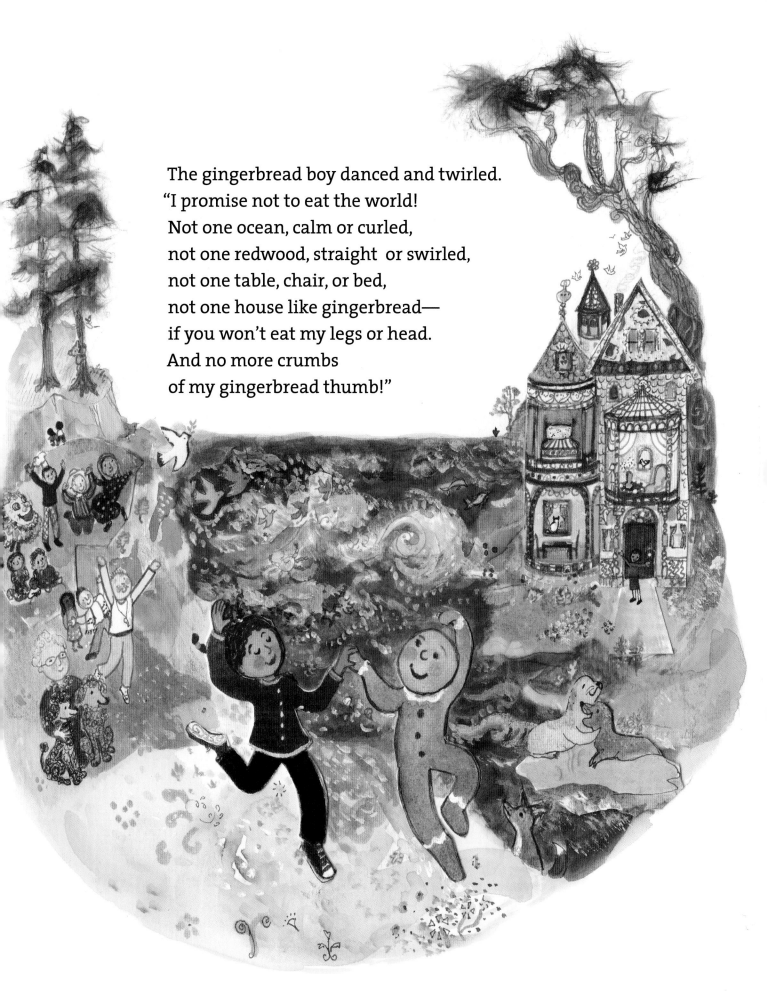

The gingerbread boy danced and twirled.
"I promise not to eat the world!
Not one ocean, calm or curled,
not one redwood, straight or swirled,
not one table, chair, or bed,
not one house like gingerbread—
if you won't eat my legs or head.
And no more crumbs
of my gingerbread thumb!"

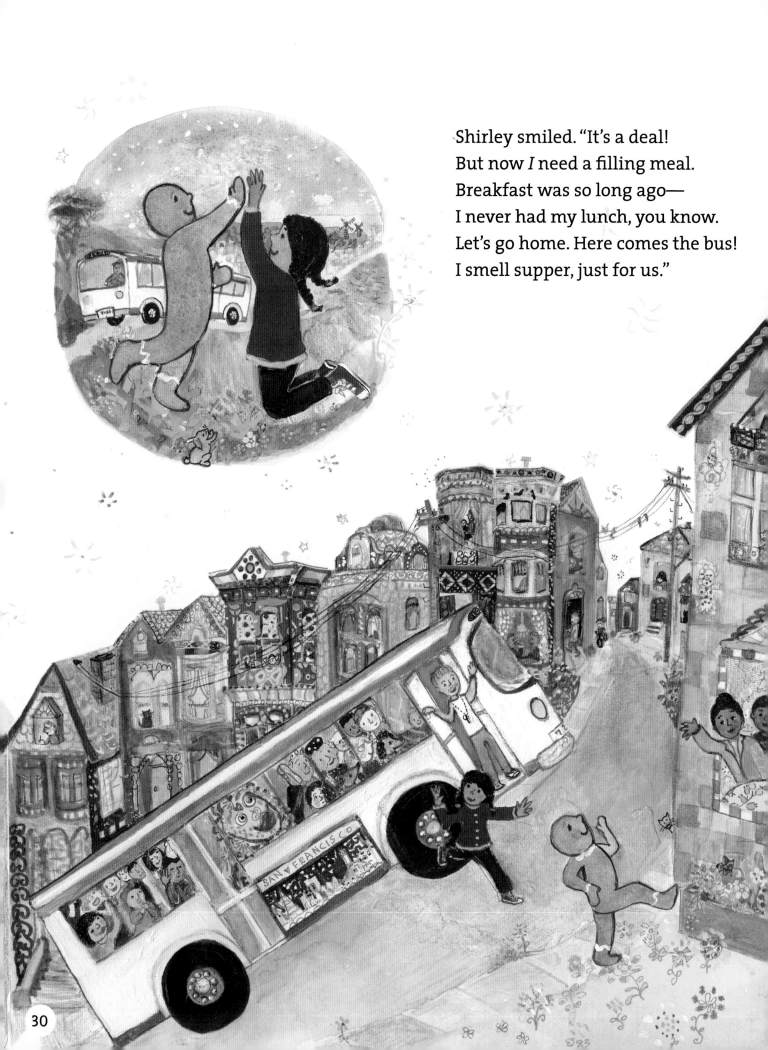

Shirley smiled. "It's a deal!
But now *I* need a filling meal.
Breakfast was so long ago—
I never had my lunch, you know.
Let's go home. Here comes the bus!
I smell supper, just for us."

"Hooray, Dad made my favorite stew!
Mom bought stuff for baking, too.
Let's make cookies—pecan sandies,
snickerdoodles topped with candies.
But no more gingerbread. I'm through!
My hands are full enough with you."

Then Shirley and her ginger friend
baked a lovely, luscious blend
of crispy cookies, rich and brown...

for all the people in the town!

In that good way, they made amends.

And that is how this story ends.

About the Tale of the Gingerbread Man

The Gingerbread Man is an old American folk tale, told from one person to another for generations. No one knows how old it is, but we do know it was first printed in 1875 in a magazine called *St. Nicholas.* In the version of the story told most often, the gingerbread man is created by a couple who wish to have a child of their own. But after coming out of the oven, the gingerbread man immediately runs away, shouting "Run, run, as fast as you can. You can't catch me, I'm the gingerbread man!" The cookie escapes all who try to catch him, except, at the end, a devious fox who eats him up.

As a child, I loved the classic gingerbread man story. How thrilling it was to see a cookie-boy jump right off a baking sheet and run out of his parents' house, into the wide world. And yet the ending always saddened me. It seemed unfair that this plucky, life-loving fellow should meet such an abrupt end, all because he trusted the fox.

It was fun to create a version of the story that I hope will address children's innate sense of justice, set in a city I love. With its gingerbread architecture, whipped-cream fog, and creative food culture, San Francisco seems a perfect home for a spicy gingerbread child. After Shirley tastes a crumb from her gingerbread boy's thumb, the cookie boy decides to break the mold and sets off to devour the delicious city. As in the classic tale, he is eventually cornered at the water—this time the Pacific Ocean instead of a river—where he can run no more. But the fox doesn't get lucky this time. Instead, the gingerbread boy and Shirley make up and make amends. Hungry for love as well as for food, Shirley's cookie proves to be sweeter as a friend than as a dessert, and, like his maker, an inspired baker too.

—Elisa Kleven

Unlike Shirley's cookie,
these sweet treats won't eat a lot,
but they're spicy and delicious,
eaten cool or piping hot.

They won't be hurt or angry
if you eat them top to toe,
for they're only little cookies
made of tasty ginger dough.

But if you want a cookie
who will play and be your friend,
you can make up your own story,
draw some pictures, and pretend!

How to Make Gingerbread People

Be sure to have an adult help you make these cookies, since hot ovens and pans can be dangerous.

Preheat oven to 350 degrees.

1. Blend well in a large bowl:
 - ½ cup of brown or white sugar
 - ¼ cup of canola oil (you can also use the same amount of softened butter, but I've found that the oil makes for crispier cookies).
 - ½ cup of dark molasses
 - 1/4 cup of water

2. In another bowl, mix well:
 - 2 ½ cups of sifted flour
 - 2 teaspoons of ground ginger
 - ½ teaspoon of cinnamon
 - ¼ teaspoon of cloves
 - ½ teaspoon of salt
 - 1 teaspoon of baking soda

3. Gradually add the dry ingredients to the sugar/butter/molasses mixture.

4. Add a little water if the dough feels too dry or a little flour if it feels too wet (it should be moist but not too sticky to shape easily). Feel free to mix the dough in your clean hands until it is thoroughly blended.

5. This dough need not be refrigerated before being rolled and baked, but it may be easier to work with if left in the fridge for an hour or more.

6. On greased cookie sheets, roll the dough until it's about ¼ inch thick, and use a cookie cutter to make your gingerbread people. Or, mold your people by hand on the cookie sheets. Make a simple cookie person by rolling a ball of dough for a head, a cylinder of dough for each of the arms and legs, a rectangle or triangle for the body, and small cylinders for hands and feet.

7. Make sure that all the body parts are firmly attached to one another (use a little water to smooth them together), so they won't break apart while baking.

8. Roll or press the gingerbread people until they are about ¼ inch thick.

9. Add buttons, eyes, and other decorations to your people, using toppings like chopped nuts, raisins, jelly beans, and Red Hots. Chocolate chips will melt and spread, but may be added after baking, with icing (see below).

10. Bake your gingerbread people for about 8 minutes, or until done.

11. If you decide to ice your cookies, wait until they are cool. You can make icing with ¼ cup of powdered sugar and a few drops of water (your icing should be wet but not too watery). Add food coloring if you wish.

 Have fun icing your gingerbread people and adding more edible decorations. Then, enjoy!

San Francisco Landmarks

On their wild romp around San Francisco, Shirley and her hungry gingerbread boy travel through many neighborhoods, passing all kinds of unique city sights and landmarks. Can you find them?

PAGE 12: THE MISSION DISTRICT

1. *Mission Dolores Chapel* The Mission District gets its name from this chapel, one of twenty-one California missions founded by Spanish Catholic priests. Built and painted by the Ohlone people in the 1780s, the chapel is the oldest structure in San Francisco.
2. *Women's Building* This gloriously painted building celebrates women's achievements around the world. Look for the crowning portrait of Guatemalan activist Rigoberta Menchú.

PAGE 13: SAN FRANCISCO CITY HALL AND UN PLAZA

3. *City Hall* This elegant building was actually San Francisco's second city hall; the first was destroyed in the 1906 earthquake and fire. The dome, decorated with gold leaf, is the fifth largest in the world.
4. *Heart of the City Farmers' Market* Since 1981, this public market has brought fresh, local food to the area, open year round—and providing the gingerbread boy with lots to eat!

PAGE 14: CHINATOWN

5. *Dragon Gate* Covering twenty-four square blocks, San Francisco's Chinatown is the largest Chinese community outside of Asia, and this gate marks the Grant Street entry. The words on the plaque, written by Sun Yat-sen, read "All under heaven is for the good of the people."
6. *This Lion Dancer* is preparing for the Chinese Autumn Moon Festival, which celebrates the harvest. But when the gingerbread boy sweeps through, the curious dancer can't help but follow!

PAGE 15: NORTH BEACH AND THE FINANCIAL DISTRICT

7. *City Lights Bookstore* North Beach is San Francisco's "Little Italy" and also the historic home of the Beat writers and poets. This famous bookstore has felt like home to many great writers.
8. *Transamerica Pyramid* Completed in 1972, the Transamerica Pyramid is covered in white crushed quartz, its design inspired by light filtering down through tall trees.

PAGE 16

9. *Cable Cars* San Francisco's cable cars were invented in the 1870s by Andrew Hallidie, who pitied the horses forced to haul streetcars up the city's steep hills—a perfect invention in a city named after Saint Francis, patron saint of animals!
10. *Alcatraz Island* This island, filled with buildings, gardens, and a water tower, has had many lives. Most famously, it was a federal penitentiary. In 1969, after the prison was shut down, it became the site of a Native American protest. Today, it is a museum.
11. *Hyde Street Pier* Look for the tall masts of the sailing ship *Balclutha,* built in 1886, and other historic ships anchored here, many open for tours.
12. *San Francisco–Oakland Bay Bridge* Built in 1936, the bridge spans over eight miles and links the East Bay to San Francisco. A section of the bridge collapsed in the 1989 Loma Prieta earthquake and was rebuilt in 2013—now the widest bridge in the world!

PAGE 17: AQUATIC PARK HISTORIC DISTRICT AND FISHERMAN'S WHARF

13. *Maritime Museum* This 1930s art deco structure was built to look like an ocean liner.
14. *Chowder in a Bread Bowl* Sourdough first became popular here when a French baker named Isidore Boudin immigrated to the city in 1849. He created his own special blend of sourdough, which is still used at Boudin Bakery today! (Be sure to leave room for dessert at Ghirardelli Square, just up the street, the site of the original chocolate factory.)

PAGE 18

15. *The Japanese Tea Garden in Golden Gate Park* This garden is a wonderful place to spend the afternoon among ponds, sculptures, and a teahouse. Like many children who visit the garden, the gingerbread boy enjoyed climbing on the drum bridge. The pagoda, drum bridge, and rustic stone bridge at nearby Stowe Lake were first built as part of the 1894 Midwinter World's Fair.

PAGE 19

16. *Conservatory of Flowers* The cake-like building and greenhouse, which the gingerbread boy wanted to bite right into, is home to the world's largest orchid collection and hundreds of other plant species.

PAGE 20

17. *Coit Tower* Perching atop Telegraph Hill, Coit Tower was built in 1933 and is painted on the inside with colorful murals.
18. *Ferry Building* Completed in 1898 as a gateway to the bay, the Ferry Building is topped by a marvelous clock tower. While it used to be a bustling ferry terminal, today it is a vibrant food marketplace.
19. *Wild Parrots* A flock of wild, green parrots also make their home in this neighborhood!

PAGE 21

20. *Lombard Street* Though the gingerbread boy wants to devour this ribbon candy–like stretch of Lombard Street, paved with red brick and bordered by flowerbeds, it was constructed in 1922 for a different purpose: to allow cars to make their way down the steep, steep hill.
21. *Fog* is commonly seen drifting around Lombard Street—and all of San Francisco—especially in summer when it pours through the Golden Gate. Sometimes it looks thick enough to eat with a spoon.
22. *Palace of Fine Arts* This magical-looking palace at the edge of a lagoon was constructed for the Panama–Pacific World's Fair of 1915. Although it was meant to be torn down when the fair ended, it was thought too beautiful to destroy.

PAGES 22 AND 23

23. *The Golden Gate Bridge* was built in 1937 and named after the Golden Gate Strait, the narrow channel separating San Francisco

Bay and the Pacific Ocean. Some forty thousand years ago, there was no bay. You could walk on dry land all the way to the Farallon Islands, and at the Golden Gate there wasn't a bridge, but an enormous waterfall!

24. *Fort Point* stands guard at the base of the bridge. It was built before the Civil War, and also used as a station for soldiers during World War II.

25. *Mount Tamalpais,* or Mount Tam as it's affectionately known, gets its name from the Coast Miwok people and means "West Hill." The lovely, forested mountain is 2,500 feet tall.

PAGE 24

26. *Coast Redwood Trees* Some of these ancient giants are as old as 2,000 years and as tall as 380 feet—good luck grinding them to a pulp! They only grow in a foggy, narrow region running from southwestern Oregon to Monterey County. In 1908 Theodore Roosevelt established Muir Woods, a preserve of ancient old-growth redwood trees on the west side of Mount Tamalpais, north of San Francisco.

PAGE 25

27. *San Francisco Bay* The bay is huge—hundreds of square miles of water, spanned by eight bridges. It includes various far-flung estuaries and wetlands, providing vital habitat for birds and marine life.

PAGES 27 AND 28

28. *Lands End,* a park within the Golden Gate National Recreation Area, abounds with cypress trees, sculpted by the ocean wind. At Eagle's Point you will find the Lands End Labyrinth. It was created by artist Eduardo Aguilera, who says his work's theme is "Peace, love, and enlightenment," making it an ideal place for Shirley and her gingerbread boy to reconcile.

PAGES 29, 30, AND ALL THROUGH THE BOOK

29. *Gingerbread Houses* Between 1849 and 1915, almost 50,000 Victorian-style houses were built in San Francisco. These colorful, decorative domiciles, also known as "Painted Ladies," help make the city a feast for the eyes and the spirit.

About Elisa Kleven

Elisa and her dog, Bella, on their favorite coast-side hike north of San Francisco. Photo by Paul Kleven.

As a child, Elisa created intricate, colorful dollhouse worlds. And when she grew up, she continued to make enchanted miniature worlds within the covers of her picture books. Elisa is the author and/or illustrator of over thirty books, which have received honors from the American Library Association, *The New York Times*, The Junior Library Guild, *School Library Journal,* Bank Street College, The American Booksellers Association, and the American Institute of Graphic Arts.

Elisa lives in the San Francisco Bay Area with her husband, daughter, son, dog, and cats. She loves to look out at the Golden Gate Bridge through her window, and she loves baking gingerbread people, and gingerbread houses too. Visit Elisa's website at www.elisakleven.com.